MW00813763

AFRICANA WOMANISM

First published in 1993, this is a new edition of the classic text in which Clenora Hudson-Weems sets out a paradigm for women of African descent. Examining the status, struggles and experiences of the Africana woman forced into exile in Europe, Latin America, the United States or at Home in Africa, the theory outlines the experience of Africana women as unique and separate from that of some other women of color, and, of course, from white women. Differentiating itself from the problematic theories of Western feminisms, Africana Womanism allows an establishment of cultural identity and relationship directly to ancestry and land.

This new edition includes five new chapters as well as an evolution of the classic Africana womanist paradigm, to that of Africana-Melanated Womanism. It shows how race, class and gender must be prioritized in the fight against every day racial dominance. *Africana Womanism: Reclaiming Ourselves* offers a new term and paradigm for women of African descent. A family-centered concept, prioritizing race, class and gender, it offers eighteen features of the Africana womanist (self-namer, self-definer, family-centered, genuine in sisterhood, strong, in concert with male in the liberation struggle, whole, authentic, flexible role player, respected, recognized, spiritual, male compatible, respectful of elders, adaptable, ambitious, mothering, nurturing), applying them to characters in novels by Hurston, Bâ, Marshall, Morrison and McMillan. It evolves from Africana Womanism to Africana-Melanated Womanism.

This is an important work and essential reading for researchers and students in women and gender studies, Africana studies, African-American studies, literary studies and cultural studies, particularly with the emergence of family centrality (community and collective engagement), the very cornerstone of Africana Womanism since its inception.

Africana Womanism represents Dr. Clenora Hudson-Weems' perception about the urgent need for Africana-Melanated people to strategize workable means by which to solidify true survival for our own. The question is, "If we don't, then who will make possible the continuation of our legacy?" This book speaks directly to the issue of justice, and that means real equity for all on all levels, race, class and gender. It's a meaningful book for all to read!

—**Lillian A. Smith**, Entrepreneur and Former Senior
Producer for the *Phil Donahue Show*

AFRICANA WOMANISM

Reclaiming Ourselves

Fifth Edition

Clenora Hudson-Weems

Routledge
Taylor & Francis Group

LONDON AND NEW YORK

Fifth edition published 2020
by Routledge
2 Park Square, Milton Park, Abingdon, Oxon, OX14 4RN

and by Routledge
52 Vanderbilt Avenue, New York, NY 10017

Routledge is an imprint of the Taylor & Francis Group, an informa business

© 2020 Clenora Hudson-Weems

The right of Clenora Hudson-Weems to be identified as author of this
work has been asserted by her in accordance with sections 77 and 78 of
the Copyright, Designs and Patents Act 1988.

All rights reserved. No part of this book may be reprinted or reproduced
or utilised in any form or by any electronic, mechanical, or other
means, now known or hereafter invented, including photocopying and
recording, or in any information storage or retrieval system, without
permission in writing from the publishers.

Trademark notice: Product or corporate names may be trademarks
or registered trademarks, and are used only for identification and
explanation without intent to infringe.

First edition published by Bedford Publishers, Inc. 1993
Fourth revised edition published by Bedford Publishers, Inc. 2004

British Library Cataloguing-in-Publication Data
A catalogue record for this book is available from the British Library

Library of Congress Cataloging-in-Publication Data
Names: Hudson-Weems, Clenora, author.
Title: Africana womanism : reclaiming ourselves /
Clenora Hudson-Weems.
Description: Second edition. | London ; New York : Routledge, 2020. |
Includes bibliographical references and index.
Identifiers: LCCN 2019020390 | ISBN 9780367253622 (hardback) |
ISBN 9780367253639 (paperback)
Subjects: LCSH: Feminist theory. | Women, Black—Social
conditions. | Feminism. | Racism. | Literature—Black authors—
History and criticism. | Literature—Women authors—History and
criticism. | Women and literature. | Womanism.
Classification: LCC HQ1190 .H83 2019 | DDC 305.48/896073—dc23
LC record available at https://lccn.loc.gov/2019020390

ISBN: 978-0-367-25362-2 (hbk)
ISBN: 978-0-367-25363-9 (pbk)
ISBN: 978-0-429-28737-4 (ebk)

Typeset in Bembo
by codeMantra

FOREWORD TO THE 5TH EDITION

James B. Stewart and Ama Mazama

For the past three decades, Dr. Clenora Hudson-Weems has focused intensely on articulating and interrogating the important construct of "Africana Womanism." The importance of Africana Womanism to Africana Studies/Africology cannot be overstated. Among its many virtues is its role as an important corrective to the continuing tendency to marginalize the experiences of Africana women and minimize their roles as active agents in the ongoing liberation struggle. Consequently, Africana Womanism is enabling Africana Studies/Africology to realize its full potential as a guiding beacon in the global battle to claim the natural rights of *all* people of African descent. Indeed, one commentator, general editor of *Call and Response*, has suggested, "Of all the theoretical models, Hudson-Weems' best describes the racially based perspective of many black women's right advocates, beginning with Maria W. Stewart and Frances W. Harper in the early nineteenth century."[1]

In developing and articulating Africana Womanism, Hudson-Weems has confronted opposition from both White and Black feminists. She confronts White feminists with the pronouncement (Chapter 1), that feminism is "a term conceptualized and adopted by White women, [and] involves an agenda that was designed to meet the needs and demands of that particular group." Elaborating on this point in a 1989 essay, she insists "as Africana women share other forms of oppression that are not necessarily a part of the overall White women's experiences, their varied kinds of victimization need to be prioritized."

Mounting a challenge to Black feminists required Hudson-Weems to deconstruct the concept of Womanism introduced by Alice Walker in her book, *In Search of Our Mothers' Gardens*. For Hudson-Weems, Walker's formulation is simply a variant of mainstream feminist thought, in which the focus "is almost exclusively on the woman, her sexuality and her culture." She treats Walker's exclusive foregrounding of gender-specific concerns as an example of the higher priority assigned to gender oppression within Black feminist thought. In truth, the very

notion of "Black feminism" is an aberration because if feminism is, indeed, articulated around the fundamental notion that women are oppressed first of all because they are women, and then (possibly) because they are Black and/or poor, then it is not possible to speak of "Black feminism." In fact, it is an oxymoron, and a typical case of conceptual incarceration because, in the end, these Black intellectuals who seek to translate and improve the negative experiences of Black women remain subordinated to White intellectuals whose analyses and concepts they try to adapt as best they can to their own reality, placing themselves *ipso facto* in an untenable situation, both theoretically and practically. In contrast, Africana Womanism prioritizes racial oppression as the central focus of liberation efforts and emphasizes the importance of organic partnerships between Africana women and men. Consequently, Hudson-Weems insists that, "Instead of alienating the Africana male sector from the struggle today, Africanans must call for a renegotiation of Africana male-female roles in society. In so doing, there must be a call to halt once and for all female subjugation, while continuing the critical struggle for the liberation of Africana people worldwide." Summarizing her disputes with White and Black feminists, Hudson-Weems declares, "Neither an outgrowth nor an addendum to feminism, *Africana Womanism* is not Black feminism, African feminism, or Walker's womanism that some Africana women have come to embrace."

It is important to recognize that Africana Womanism does not ask Black women to ignore or subordinate their legitimate concerns regarding maltreatment and restricted opportunities. To illustrate, Hudson-Weems reminds the reader, "It has been apparent from the beginning that Africana women in particular have been and must continue to be concerned with prioritizing the obstacles in this society—the lack of equal access to career opportunities, fair treatment of their children, and equal employment for their male counterparts." In addition, she maintains that "the Africana womanist, above all, demands *respect* for and *recognition* of herself in order to acquire true self-esteem and self-worth, which in turn enables her, among other things, to have complete and positive relationships with all people." In Chapter 4, entitled "The Agenda of the Africana Womanist," she identifies eighteen traits attributable to the Africana womanist as "Self-Namer," "Self-Definer," "Family-Centered," "In Concert with Males in Struggle," "Flexible Roles," "Genuine Sisterhood," "Strength,", "Male Compatible," "Respect and Recognized," "Whole and Authentic," "Spirituality," "Respectful of Elders," "Adaptable," "Ambitious," and "Mothering and Nurturing." These traits are used in the second section of the book to explore how selected novels have incorporated Africana womanist themes.

Hudson-Weems laid the groundwork for testing the efficacy of Africana womanist theory in her first Africana Womanism book, *Africana Womanist: Reclaiming Ourselves* (1993). Her methodology involves, in part, demonstrating how fictional characters in selected novels embody Africana womanist traits. The use of fictional characters to "test" and explicate Africana womanist theory is strikingly similar to the use of fictional characters by W.E.B. Du Bois to explore the themes of psychic duality and racial uplift.[2] Hudson-Weems' analysis results in

the reinterpretation of some works previously characterized as decidedly feminist tracts. One example is the character Janie in Zora Neale Hurston's *Their Eyes Were Watching God*, who has been widely celebrated as a feminist icon. Hudson-Weems demonstrates convincingly that Janie exhibits many significant Africana womanist attributes. A similar conclusion emerges from her examination of Ramatoulaye in Mariama Bâ's *So Long a Letter*, Avey in Paule Marshall's *Praisesong for the Widow*, Sethe and Baby Suggs in Toni Morrison's *Beloved*, and Zora in Terry McMillan's *Disappearing Acts*.

The third section of the book, "From Africana Womanism to Africana-Melanated Womanism," presents previously unpublished material reflecting the ongoing evolution of Hudson-Weems' thinking. The correct naming of her project has always been a central concern and, consequently, introduction of the term, "Africana-Melanated Womanism" to supplant the original "Africana womanist" construction is noteworthy. Responding to the global embrace of the central tenets of Africana Womanism, Hudson-Weems insists that the term, "Africana-Melanated Womanism … allows us to not have to choose among options that unfortunately do not meet the demands, concerns and priorities of our people worldwide, which is the continuous pursuit of our God-given birthright as a people—freedom, security, and happiness."

The African concept of "Nommo" emphasizes naming as a precursor to operationalizing an idea. And there is evidence that Africana Womanism/Africana-Melanated Womanism is impacting the lives of global Africana women. The article "From Shack Dweller to Home Owner: The Power of the MBOP, Africana Womanism, and Self-Help Housing among the Shack Dwellers Federation of Namibian" describes how the women in this particular area practiced and applied the tenets of Africana Womanism in their everyday lives in ways that made a significant change in their circumstances.[3] This is, perhaps, the most significant evidence to date of the validity of Hudson-Weems' assertion, "If Africana Womanism is allowed to reach its full potential, that of reclaiming Africana women via identifying our own collective struggle and acting upon it, then Africana people the world over will be better for it."

James B. Stewart, Ph.D.—Professor Emeritus, Labor Employment Relations & Africana Studies; Vice Provost, Penn State University, 2018; former President—the National Council for Black Studies

Ama Mazama, Ph.D.—Professor, Department of Africology, Temple University, 2018; Editor—*Journal of Black Studies* 2019

Notes

1 Liggins Hill 1379.
2 See Stewart, "Psychic Duality" and "Perspectives on Reformist, Radical, and Recovery Models."
3 Cowser and Barnes.

PREFACE FROM THE 1ST EDITION

Clenora Hudson-Weems

I am eternally indebted to the many formal and informal debates I have had since beginning my research focus in 1985 on *Africana Womanism*, then called *Black Womanism*. During my first semester in the fall of 1985 as a doctoral candidate at the University of Iowa, I wrote the seminal paper for this concept entitled "The Tripartite Plight of the Black Woman—Racism, Classism, and Sexism—in *Our Nig*, *Their Eyes Were Watching God* and *The Color Purple*." This paper was the lead for the panel I set up on "Black Womanism versus Black Feminism—Racism First, Sexism Last: The Survival of the Black Race," which was held at the March 13–16, 1986 National Council for Black Studies Annual Conference in Boston. Interrogation from my colleagues about my insistence that early Black women activists such as Sojourner Truth, Harriet Tubman and Ida B. Wells not be re-ferred to as pre-feminists compelled me to continue this research, and for that dialogue I am grateful. Special gratitude goes to Professor Vivian Gordon, who openly offered statistical data as a sociologist in my support during that heated debate in Boston.

The following year, I presented this paper again at the June 24–28, 1987 Na-tional Women's Studies Association Convention in Atlanta, Georgia on a panel I organized under the title "The Tripartite Plight of Black Women."

I had maintained for several years that Africana women were not feminists by the very nature of their historical and cultural experiences. I had debated this point with colleagues at national conventions, at Delaware State College where I was then serving as Director of Black Studies, and later in my classes at the University of Iowa. In the Fall 1985 class with Mae Henderson, I stood opposed to the interpretation of Africana women writers as feminists—a position that stimulated much discussion. The paper later appeared in the December 1989 is-sue of *The Journal of Black Studies*, which, while highlighting how works abound in the female protagonists' struggle against female subjugation, acknowledges the

primacy of racial oppression in the world of Africana people, thereby complicating the phenomenon of Africana women's unfortunate and misguided victimization by their male counterparts as dictated by a patriarchal system.

My next formal paper on the subject, "Black Womanism versus Black Feminism: A Critical Issue for Human Survival," was inspired by my first paper. It was presented at a symposium at the University of Iowa in 1987 and later at both the April 7–9, 1988 National Council for Black Studies, and the April 28–30, 1988 African Heritage Studies Association Annual Conferences. The supportive dialogue with my colleagues at these conferences was encouraging. On my arrival at the opening plenary, Professor Delores Aldridge, Chairperson for the National Council for Black Studies, Inc. requested my remarks on the question of the Africana woman. I am especially grateful to the chief editor of *The Western Journal of Black Studies*, Professor Talmadge Anderson, for suggesting that I submit the paper for publication. It appeared in the 1989 Winter issue under the title "Cultural and Agenda Conflicts in Academia: Critical Issues for Africana Women's Studies" of *The Western Journal of Black Studies*. In an article in his syndicated column (June 25, 1990), journalist Tony Brown referred to my emphasis on naming and prioritizing, which broadened the readership of my work and resulted in much positive response from people in various fields. I wish to thank him for that exposure. I am grateful for all those unnamed colleagues who have kept the faith in me in my refusal to place the unique experiences of Africana women within a feminist framework, thereby refining a new paradigm for Africana women and an Africana women's movement.

My sincere gratitude also goes to Professor William H. Turner for extending a special invitation to me to speak in February 1988 at his university, Winston-Salem State. During this visit, I was invited to the home of Professor C. Eric Lincoln of Duke University where we spent hours discussing the effects of Africana women's assimilation of feminist rhetoric and philosophy. I thank Professor James Stewart (who has been there for me) for an invitation as resource specialist speaking on Africana Womanism at the 1989 Summer Faculty Institute at Indiana University in Bloomington under the auspices of the National Council for Black Studies in connection with a grant from the Ford Foundation.

Special gratitude goes to Professor Betty Taylor Thompson for inviting me to conduct a two-day workshop on Africana Womanism in the spring of 1991 during her tenure as Chair of the Department of English at Texas Southern University. This workshop enabled me to further refine my ideas. I wish to thank Professor Robert Harris, Director of the Africana Studies and Research Center at Cornell University for extending to me an invitation as guest speaker at Cornell's Africana Studies Center's 1993 International Scholars-in-Residence symposium, where dialogue with and questions by such international figures as Micero Mugo were both stimulating and affirming.

A very special thanks goes to my first true mentor, Lucy Grigsby, Professor Emeritus and former Chair of the Department of English, who extended her arms to me upon my arrival at Atlanta University. Special gratitude goes to

my life-long mentor and friend, Richard K. Barksdale, Professor Emeritus of the University of Illinois-Champaign, who never doubted my insights into the Africana culture, and to his wife, Professor Mildred Barksdale, whose inspiration remains invaluable to me. I also wish to acknowledge other encouraging on- and off-campus colleagues—Professors Doreatha Drummond Mbalia, Wilfred Samuels, Annette Ivory Dunzo, John Morrison, Kathy Gibson, James Scott King, Maria Mootry, Charshee McIntyre and Donnarae MacCann—for listening and responding to my ideas and interpretations, my enthusiasm and my rage during the process of my finding a proper place for Africana women and our historical, current and future levels of struggle.

I am equally indebted to special friends—Joe Henry, Mae Morrison, Emogene McCathen, Alvin Chambliss, Sandra Lemieux, Sandy Kravitz, Minnie Logan, Frankie McCullough and Chinwa—who witnessed the refinement of the concept of Africana Womanism through the many dialogues I had with them dating back over a decade. Also thank you, Kevin Lemieux, for so often rescuing my documents on this and many other subjects from my computer. Enduring gratitude goes to Carolyn Banks Thompson, my eternal friend and colleague, whose undying faith in me commenced on my first day of school at LeMoyne College and to Marjorie Gibson, also my eternal friend.

Special gratitude goes to Fern McClanahan for her invaluable secretarial assistance to me while working on this project; to my supportive Chair, Professor Ellie Ragland; to Lynn Lewis, my graduate assistant; and to my enthusiastic students in my classes, Contemporary Africana Women Writers (English 304) and Contemporary Africana Thought and Theory (English 493) at the University of Missouri-Columbia. My gratitude extends to the university's International Faculty Travel Fund and to Dr. Larry Clark, Dean of the School of Arts and Sciences, for making it possible for me to present my theory at an International Conference on Women of Africa and the African Diaspora at the University of Nigeria-Nsukka in July 1992. Dialoguing with Africana women from all over the world, and particularly with Professors 'Zulu Sofola, who is distinguished as Nigeria's first female playwright, and Daphne Williams Ntiri, a Sierra Leonean who resides in the United States but who is active in international affairs on Africana women, enabled me to further globalize my concept upon my return to the United States. Ntiri was particularly helpful in supplying me with a short bibliography on Africana women, including the book she edited entitled *One is Not a Woman, One Becomes: The African Woman in a Traditional Society.*

Finally, eternal gratitude goes to God, Jesus Christ, for inspiring me and granting me a supportive family.

Clenora Hudson-Weems, Ph.D.
University of Missouri-Columbia

INTRODUCTION

Daphne Williams Ntiri

"Women are the Blacks of the human race". Can they tell us then what or who are Black Women? The Blacks of the Blacks of the human race?

You would think that Black women did not exist. In fact, they find themselves denied, in this way, by the very women who claim to be fighting for the liberation of all women.

(Thiam)

Imagine the intensity of pain and feeling of degradation in these statements by Senegalese writer and activist, Awa Thiam. She challenges and denounces insinuations and subtleties in the messages of some White feminists whom she accuses of insensitivity and disfavor toward Africana women. Kate Millet in a 1976 rally in Paris on the theme "Ten Hours against Rape" is quoted as saying *Rape is to women what lynching is to Blacks*. As interpreted by Thiam the message resonates with racist overtones and a double sexist message. Thiam formulates the equation to mean: *women = Blacks (insofar as both are oppressed); therefore, rape = lynching*. Of course, the comparison is totally misleading and rendered invalid by the very fact that it ignores the existence of Black women who do get raped by Black men or White men, for that matter. Or else Millet's conscious or unconscious intention is to view her brand of feminism as inherently exclusive with references solely to White women. She, however, is not brave enough to say so.

For years Africana women have found themselves in a serious ideological predicament. In the absence of viable organized women's groups they have been invited to embrace feminism as an instrument of emancipation and as a newfound source of empowerment and status-building. However, the majority of Africana women on public platforms have rejected feminism for a multiplicity of reasons. First, there is the unquestionable need to reclaim Africana women; second, they are perplexed over the racist origins of the feminist movement; third, they have found little solace in the doctrines and mission of the feminist movement; and, fourth, the realities, struggles and expectations of the two groups remain on different planes. The privileges and advantages still belong to the dominant group. This leads to

the conclusion that feminism is to Africana women as post-Mandela apartheid is to Black South Africans. In other words, though slavery, colonialism and apartheid are said to have been dismantled and Africana people are free, the yoke of oppression is still ever-present. What I witness, in essence, is a transformation—a transformation in time and form. The institutions of the past are the same institutions of oppression that are masquerading under different guises and exerting the same or even greater level of oppression on the Africana masses. Why, then, should an Africana woman, handicapped by a global system of oppression and racism, embrace the feminist movement with its distinct orientation to Eurocentric ideals?

Lerone Bennett, Jr., the activist and social critic, in his discourse on lost identity and Black consciousness, believes that the naming process is of extraordinary importance. How people have been classified and named in the social order in the past has a lot to do with the myriad distorted images created. Naming is too critical an act to be left in the hands of the dominant group at this phase of our history, he says. "We have been named, we should now become 'namers'." These philosophical statements are a guiding principle and support the increasing need Africana people have for self-naming, self-defining and self-identity. Clenora Hudson-Weems articulates this clearly in her concept of *Africana Womanism*:

> the Africana woman, in realizing and properly assessing herself and her movement, must properly name herself and her movement—Africana womanist and African womanism. This is a key step which many women of African descent have failed to address. While they have taken the initiative to differentiate their struggle from the white woman's struggle to some degree, they have yet to give their struggle its own name.
>
> *(55–56)*

As compelling as the reasons are for the naming continuum of African people in the United States to reaffirm their race and establish stronger African affinity (Negro/Colored to Blacks, to Afro-American to African-American), so necessary are the reasons to advocate a theory that is properly labeled, more attuned and appropriate to the needs of the Africana woman. Granted, women, no matter what continent or race, suffer from sexist domination and exploitation. Indeed, this is a basic tenet of human cooperation. But the discourse involving Africana women cannot escape the historical realities of hegemony and ethnocentrism by Western cultures and the accompanying atrocities of slavery, colonialism and oppression. The status, struggles and experiences of the Africana woman in forced exile in Europe, Latin America, the United States or at home in Africa remain typically unique and separate from that of other women of color, and of course from White women. In reality, the prototypical image is of a poor, struggling, Africana woman overburdened by labor-intensive, domestic and non-domestic projects and multiple offspring. This is not the same for the White woman.

Is it not true, then, that race precedes sexism in a racist world? Or that society has conditioned its lookers to see race before sex? And that racism and classism

upheaval of social structures. Where Black women have to combat colonialism and neo colonialism, capitalism and the patriarchal system, European women only have to fight against capitalism and patriarchy.

(Thiam 116)

The mainstream feminist's assertion is for equal and individual rights for White women in a patriarchy where White men have monopolized power. Her fight against her White male counterpart has to do with her submission of rights and property and her subsequent inferior status in society attributable to years of domination by the males in her life.

The Africana woman, on the other hand, has a different attitude and approach to the man in her world. His presence assures her of the struggle toward a common destiny. Africana males are unaccustomed to the privileges and advantages enjoyed by White males; therefore, it is not necessary for the Africana female to see her man as her primary enemy as does the White feminist. Since Africana men have never had the same institutionalized power to oppress as have White men, family pride and solidarity are embraced warmly from the Africana woman's perspective. Complementarity between men and women is encouraged. In fact, to do otherwise would be most harmful and disadvantageous to a race that has been subjected to economic exploitation, racial oppression and genocide in relation to the dominant White group.

Awa Thiam in her work summarizes the relationships of coexistence between males and females in the African context:

> Some women tend to equate man with society and by inference see men as their enemy. We do not feel that, as far as Black Africa is concerned, men are the enemy. It is certainly true that in any patriarchal system, institutions are set up by men, and this might reinforce the arguments given by "sexist" feminists; but we should ask ourselves whether or not men are alienated as well. Doesn't the very fact of having devised a system of values which disadvantage women offer clear proof of men's alienation? The sex which oppresses is not a free sex. A society made up of non-alienated individuals would be an egalitarian society, in which there would be neither master nor slave, neither tyrant nor tyrannized, neither colonial nor colonized, neither chief not subordinate.
>
> Such a society does not exist. Until now there have only been attempts to create it. It is now our task to do so. To succeed in this, sexism must be excluded from our praxis, from the praxis of every woman enlisted in the struggle.

(Thiam 121)

The primary strategy outlined for Africana woman's survival is spelled out accurately by Hudson-Weems:

> The Africana womanist, focusing on her particular circumstances, comes from an entirely different perspective, one which embraces the concept of

collectivism for the entire family in its overall liberation struggle for survival, thereby resolving the question of her place in the venue of women's issues.

(44)

She brings out some vital differences between the Black and White woman by pointing to class distinction and the baseline struggles between the dominant and oppressed groups. The class issue is clear in this context:

> Indeed, Africana women have not had that sense of powerlessness that White women speak of, nor have they been silenced or rendered voiceless by their male counterparts, as is the expressed experience of White women. The labels "Black Matriarch," "Sapphire" and "bitch" appended to the Africana woman to describe her personality and character clearly contradict the notion of the Africana woman as voiceless. Moreover, unlike the White woman, the Africana woman has been neither privileged nor placed on a pedestal for protection and support.

(48)

One of the more distressing areas of conflict concerns the changing status of the White feminist in the system. As she experiences the ever-growing ladder of success, the question that surfaces is how does she, or does she at all, use her newly found power to alleviate the pain and suffering of the powerless and disadvantaged? Upon acquisition of power, to what extent does she continue to perpetuate the system of unfairness and exploitation against Africana people regarding equality, power sharing and access to opportunity and resources? Note Hudson-Weems' sentiment on this:

> Though criticizing the power that men monopolize, the liberal feminist tends to join, rather than question, the White male-dominated power system itself. The radical feminist acknowledges the differences between males and females, but sees the two as antagonistic and in conflict.

(44)

Hudson-Weems has devoted years of research to the evolving movements that affect the lives of women of African descent. She situates and defines the complex realities, and creates the criteria and instruments for assessing the thoughts and actions of the Africana woman through this work, *Africana Womanism*. She demonstrates academic leadership and responsibility for the continuing preservation and protection of op pressed groups to resist assimilation and carve out a group identity that uniquely windows the historical truths and cultural and political circumstance of the woman of African descent.

My association with Hudson-Weems began at the First International African Diaspora Conference in Nigeria in the summer of 1992. This meeting was an attempt to bridge academia and activism among women in the Africana diaspora. It

assembled scholars and practitioners to seek answers and define new parameters to sex and gender issues. As an active researcher myself, and a product of the women's decade, I had attended the Mexico City (1975) and Copenhagen (1980) meetings as a lobbyist for the Women's International League for Peace and Freedom. I have also for some years taught Women in Development courses at Wayne State University. With this background I welcomed Hudson-Weems' new impetus and vision to the scholarly action on Africana women. Here was a theoretical construct, *Africana Womanism*, authentic and legitimate, offering a structure to provide new insights into old problems. For me the potential of this scholarship was enormous. It is the kind of framework that could have been applied to earlier consulting work I had done among women in rural Somalia and elsewhere in Africa under auspices of UNESCO. In the late 1970s, during the Decade for Women, I had put some effort into trying to be a feminist; however, I withdrew from the movement after a short while. I begin to see now what had happened to me. I believe my withdrawal was prompted by alienation and the irrelevant agenda. As a Third World activist, a Sierra Leonean, to be more precise, I was searching for more realistic solutions to the problems of a Third World society. I was less concerned with the struggle between men and women, *ipso facto* as is proposed by feminism, and more anxious to seek answers to the Third World condition, especially Africa's. My major preoccupation was to overcome the more fundamental and disastrous environmental and living dilemmas of African women.

In *One is Not a Woman, One Becomes: The African Woman in a Transitional Society*, a work I edited in the early 1980s, I show how the concept of equality between men and women disappeared due to the advent of foreign forces on the continent. I show, for example, how the historical forces influenced and altered traditional gender roles in Africa. On the one hand, there were the competing and monotheistic religions, Christianity and Islam, whose tenets and practices relegated and continue to relegate women to the inferior status they now hold. On the other hand, the effects of the colonial powers, seemingly permanent, explain the creation of a dichotomous society between an elitist minority and an educationally and socio-economically under-privileged majority. The latter, of course, being women. I point to how colonialism intensified the sexual division of labor and gender subordination in the pre-capitalist modes of production. Of more importance is how men disposed of land and labor of women, gained control over cash/export crop production and relegated women to the hardships of the subsistence sector with inadequate remuneration. The transformation of African societies in the wake of these foreign forces has forced us to wonder about the future, and whether the social order would not have been more functional without these repeated disruptions.

Hudson-Weems' presentation received serious attention from panelists and participants alike at the Nigeria meeting. Her diligent portrayal of the historical facts that have systematically marginalized women of African descent—even the African woman in her own land—drove home some hard facts and opened the eyes of the women to new intellectual realms. As Chair of the Panel on Women and Ideologies where Hudson-Weems presented, I noted large-scale concurrence from Africana womanists in the standing-room-only crowd. The heartening

response to Africana Womanism was a strong indicator of acceptance, timeliness and appropriateness of theme. The audience, which included women from the United States, Canada, Nigeria, South Africa, Jamaica, Brazil, England and many other countries, were loud in their applause and support of *Africana Womanism*. Endless interviews and newspaper stories marked the symbolic importance of the new movement. *The Nigerian Daily Times* of Monday, July 27, 1992 contributed to globalizing the concept and endorsing this new action.

> Personal and racial experiences ... will be the factors responsible for the evolution of *Africana Womanism*. Therefore, legitimate concerns of the Africana Woman are issues to be addressed within the context of African culture and history. Africana Womanists do not believe in "bra burning." They believe in womanhood, the family and society.

This landmark pioneering treatise of Africana woman's realities cannot be ignored. With seeds planted on fertile soil, the harvest will be bountiful. It will unlock closed doors and usher in a spirit of renewed plenitude. *Africana Womanism* is reminiscent of a comparable avant-garde movement of the 1930s by diasporan Black scholars Leopold Sedar Senghor, Leon Damas, and Aime Cesaire, who struggled to seek reassurance of their blackness. "Negritude" was an expression of Black assertion and Black rejection. In the words of Aime Cesaire, one of the negritude poets, "Blackness is not absence, but refusal." Similarly, Hudson-Weems provides a vision that has been carefully formulated within the framework of novels of Africana womanist writers Zora Neale Hurston, Mariama Bâ, Toni Morrison, Paule Marshall, and Terry McMillan. In Part II of this work, she chooses literature as an effective medium to reflect on life and those experiences that shape life. She also identifies and embodies a set of eighteen distinct and effective descriptors to define the profile and character of the Africana woman. These encompass all aspects of her life. It is an action on her part authorizing Africana women to think of themselves as their own historians, writers or persons capable of articulating their own dreams and fears. Though the bulk of her selected literary works deal with the Black experience in the Western world, the theoretical premise inspires change and holds practical usefulness for the Africana woman in Soweto, London, Nairobi, Belize, São Paulo or Washington, DC. The work organizes the priorities in an Afrocentric sense and maps the dangers that Africana women face in a world dominated by a White, male-dominated capitalist economy.

Daphne Williams Ntiri, Ph.D.
Wayne State University, Detroit, Michigan

PART I
Theory

Women who are calling themselves Black feminists need another word that describes what their concerns are. Black Feminism is not a word that describes the plight of Black women. In fact ... black feminists have not even come together and come to a true core definition of what black feminism is. The white race has a woman problem because the women were oppressed. Black people have a man and woman problem because Black men are as oppressed as their women.

(Hare 15)

1

AFRICANA WOMANISM

Black feminism, African feminism, Womanism ...

> Feminism. You know how we feel about that embarrassing Western philosophy? The destroyer of homes. Imported mainly from America to ruin nice African women.
>
> *(Aidoo)*

Central to the spirit of Africanans (Continental Africans and Africans in the diaspora) regarding feminism in the Africana community is the above quotation by internationally acclaimed African novelist and critic, Ama Ata Aidoo. One of today's most controversial issues in both the academy and the broader community is the role of the Africana woman within the context of the modern feminist movement. Both men and women are debating this issue, particularly as it relates to Africana women in their efforts to remain authentic in their existence, such as prioritizing their needs even if the needs are not of primary concern for the dominant culture. The ever-present question remains the same: what is the relationship between an Africana woman and her family, her community and her career in today's society that emphasizes, in the midst of oppression, human suffering and death, the empowerment of women and individualism over human dignity and rights?

While many academics uncritically adopt feminism, the established theoretical concept based on the notion that gender is primary in women's struggle in the patriarchal system, most Africana women in general do not identify with the concept in its entirety and thus cannot see themselves as feminists. Granted, the prioritizing of female empowerment and gender issues may be justifiable for those women who have not been plagued by powerlessness based on ethnic differences; however, that is certainly not the case for those who have—Africana

women. For those Africana women who do adopt some form of feminism, they do so because of feminism's theoretical and methodological legitimacy in the academy and their desire to be a legitimate part of the academic community. Moreover, they adopt feminism because of the absence of a suitable framework for their individual needs as Africana women. But while some have accepted the label, more and more Africana women today in the academy and in the community are reassessing the historical realities and the agenda for the modern feminist movement. These women are concluding that feminist terminology does not accurately reflect their reality or their struggle.[1] Hence, feminism, and more specifically, Black feminism, which relates to African-American women in particular, is extremely problematic as labels for the true Africana woman and invites much debate and controversy among today's scholars and women in general. (The exact sentiment of Julia Hare in the opening epigraph.)

It should be noted here that there is another form of feminism that is closely identified with Africana women around the world. While African feminism is a bit less problematic for Africana women than is feminism in general, it is more closely akin to *Africana Womanism*. According to African literary critic Rose Acholonu in a paper she presented in July 1992 at the International Conference on Africana women in Nigeria:

> The negative hues of the American and European radical feminism have succeeded in alienating even the fair-minded Africans from the concept. The sad result is that today [the] majority of Africans (including successful female writers), tend to disassociate themselves from it.[2]

Hence, in spite of the accuracy of Filomina Chioma Steady in *The Black Woman Cross-Culturally* in her astute assessment of the struggle and reality of Africana women, the name itself, African feminism, is problematic, as it naturally suggests an alignment with feminism, a concept that has been alien to the plight of Africana women from its inception. This is particularly the case in reference to racism and classism, which are prevailing obstacles in the lives of Africana people, a reality that the theorist herself recognizes. According to Steady:

> Regardless of one's position, the implications of the feminist movement for the black woman are complex ... Several factors set the black woman apart as having a different order of priorities. She is oppressed not simply because of her sex but ostensibly because of her race and, for the majority, essentially because of their class. Women belong to different socio-economic groups and do not represent a universal category. Because the majority of black women are poor, there is likely to be some alienation from the middle-class aspect of the women's movement which perceives feminism as an attack on men rather than on a system which thrives on inequality.

(23–24)

In "African Feminism: A Worldwide Perspective," from *Women in Africa and the African Diaspora*, Steady asserts that

> For the majority of black women poverty is a way of life. For the majority of black women also racism has been the most important obstacle in the acquisition of the basic needs for survival. Through the manipulation of racism the world economic institutions have produced a situation which negatively affects black people, particularly black women ... What we have, then, is not a simple issue of sex or class differences but a situation which, because of the racial factor, is castlike in character on both a national and global scale.
>
> *(18–19)*

It becomes apparent, then, that neither the terms Black feminism nor African feminism are sufficient to label women of such complex realities as Africana women, particularly as both terms, through their very names, align themselves with feminism.

Why not feminism for Africana women? To begin with, the true history of feminism, its origins and its participants, reveals its blatant racist background, thereby establishing its incompatibility with Africana women. Feminism, earlier called the Woman Suffrage Movement, started when a group of liberal White women, whose concerns then were for the abolition of slavery and equal rights for all people regardless of race, class and sex, dominated the scene among women on the national level during the early to mid-nineteenth century. At the time of the Civil War, such leaders as Susan B. Anthony and Elizabeth Cady Stanton held the universalist philosophy on the natural rights of women to full citizenship, which included the right to vote. However, in 1870 the Fifteenth Amendment to the Constitution of the United States ratified the voting rights of Africana men, leaving women, White women in particular, and their desire for the same rights, unaddressed. Middle-class White women were naturally disappointed, for they had assumed that their efforts toward securing full citizenship for Africana people would ultimately benefit them, too, in their desire for full citizenship as voting citizens. The result was a racist reaction to the Amendment and Africanans in particular. Thus, from the 1880s on, an organized movement among White women shifted the pendulum to a radically conservative posture on the part of White women in general.

In 1890 the National American Woman Suffrage Association (NAWSA) was founded by northern White women, but "southern women were also vigorously courted by that group" (Giddings 81), epitomizing the growing race chauvinism of the late nineteenth century. The organization, which brought together the National Woman Suffrage Association and the American Woman Suffrage Association, departed from Susan B. Anthony's original women's suffrage posture. They asserted that the vote for women should be utilized chiefly by middle-class White women, who could aid their husbands in preserving the virtues of the

Republic from the threat of unqualified and biological inferiors (Africana men) who, with the power of the vote, could gain a political foothold in the American system. For example, staunch conservative suffragist leader Carrie Chapman Catt and other women of her persuasion insisted upon strong Anglo-Saxon values and White supremacy. They were interested in banding with White men to secure the vote for pure Whites, excluding not only Africanans but White immigrants as well. Historians Peter Carroll and David Nobel quoted Catt in *The Free and the Unfree* as saying that "there is but one way to avert the danger. Cut off the vote of the slums and give it to [White] women." She continued that the middle-class White men must recognize "the usefulness of woman suffrage as a counterbalance to the foreign vote, and as a means of legally preserving White supremacy in the South" (296). These suffragists felt that because Africana people, Africana men in particular with their new status as voters, were members of an inferior race, they should not be granted the right to vote before them, which did not come until much later with the August 1920 Nineteenth Amendment. Thus, while the disappointment of being left out in the area of gaining full citizenship, i.e., voting rights, for White women was well founded, their hostility and racist antagonistic feelings toward Africanans in general cannot be dismissed lightly.

Feminism, a term conceptualized and adopted by White women, involves an agenda that was designed to meet the needs and demands of that particular group. For this reason, it is quite plausible for White women to identify with feminism and the feminist movement. Having said that, the fact remains that placing all women's history under White women's history, thereby giving the latter the definitive position, is problematic. In fact, it demonstrates the ultimate of racist arrogance and domination, suggesting that authentic activity of women resides with White women. Hence, in this respect for White women, Africana women activists in America in particular, such as Sojourner Truth (militant abolition spokesperson and universal suffragist), Harriet Tubman (Underground Railroad conductor who spent her lifetime aiding Africana slaves, both males and females, in their escape to the North for freedom), and Ida B. Wells (anti-lynching crusader during the early twentieth century), were pre-feminists, in spite of the fact that the activities of these Africana women did not focus necessarily on women's issues. Considering activities of early Africana women such as those mentioned above and countless other unsung Africana heroines, what White feminists have done in reality was to take the lifestyle and techniques of Africana women activists and used them as models or blueprints for the framework of their theory, and then name, define and legitimize it as the only real substantive movement for women. Hence, when they define a feminist and feminist activity, they are, in fact, identifying with independent Africana women, women they both emulated and envied. Such women they have come in contact with from the beginning of American slavery, all the way up to the modern Civil Rights Movement with such Africana women activists as Mamie Till Mobley, the mother of Emmett Louis Till,[3] and Rosa Parks, the mother of the modern Civil Rights Movement—and the aftermath. Therefore, when Africana women come along and embrace feminism, appending it to their

identity as Black feminists or African feminists, they are in reality duplicating the duplicate. *Africana Womanism* is a term I coined and defined in 1987 after nearly two years of publicly debating the importance of self-naming for Africana women. Why the term "*Africana Womanism*"? Upon concluding that the term "Black Womanism" was not quite the terminology to include the total meaning desired for this concept, I decided that "*Africana Womanism*," a natural evolution in naming, was the ideal terminology for two basic reasons. The first part of the coinage, *Africana*, identifies the ethnicity of the woman being considered, and this reference to her ethnicity, establishing her cultural identity, relates directly to her ancestry and land base—Africa. The second part of the term, *Womanism*, recalls Sojourner Truth's powerful impromptu speech "And Ain't I a Woman," one in which she battles with the dominant alienating forces in her life as a struggling Africana woman, questioning the accepted idea of womanhood. Without question, she is the flip side of the coin, the co-partner in the struggle for her people, one who, unlike the White woman, has received no special privileges in American society. But there is another crucial issue that accounts for the use of the term woman(ism). The term "woman," and by extension "womanism," is far more appropriate than "female" ("feminism") because of one major distinction—only a female of the human race can be a woman. "Female," on the other hand, can refer to a member of the animal or plant kingdom as well as to a member of the human race. Furthermore, in electronic and mechanical terminology, there is a female counterbalance to the male correlative. Hence, terminology derived from the word "woman" is more suitable and more specific when naming a group of the human race.

The Africana womanist is not to be confused with Alice Walker's "womanist" as presented in her collection of essays entitled *In Search of Our Mothers' Gardens*. According to Walker, a womanist is:

> A black feminist or feminist of color ... who loves other women, sexually and/or nonsexual. Appreciates and prefers women's culture ... [and who] sometimes loves individual men, sexually and/or non-sexually. Committed to survival and wholeness of entire people, male and female ... Womanist is to feminist as purple to lavender.

> *(xii, xii)*

Clearly the interest here is almost exclusively in the woman, her sexuality and her culture. The culminating definition, "womanist is to feminist as purple to lavender," firmly establishes the author's concept of the affinity between the womanist and the feminist. There is hardly any differentiation, only a slight shade of difference in color. The Africana womanist, on the other hand, is significantly different from the mainstream feminist, particularly in her perspective on and approach to issues in society. This is to be expected, for obviously their historical realities and present stance in society are not the same. Africana women and White women come from different segments of society and, thus, feminism as an ideology is not equally applicable to both.

Neither an outgrowth nor an addendum to feminism, *Africana Womanism* is not Black feminism, African feminism, or Walker's womanism that some Africana women have come to embrace. *Africana Womanism* is an ideology created and designed for all women of African descent. It is grounded in African culture, and therefore, it necessarily focuses on the unique experiences, struggles, needs, and desires of Africana women. It critically addresses the dynamics of the conflict between the mainstream feminist, the Black feminist, the African feminist, and the Africana womanist. The conclusion is that *Africana Womanism* and its agenda are unique and separate from both White feminism and Black feminism, and moreover, to the extent of naming in particular, *Africana Womanism* differs from African feminism.

Clearly there is a need for a separate and distinct identity for the Africana woman and her movement. Some White women acknowledge that the feminist movement was not designed with the Africana woman in mind. For example, White feminist Catherine Clinton asserts that "feminism primarily appealed to educated and middle-class White women, rather than Black and White working-class women" (63). Steady, in her article entitled "African Feminism: A Worldwide Perspective," which appears in *Women in Africa and the African Diaspora*, admits that:

> Various schools of thought, perspectives, and ideological proclivities have influenced the study of feminism. Few studies have dealt with the issue of racism, since the dominant voice of the feminist movement has been that of the white female. The issue of racism can become threatening, for it identifies white feminists as possible participants in the oppression of blacks.
>
> *(3)*

Africana men and women do not accept the idea of Africana women as feminists. There is a general consensus in the Africana community that the feminist movement, by and large, is the White woman's movement for two reasons: first, the Africana woman does not see the man as her primary enemy as does the White feminist, who is carrying out an age-old battle with her White male counterpart for subjugating her as his property. Africana men have never had the same institutionalized power to oppress Africana women as White men have had to oppress White women. According to Africana sociologist Clyde Franklin II: "Black men are relatively powerless in this country, and their attempts at domination, aggression, and the like, while sacrificing humanity, are ludicrous" (112).

Joyce Ladner, another Africana sociologist, succinctly articulates the dynamics of the relationship between Africana men and women and does not view the former as the enemy of the latter in *Tomorrow's Tomorrow*: "Black women do not perceive their enemy to be black men, but rather the enemy is considered to be oppressive forces in the larger society which subjugate black men, women and children" (277–278).

Since Africana women never have been considered the property of their male counterpart, Africana women and men dismiss the primacy of gender issues

in their reality, and thus dismiss the feminist movement as a viable framework for their chief concerns. Instead, they hold to the opinion that those Africana women who embrace the feminist movement are mere assimilationists or sellouts who, in the final analysis, have no true commitment to their culture or their people, particularly as it relates to the historical and current collective struggle of Africana men and women.

Second, Africana women reject the feminist movement because of their apprehension and distrust of White organizations. In fact, White organized groups in general, such as the Communist Party and the National Organization for Women (N.O.W.), have never been able to galvanize the majority of Africana people. On the whole, Africanans are grassroots people who depend on the support and confidence of their communities and who, based on historical instances of betrayal, are necessarily suspicious of organizations founded, operated and controlled by Whites. In general, unlike members of the dominant culture, Africanans are not issue-oriented. Instead they focus on tangible things that can offer an amelioration of or exit from oppression, which are of utmost importance for survival in the Africana community. Those Africana intellectuals who insist on identifying with organizations that offer them neither leadership nor high visibility generally subordinate their Blackness to being accepted by White intellectuals. Unfortunately for those Africana intellectuals, philosophy and scholarship surpass even self-identity, and they seem to be sufficiently appeased by merely belonging to a White group.

Having established that the major problem with the African feminist is that of naming, what is the major problem with the Black feminist? Briefly stated, the Black feminist is an Africana woman who has adopted the agenda of the feminist movement to some degree in that she, like the white feminist, perceives gender issues to be most critical in her quest for empowerment and selfhood. On the outskirts of feminist activity, Black feminists possess neither power nor leadership in the movement. Black feminist bell hooks obviously realizes this, as she makes a call for Africana women to move "from margin to center" of the feminist movement in her book entitled *Feminist Theory: From Margin to Center*. Receiving recognition as heralds of feminism by way of legitimating the movement through their identification with it, Black feminists are frequently delegated by White feminists as the voice of Africana women. However, this peripheral promotion of Black feminists is only transient, as they could never reach the same level of importance as that of White feminists. It is quite obvious, for example, that bell hooks will never be elevated to the same status as either Betty Friedan or Gloria Steinem. At best, she and other Black feminists like her are given only temporary recognition as representatives and spokespersons for Africana people in general and Africana women in particular. Black feminists advance an agenda that is in direct contravention to that in the Africana community, thereby demonstrating a certain lack of African-centered historical and contemporary perspective. Although White feminists contend that the movement is a panacea for the problems of Africana women, they have been unsuccessful in galvanizing

the majority of Africana women as feminists. In fact, there is no existing group of White women controlling the majority of Africana women to the extent of directing and dictating the latter's thought and action.

While Africana women do, in fact, have some legitimate concerns regarding Africana men, these concerns must be addressed within the context of African culture. Problems must not be resolved using an alien framework, i.e., feminism, but must be resolved from within an endemic theoretical construct—*Africana Womanism*. It appears that many Africana women who become Black feminists (or who are inclined more in that direction) base their decisions upon either naivety about the history and ramifications of feminism or on negative experiences with Africana men. For example, because there are some Africana women who pride themselves on being economically independent—which was the way of life for Africana women long before the advent of feminism—and because one of the chief tenets of feminism in the larger society is that a woman is economically independent, many Africana women unthinkingly respond positively to the notion of being a feminist. To be sure, Africana women have always been, by necessity, independent and responsible co-workers and decision-makers. But while this naivety can be easily corrected, negative personal experiences cannot be rectified so readily.

True, one's personal experiences are valid ways of determining one's worldview; however, the resulting generalization that many Black feminists share— that all or most Africana men are less worthy than women—is based upon intellectual laziness, which requires effortless rationalization. By the same analysis, it is easy for some people to believe that all White people or all people of any race or sex are a certain way, and it is difficult for them to treat people as individuals. This is important because, in reality, relationships are based upon individual particularities rather than upon an overriding group characteristic. For example, an Africana brother having a bad experience with an Africana woman might conclude that all Africana women are undesirable, thus castigating this entire group of people. A classic example of gross exaggeration based not on facts but on polemics or limited personal experiences, is Michelle Wallace's book entitled *Black Macho and the Myth of the Super Woman* (1980). In this book, the author makes a serious attack on Africana men by categorizing them as super macho men who physically and mentally abuse Africana women. It is apparent that the author's personal negative experiences with Africana men, which she relates throughout the book, influenced her ideology. The tragedy is that her book, which was encouraged in different ways by the many feminists listed in the Acknowledgments, received such wide exposure that it consequently influenced the thoughts of an entire generation, thereby representing a watershed in the development of modern Black feminist thought.

If one considers the collective plight of Africana people globally, it becomes clear that we cannot afford the luxury, if you will, of being consumed by gender issues. A supreme paradigm of the need for Africana women to prioritize the struggle for human dignity and parity is presented by South African woman

activist Ruth Mompati. In her heart-rending stories of unimaginable racial atrocities heaped upon innocent children, as well as upon men and women, Mompati asserts the following:

> The South African woman, faced with the above situation, finds the order of her priorities in her struggle for human dignity and her rights as a woman dictated by the general political struggle of her people as a whole. The national liberation of the black South African is a prerequisite to her own liberation and emancipation as a woman and a worker. The process of struggle for national liberation has been accompanied by the politicizing of both men and women. This has kept the women's struggle from degenerating into a sexist struggle that would divorce women's position in society from the political, social, and economic development of the society as a whole.
>
> From the South African women who together with their men seek to liberate their country, come an appeal to friends and supporters to raise their voices on their behalf.
>
> *(112–113)*

Overall, "human discrimination transcends sex discrimination ... the costs of human suffering are high when compared to a component, sex obstacle" (Ntiri, *One is Not a Woman* 6). Furthermore, according to Steady in *The Black Woman Cross-Culturally*:

> for the black woman in a racist society, racial factors, rather than sexual ones, operate more consistently in making her a target for discrimination and marginalization. This becomes apparent when the "family" is viewed as a unit of analysis. Regardless of differential access to resources by both men and women, white males and females, as members of family groups, share a proportionately higher quantity of the earth's resources than do black males and females. There is a great difference between discrimination by privilege and protection, and discrimination by deprivation and exclusion.
>
> *(27–28)*

Steady's assessment here speaks directly to the source of discrimination that Africana women suffer at the hands of a racist system. There is the oppression of the South African woman who must serve as maid and nurse to the White household with minimum wage earnings, the Caribbean woman in London who is the ignored secretary, and the Senegalese or African worker in France who is despised and unwanted. There is the Nigerian subsistence farmer, such as the Ibo woman in Enugu and Nsukka, who farms every day for minimum wages, and the female Brazilian factory worker who is the lowest on the totem

pole. Clearly, the problems of these women are not inflicted upon them solely because they are women. They are victimized first and foremost because they are Black; they are further victimized because they are women living in a male-dominated society.

The problems of Africana women, including physical brutality, sexual harassment and female subjugation in general perpetrated both within and out-side the race, ultimately have to be solved on a collective basis within Africana communities. Africana people must eliminate racist influences in their lives first, with the realization that they can neither afford nor tolerate any form of female subjugation. Along those same lines, Ntiri summarizes Mompati's position that sexism "is basically a secondary problem which arises out of race, class and economic prejudices" (*One is Not a Woman* 5).

Because one of the main tensions between Africana men and women in the United States involves employment and economic opportunity, Africanans frequently fall into a short-sighted perception of things. For example, it is not a question of more jobs for Africana women versus more jobs for Africana men, a situation that too frequently promotes gender competition. Rather, it is a ques-tion of more jobs for Africanans in general. These jobs are generated primarily by White people, and most Africanans depend on sources other than those supplied by Africana people. The real challenge for Africana men and women is how to create more economic opportunities within Africana communities. Many people talk about the need for enhanced Africana economic empowerment. If our real goal in life is to be achieved—that is, the survival of our entire race as a primary concern for Africana women—it will have to come from Africana men and women working together. If Africana men and women are fighting within the community, they are ultimately defeating themselves on all fronts.

Perhaps because of all the indisputable problems and turmoil heaped upon the Africana community, much of which is racially grounded, Africanans frequently fail to look closely at available options to determine if those options are, in fact, sufficiently workable. Rather than create other options for them-selves, Africanans become confluent with White privileged-class phenomenon, as in the case of feminism. On the other hand, when a group takes control over its struggle, tailoring it to meet its collective needs and demands, the group is almost always successful. When success in one's goals is realized, it makes for a more peaceful reality for all concerned, and one is more inclined to a whole-some and amicable relationship with others, knowing that the concerns of the people are respected and met. As *Africana Womanism*—rather than feminism, Black feminism, African feminism, or Womanism—is a conceivable alternative for the Africana woman in her collective struggle with the entire commu-nity, it enhances future possibilities for the dignity of Africana people and the humanity of all. In short, the reclamation of Africana women via identifying our own collective struggle and acting upon it is a key step toward human harmony and survival.

Notes

1 For many reasons, many White women as well as African women have become disenchanted with feminism.
2 Rose Acholonu presented a paper entitled "Love and the Feminist Utopia in the African Novel" at the International Conference on Women in Africa and the African Diaspora: Bridges Across Activism and the Academy at the University of Nigeria-Nsukka, July 1992.
3 Emmett Louis "Bobo" Till was the fourteen-year-old Africana Chicago youth who was lynched in 1955 in Money, Mississippi for whistling at a twenty-one-year-old White woman. For a detailed explanation of Till's importance to the modern Civil Rights Movement, read Clenora Hudson's (Hudson-Weems') 1988 doctoral dissertation entitled *Emmett Till: The Impetus for the Modern Civil Rights Movement* and *Emmett Till: The Sacrificial Lamb of the Civil Rights Movement*.

2

CULTURAL AND AGENDA CONFLICTS IN ACADEMIA

Critical issues for Africana women's studies[1]

> Well, chillun, whar dar is so much racket, dar must be something out o' kilter. I t'ink dat 'twixt de niggers of de Souf an' de women at de Norf all a-talkin' bout rights, de white men will be in a fix pretty soon … Dat man ober dar say dat women needs to be helped into carriages, and lifted ober ditches, and to have de best place everywhere. Nobody eber helped me into carriages, or ober mud puddles, or give me any best place. And ain't I a Woman?
>
> *(Truth 104)*

During her lifetime as a staunch upholder of truth and justice, Sojourner Truth, born a slave in 1797 and freed under the 1827 New York State Emancipation Act, often unexpectedly appeared at antislavery and women's rights rallies. Her impromptu remarks often refuted antagonistic arguments against both her race and her sex, and in that order. Her frequently quoted speech above, which was both unsolicited and initially unwelcomed because of her color by the White audience at an 1852 Women's Rights Convention in Akron, Ohio, is used here to demonstrate the critical position of the Africana woman within the context of the modern feminist movement.

Historically, Africana women have fought against sexual discrimination as well as race and class discrimination. They have challenged Africana male chauvinism, but have stopped short of eliminating Africana men as allies in the struggle for liberation and familyhood. Historically, Africana women have wanted to be "liberated" to the community, family and its responsibilities. The daily evacuation of males and females from the Africana community in a nine-to-five society has wreaked havoc on the sense of security of Africana children. The distress of these Africana children and their need for comforting seems to have been ignored, overlooked and vastly underplayed, suggesting that these children do not need this kind of support. The result is generations of hurt and rejection.

Even Africana women who happen to be on welfare and may be at home are condemned for not having a job and are, thus, often not regarded as positive figures for these children, even though they at least offer an adult presence. With polarized minds, Africanans have bought into this view, embracing all too frequently the stereotype of the Africana woman on welfare and society's disapproval of them. Nevertheless, Africana women are seeking to reclaim security, stability and nurturing of a family-based community.

According to Africana sociologist Vivian Gordon in *Black Women, Feminism and Black Liberation: Which Way?*:

> To address women's issues, therefore, is not only to address the crucial needs of Black women, it is also to address the historic primacy of the African and African American community; that is, the primacy of its children and their preparation for the responsibilities and privileges of mature personhood.
>
> *(viii)*

Africana women have historically demonstrated that they are diametrically opposed to the concept of many White feminists who want independence and freedom from family responsibility. In the Statement of Purpose, which was issued by the National Organization of Women (NOW) in 1966 and which is still in effect today, "it is no longer either necessary or possible for women to devote the greater part of their lives to child rearing."[2] Some women take this statement a step further and wish to be liberated not only from their families but from their obligation to men in particular. This sentiment may appeal more to radical lesbian feminists or radical feminist separatists. Many White feminists deny traditional familyhood as an integral part of their personal and professional lives.

All too frequently, Sojourner's resounding query, "And ain't I a woman?" is extrapolated from the text in order to force a feminist identification of the speaker without any initial or even later reference to her first obstacle, which is her race. As mentioned earlier, during Sojourner's speech in 1852, Whites had not even deemed her as human, let alone deem her as a woman, which is precisely why she was mocked before they finally allowed her to speak. One may question what this has to do with the modern feminist movement. The fact is that these racist perceptions have not changed significantly as to suggest that Africana women do not yet have to contend with the same problem of insidious racism, with almost equal intensity even though it is somewhat masked today.

In attempting to unearth the historical truths about the feminist movement that divide the White feminist from Africana women, Africana literary theorist Hazel V. Carby asserts that: "In order to gain a public voice as orators or published writers, black women had to confront the dominant domestic ideologies and literary conventions of womanhood which excluded them from the

definition 'women'" (Carby 6). Moreover, many White feminists ironically have used Sojourner's quotation to justify labeling this freedom fighter as a feminist or a "pre-feminist." Often, they include their interpretation of the Africana experience when it is convenient—Sojourner's experience becomes a dramatization of female oppression. Ironically, Sojourner was not embracing the Women's Rights movement; instead she was attacking that element of the Women's Rights agenda that excluded her. Instead of establishing a feminist alignment, she was engaging in self-actualization, forcing White women in particular to recognize her and all Africana women as women, and as a definite and legitimate part of society in general. During the abolitionist movement White women learned from Africana women techniques on how to organize, hold public meetings and conduct petition campaigns. As abolitionists, the White women first learned to speak in public and began to develop a philosophy of their place in society and of their basic rights. Africana women, on the other hand, learned and practiced all these same things centuries ago in their ancestral home of Africa.

Procrusteans have mislabeled Africana women activists, like Sojourner Truth, and other prominent Africana women freedom fighters, such as Harriet Tubman and Ida B. Wells, simply because they were women. Indeed, the primary concerns of these women were not of a feminist nature, but rather a commitment to the centrality of the African-American freedom struggle. Their primary concern was the life-threatening plight of all Africana people, both men and women, at the hands of a racist system. To cast them in a feminist mode, which de-emphasizes their major interest, is an abomination and an outright insult to their level of struggle.

Too many Blacks have taken the theoretical framework of "feminism" and have tried to make it fit their particular circumstance. Rather than create their own paradigm and name and define themselves, some Africana women, scholars in particular, have been persuaded by White feminists to adopt or to adapt to the White concept and terminology of feminism. The real benefit of the amalgamation of Black feminism and White feminism goes to White feminists who can increase their power base by expanding their scope with the convenient consensus that sexism is their commonality and primary concern. They make a gender analysis of Africana-American life with the goal of equating racism with sexism. Politically and ideologically for Africana women, such an adoption is misguided and simplistic. Most Africanans do not share the same ideology as traditional White feminists. True, the two groups may share strategies for ending sexual discrimination, but they are divided on how to change the entire political system to end racial discrimination and sexual exploitation. While the White feminist has not sacrificed her major concern, sexism, the Black feminist has, in that she has yielded to her primary concern for racism, and is forced to see classism as secondary and tertiary issues. The modified terminology, "Black feminism," is some Africana women's futile attempt to fit into the constructs of an established White female paradigm. At best, Black feminism may relate to sexual discrimination outside of the Africana community, but cannot claim to resolve

the critical problems within it, which are influenced by racism and classism. White feminist, Bettina Aptheker, accurately analyzes the problem:

> When we place women at the center of our thinking, we are going about the business of creating an historical and cultural matrix from which women may claim autonomy and independence over their own lives. For women of color, such autonomy cannot be achieved in conditions of racial oppression and cultural genocide … In short, "feminist," in the modern sense, means the empowerment of women. For women of color, such an equality, such an empowerment, cannot take place unless the communities in which they live can successfully establish their own racial and cultural integrity.
>
> *(Aptheker 13)*

For many White women, Africana women exist for their purpose—a dramatization of oppression. As for their identity, they consider themselves the definitive woman and thus there is no need, for example, to name their studies "White" Women's Studies. Moreover, while gender-specific discrimination is the key issue for Women's Studies, it unfortunately narrows the goals of Africana liberation and devalues the quality of Africana life. Gender-specific neither identifies nor defines the primary issue for Africana women or other non-White women. It is crucial that Africana women engage in self-naming and self-definition, lest they fall into the trap of refining a critical ideology at the risk of surrendering the sense of identity.

Africana women might begin by naming and defining their unique movement "*Africana Womanism.*" The concept of Womanism can be traced back to Sojourner's speech that began to develop and highlight Africana women's unique experience into a paradigm for Africana women. In refining this terminology into a theoretical framework and methodology, "*Africana Womanism*" identifies the participation and the role of Africana women in the struggle, but does not suggest that female subjugation is the most critical issue they face in their struggle for parity. Like Black feminism, *Africana Womanism* acknowledges societal gender problems as critical issues to be resolved; however, it views feminism, the suggested alternative to these problems, as a sort of inverted White patriarchy, with the White feminist now in command and on top. Mainstream feminism is women's co-opting themselves into mainstream patriarchal values. According to Gordon, "The Movement fails to state clearly that the system is wrong; what it does communicate is that White women want to be a part of the system. They seek power, not change" (47).

The Africana womanist, on the other hand, perceives herself as the companion to the Africana man, and works diligently toward continuing their established union in the struggle against racial oppression. Within the Africana culture, there is an intrinsic, organic equality that has always been necessary for the survival of the Africana culture, in spite of the individual personal problems

of female subjugation that penetrated the Africana family structure as a result of the White male cultural system. This issue must be addressed. However, the White male's privilege is not the Africana men's or women's personal problem but rather a political problem of unchallenged gender chauvinism in the world. Critiquing Women's Studies, Aptheker concludes that:

> women's studies programs operate within a racist structure. Every department in every predominantly white institution is centered on the experience, history, politics, and culture of white men, usually of the elite. What is significant, however, is that women's studies, by its very reason for existence, implies a reordering of politics, a commitment to community, and an educational purpose which is inherently subversive of its institutional setting … Insofar as women's studies replicates a racial pattern in which white rule predominates, however, it violates its own principles of origin and purpose. More to the point: it makes impossible the creation of a feminist vision and politics.
>
> *(13)*

Africanans have critical and complex problems in their community, most of which stem from racial oppression. The Africana woman acknowledges the problem of classism, a reproachable element in America's capitalistic system. However, even there the plight of the middle-class Africana woman becomes intertwined with racism. Given that both the Africana womanist and the Black feminist address these critical issues and more, there must be something that makes the issues of the Africana womanist different, and that something is prioritizing on the part of the Africana woman. She realizes the critical need to prioritize the antagonistic forces as racism, classism and sexism, respectively. In the final analysis, *Africana Womanism* is connected to the tradition of self-reliance and autonomy, working toward participation in Africana liberation.

Observe the importance of Africana identity in the case of Sojourner Truth, for example. Before one can properly address her much-quoted query, one must, as she did, first consider her color, for it was because of color that Sojourner was initially hissed and jeered at for having the gall to address the conflict between men and women and the rights of the latter. Before Sojourner could hope to address gender problems, she had to first overcome discrimination from her White audience. Clearly, gender was not her primary concern. By reiterating "And Ain't I a Woman," Sojourner insisted that she, too, possessed all the traits of a woman, notwithstanding her race and class, that the dominant culture used to exclude her from that community. The key issue for the Africana woman, as well as for the Africana man, is racism, with classism intertwined therein.

While women of all ethnic orientations share the unfortunate commonality of female subjugation, it is naive, to say the least, to suggest that this kind of oppression should be the primary concern of all women, particularly women of color. When the Black feminist buys the White terminology, she also buys its

agenda. Because Africana women share other forms of oppression that are not necessarily a part of the overall White women's experiences, their varied kinds of victimization need to be prioritized. Instead of alienating the Africana male sector from the struggle today, Africanans must call for a renegotiation of Africanan male-female roles in society. In so doing, there must be a call to halt once and for all female subjugation, while continuing the critical struggle for the liberation of Africana people worldwide.

As previously stated, the notion of Africana women moving "from margin to center"[3] of the feminist movement, as proposed by bell hooks, is ludicrous. For how can any woman hope to move from the peripheral to the center of a movement that, historically, has not included her on the agenda. Even during the resurgence of the Women's Liberation movement of the mid-1960s the critical concerns of the Africana woman were not part of the agenda. Be that as it may, hooks complains that contemporary Africana women do not join together for women's rights because they do not see womanhood as an important aspect of their identity. Further, she states that racist and sexist socialization have conditioned Africana women to devalue their femaleness and to regard race as their only relevant label of identity. In short, she surmises that Africana women have been asked to deny a part of themselves and they have. Clearly this position evokes some controversy, as it does not take into account the reasons for the Africana woman's reluctance to embrace feminism.

Consider the experience of a woman who said that from so many feet away, her race was noticed; as she got into closer proximity, her class was detected; but that it was not until she got in the door that her sex was known. Does not that suggest the need for prioritizing? The prioritizing of the kinds of relegation to which the Africana woman is subjected should be explored in a serious effort to recognize and to understand the existence of her total sense of oppression. What one really wants to do is appreciate the triple plight of Africana women. Society needs to deal with all aspects of the oppression of the Africana woman in order to better combat them. Race and class biases are the key issues for non-Whites and must be resolved even before gender issues if there is any hope for human survival. It is impossible to conceive of any human being succumbing to absolute regression without an outright struggle against it.

Sojourner Truth demonstrated early on in the Women's Rights movement that a commonality exists between the Africana men and women of the South and the women of the North in their struggle for freedom. Clearly, the Africana woman had, neither then nor now, no exclusive claim on the struggle for equal rights apart from her male counterpart. Africana men and Africana women are, and should be, allies, struggling as they have since the days of slavery for equal social, economic, and political rights as fellow human beings in the world. There is an inherent contradiction in the ideology of "Black feminism" that should be re-evaluated. A more compatible concept is *"Africana Womanism."* Indeed, this issue must be properly addressed if Women's Studies is to be truly respected and if a positive agenda for Africana Women's Studies is to be truly realized.

Notes

1 This chapter is reprinted with permission from *The Western Journal of Black Studies*, which first appeared in the Winter 1989 issue. The author introduced the "Africana Womanism" concept at the National Council for Black Studies Conference, March 1988.

2 NOW Statement of Purpose (adopted at the organizing conference in Washington, DC, October 29, 1966).

3 See bell hooks' *Feminist Theory: From Margin to Center.*

3

AFRICANA WOMANISM

A theoretical need and practical usefulness

> When you really look at the stereotypes of Black women, the worst you can say about them, that is once you disregard the vocabulary and the dirty words and deal with the substance of what is being said, it is quite complimentary ... What is being said is, that Black women are wonderful mothers and nurturers (mammies), that we are sexually at home in our bodies (oversexed), and that we are self-sufficient and tough (henpecking and overbearing). And isn't that exactly what every woman wants to be: Loving and nurturing, sexually at home in her body, competent and strong?
>
> (Morrison, "What the Black Woman Thinks About Women's Lib")

Central to the theory of *Africana Womanism* is the idea expressed in the above quotation by Africana novelist and literary critic Toni Morrison. Once the basic stereotypes about Africana women as mammies and as promiscuous, aggressive, domineering and super-strong matriarchs are laid to rest, it can be seen that they are actually very positive beings. One thing that comes out very clearly is that they are, regardless of class stature, Black and female, not one without the other. Similar to Du Bois' concept of "Double Consciousness," which he explicates in *The Souls of Black Folk*,[1] expressing the "twoness" of the character of Blacks as both American and Black, the Africana woman has a triple identity and each third is inextricably linked to the others.

Is the notion of prioritizing the triple plight of Africana women valid, in as much as it suggests a significantly different concept from that of modern-day mainstream feminist theory? The answer is yes, because such a premise would bring into consideration the historical context and the current reality of the Africana woman, thereby framing her agenda and her priorities. The mainstream feminist aspires to androgenize women to some degree; her primary focus is equal rights and individual rights for women. This is a type defined by Steady as

the Bourgeois feminist, who "fails to deal with the major problem of equitable distribution of resources to all socioeconomic groups. Such an approach leads to a concentration of energies on sexual symbolism rather than on more substantive economic realities" (*The Black Woman Cross-Culturally* 24). Though criticizing the power that men monopolize, the liberal feminist tends to join, rather than question, the White-male-dominated power system itself. The radical feminist acknowledges the differences between males and females, but sees the two as antagonistic and in conflict. The Africana womanist, focusing on her particular circumstances, comes from an entirely different perspective, one that embraces the concept of a collective struggle for the entire family in its overall struggle for liberation survival, thereby resolving the question of her place in the venue of women's issues. To be sure, she approaches her complex realities from an Africana womanist perspective as reflected in both her life and in her literature.

Focusing on twentieth-century feminism (which is identified with early White elite women of the century such as Mary Wollstonecraft and Virginia Woolf) as it relates to today's Africana women in particular, even the upper-middle-class Africana women, let alone Africana women in general, have very limited power and visibility within the organization. The modern feminist movement, a vague reflection of Africana women in action in the Civil Rights movement of the 1950s and the 1960s, was originally identified with the upper-middle-class White woman's restive feelings of unhappiness. It was characterized and raised to public consciousness as the "feminine mystique" by Betty Friedan, one of the shapers of late-twentieth-century feminism. In her book *The Feminist Mystique*, Friedan describes the unnamed problem of many upper-middle-class White women, as a:

> strange stirring, a sense of dissatisfaction, a yearning that women suffered in the middle of the twentieth century in the United States. Each suburban wife struggled with it alone as she made the beds, shopped for groceries, matched slipcover materials, ate peanut butter sandwiches with the chil-dren, chauffeured Cub Scouts and Brownies, lay beside her husband at night—she was afraid to ask even of herself the silent question—is this all?
> *(11)*

Many of these very women sought to break away from such household drudgery, described also by Sylvia Ann Hewlett in *A Lesser Life* as "tasks for feeble minded girls and eight-year-olds" (187). They fled their suburban homes, finding refuge away from home with their newfound status as working women. Friedan asserts that "We can no longer ignore that voice within women that says: 'I want something more than my husband and my children and my home'" (27). She also states that:

> The problem of identity was new for women then, truly new. The femi-nists were pioneering on the front edge of woman's evolution. They had to prove that women were human. They had to shatter, violently if necessary,

the decorative Dresden figurine that represented the ideal woman of the last century. They had to prove that woman was not a passive empty mirror, not a frilly, useless decoration, not a mindless animal, not a thing to be disposed of by others, incapable of a voice in her own existence, before they could even begin to fight for the rights of women needed to become the human equals of men.

(11)

Contrary to the White feminists' need to be equal to men as human beings, Black women have always been equal to their male counterparts, in spite of some Africana men's attempts to subjugate them on some levels. According to Angela Davis in *Women, Race and Class*:

> The salient theme emerging from domestic life in the [American] slave quarters is one of sexual equality. The labor that slaves performed for their own sake and not for the aggrandizement of their masters was carried out on terms of equality. Within the confines of their family and community life, therefore, Black people ... transformed that negative equality which emanated from the equal oppression they suffered as slaves into a positive quality: the egalitarianism characterizing their social relations.

(18)

Clearly the differences in the historical realities of Africana women and White women as exemplified in the above quotations by women of both groups have been adequately established, even though in her later book, *The Second Stage*, Friedan necessarily re-evaluates her earlier position on the family and, hence, acknowledges its importance.

From its very nature, *Africana Womanism*—much like other theories emerging from the experiences of Africana people (like Leopold Senghor's ideological concept "Negritude," authenticating Africana culture, and Henry Louis Gates' narrative concept "Signification,"[2] identifying this literary trope as authentically African)—has a definite slant toward Afrocentricity in its truest meaning/sense. According to Molefi Asante, Afrocentricity means "placing African ideals at the center of any analysis that involves African culture and behavior" (*The Afrocentric Idea* 6). What Asante is advocating here, like other great Afrocentric scholars before him (Cheikh Anta Diop, John Henry Clark, Yosef Ben-Jochannan and Chancellor Williams, to name a few), is an Afrocentric perspective on Africana issues—putting Africa in the center of the lives and concepts of Africanans. In this same way, *Africana Womanism* commands an African-centered perspective of Africana women's lives—their historical, current and future interaction with their community, which includes their male counterparts. According to Nigeria's first woman playwright, Dr. 'Zulu Sofola:

> It [the dual-gender system between African men and women] is not a battle where the woman fights to clinch some of men's power, [which]

consequently has set in motion perpetual gender conflict that has now poisoned the erstwhile healthy social order of traditional Africa.[3]

This equality exists because in African cosmology, further asserts Sofola, the woman at creation is equal to her male counterparts, which is not the case in European cosmology, which holds that the woman is an appendage (rib) of man.

During American slavery, for example, Africana women were as harshly treated, physically and mentally, as were their male counterparts, thereby invalidating the alignment of Africana women and White women as equals in the struggle. Indeed, the endless chores of the Africana woman awaited her both in and outside the home. Africana men and women have been equal partners in the struggle against oppression from early on. Thus, they could not afford division based on sex. Granted, in some traditional societies, male domination was a characteristic; but in the African-American slave experience, Africana men and women were viewed the same by the slave owners, thereby negating traditional (African and European) notions of male or female roles.

Today, Africana women must insist that (as their reality has demonstrated) they are equal partners in a relationship in which passive female subjugation neither was nor is the norm in their community. According to Morrison in "What the Black Woman Thinks About Women's Lib":

> for years black women accepted that rage, even regarded that acceptance as their unpleasant duty. But in so doing they frequently kicked back, and they seem never to have become the true slaves that White women see in their own history.
>
> *(63)*

Indeed, Africana women have not had that sense of powerlessness that White women speak of, nor have they been silenced or rendered voiceless by their male counterparts, as is the expressed experience of White women. The labels "Black Matriarch," "Sapphire" and "bitch" appended to the Africana woman to describe her personality and character clearly contradict the notion of the Africana woman as voiceless. Moreover, unlike the White woman, the Africana woman has been neither privileged nor placed on a pedestal for protection and support.

There is also the question of class in the Africana woman's experience, which goes hand in hand with the question of race. From a historical perspective, slavery was synonymous with poverty. When one examines the origin of American racism, one realizes it was an attitude constructed to authorize exploitation by the dominant culture to acquire free or cheap labor—economic exploitation arguing race inferiority as a justification for slavery. Hence, racism and classism are inextricable. It should be noted, however, that racism has become a bigger monster than classism for Blacks, even though the latter is the parent of the former. According to Steady:

> the issue of black women's oppression and racism are part of the "class issue," but there is a danger of subsuming the black woman's continued

oppression to class and class alone. For even within the same class there are groups that are more oppressed than others. Blacks are likely to experience hardship and discrimination more severely and consistently than whites, because of racism.

(The Black Woman Cross-Culturally 26)

It has been apparent from the beginning that Africana women in particular have been and must continue to be concerned with prioritizing the obstacles in this society—the lack of equal access to career opportunities, fair treatment of their children, and equal employment for their male counterparts. Long before the question of gender and class came to the forefront in contemporary literary criticism and theoretical constructs, positions were taken and decisions were made about options available to the Africana woman on the basis of her race. Thus, it was and remains evident that the Africana woman must first fight the battle of racism.

There is no need to defend the legitimacy or viability of the feminist in society. Clearly the needs of the White woman are just as real and valid for her as are those for the Africana womanist. However, when one considers that Africana women suffer from the triple marginality, one must also consider the order in which to attack those problems. This is not to suggest that any one is insignificant. Instead, the intent here is to point out the need for Africana women themselves to decide their special interests, to define their reaction to their plight, and to take charge in their lives by dealing with first things first.

While White feminists today are not necessarily hostile to the most dominant issues that impact more upon the lives of Africana women, the majority are not sensitive to the magnitude of these concerns. For example, the feminist movement is not free from racism, since many feminists are guilty of it. Many mainstream feminists (Gloria Steinem, founding editor of *Ms.* magazine, for example), in their effort to highlight the overwhelming threat of sexism in society, tend to dilute the potency of racism, as they almost invariably equate sexism with racism, which is too simplistic, unfair, insensitive and, therefore, unacceptable to most Africanans.[4] As Giddings says of Africana women's response to the women's liberation movement:

> Comparing the status of women to that of Blacks was particularly upsetting. That White women would characterize themselves as "niggers," and even as a minority deserving special favor, enraged many Black women … Indeed, history had offered little comfort to Black women. In the past, White activists had exploited the parallels between White women's and Blacks' oppression, only to betray Black women in the end.
>
> *(308)*

These issues for the Africana woman are not properly addressed within the context of the modern feminist theory or movement. The primary goal of Africana women, then, is to create their own criteria for assessing their realities, both in thought and in action.

What, then, is the ultimate role of the Africana womanist in contrast to the mainstream feminist? In a 1970 interview with Eleanor Holmes Norton, Ida Lewis considers where the Black (Africana) woman stands in relation to the Women's Liberation movement: "As a Black woman I view my role from a Black perspective—the role of Black women is to continue the struggle in concert with Black men for the liberation and determination of Blacks" (15). Clearly, the liberation of the entire Africana family has priority over women's liberation for Africana women, and thus, their struggle cannot afford any distractions. In fact, Africana sociologist Delores Aldridge proposes the following in *Focusing: Black Male-Female Relationships*:

> One might argue ... that the women's liberation—as it is presently defined and implemented—has a negative impact on the Black liberation move-ment ... [for] Women's liberation operates within the capitalist tradition and accepts the end goals of sexist white males.
>
> *(35)*

Because of the unique position of the Africana womanist on this issue, it becomes clear that she and the mainstream feminist have two separate agendas in terms of procedure, orientation and issues. To be sure, the chief role of the Africana woman is to aid in bringing to fruition the liberation of her entire race.

Notwithstanding the obvious differences in agendas for the two groups, the feminist generally assumes that the cultural ideas and constructs of the two are the same, meaning her position is absolute and the definitive one and all others must follow suit. As Elsa Barkley Brown correctly notes about ideology, perspec-tive, methodology and techniques relating to research in Women's Studies, the experiences and concerns of Africana women are excluded. White women

> place black women inside feminist perspectives which, by design, have omitted their experiences. Nowhere is this exclusion more apparent than in the process of defining women's issues and women's struggle. Because they have been created outside the experiences of black women, the defi-nitions used in women's history and women's studies assume the separa-bility of women's struggles and race struggle. Such arguments recognize the possibility that black women may have both women's concerns and race concerns, but they insist upon delimiting each. They allow, belatedly, black women to make history as women or as Negroes but not as "Negro women. What they fail to consider is that women's issues may be race is-sues, and race issues may be women's issues."
>
> *(Quoted in Hines 3)*

To be sure, the feminist either lacks the recognition or refuses to acknowledge that her issues and methods are not the same as those of the Africana woman. Brown's assessment is reflected in similar commentaries by scholars such as Pepe

Roberts for example. In his article "Feminism in Africa: Feminism and Africa," he asserts that:

> The feminist movement in the west has been accused of racism, that is to say that it has failed to recognize the different historical experience of black women compared to that of white women and has been aggressive towards their cultural values and struggles for freedom as black women.
>
> *(175)*

With that crucial element, which prohibits equal ground for both groups, it becomes clear that if the needs of the African woman are to be met, then a refined theory designed to meet those needs must be constructed.

Notes

1 For full explanation of Du Bois' concept of Double Consciousness, see Chapter 1 entitled "Of Our Spiritual Strivings" in the book.
2 For further explication of the concepts of Negritude and Signification, see Leopold Senghor's *Negritude* and Henry Louis Gates' *The Signifying Monkey.*
3 This quotation comes from a paper delivered by 'Zulu Sofola at The International Conference on Women of Africa and the African Diaspora: Bridges Across Activism and the Academy, which was held in July 1992 at the University of Nigeria-Nsukka.
4 See Gloria Steinem's "Humanism and the Second Wave of Feminism" in *The Humanist*, and "Looking to the Future" in *Ms.* in which she discusses the stages of feminism and in which she equates sexism with racism.

4

THE AGENDA OF THE AFRICANA WOMANIST (REVISED)

> ... Definitions belonged to the definers—not the defined.
>
> *(Morrison's* Beloved, *190)*

Toni Morrison's narrator in *Beloved* aptly articulates the forced position of the Africanan during slavery as one who is defined not by self, but rather by the dominant culture—the definer. It is a peculiar predicament, one that Africanans have been experiencing for centuries. This situation must be challenged and changed if Africana people the world over are to realize true parity. It is in this vein that the Africana woman is being reclaimed, renamed and redefined. There are eighteen distinct and diverse characteristics of Africana Womanism; the true Africana womanist possesses all of these qualities to a varying degree, encompassing all aspects of her life.

It is this 1993 publication, which carefully defines and refines the paradigm, that Hudson-Weems initiated this empowering list of eighteen distinct characteristics of Africana womanism via the overall character of the Africana Womanist: She is "Self Namer; Self Definer; Family Centered; Genuine in Sisterhood; Strong; In Concert with Male in the Liberation Struggle; Whole; Authentic; Flexible Role Player; Respected; Recognized; Spiritual; Male Compatible; Respectful of Elders; Adaptable; Ambitious; Mothering; Nurturing." From this broad list, categorizing a broad spectrum of defining descriptors, comes an important mandate: we must begin this controversial debate at the beginning—the primacy of self-naming and self-definition. All else, that is the remaining sixteen Africana Womanism features, will naturally follow suit, vividly reflecting the overall physical and spiritual essence of the authentic Africana womanist, actualizing the beauty of the rich legacy of Africana people.

In African cosmology, it is through the proper naming of a thing that its essence comes into existence—*Nommo*. This powerful first is closely followed by self-definition, a key component in life, which gives top priority status. Our responsibility, then, is to both name ourselves, lest someone else does it, and then proceed to define ourselves and our reality, consciously exercising these elements from our own authentic Africana perspective or worldview. However, it must be first established that while the name for the paradigm is, indeed, relatively new, the actual presence and practice of the concept is not new. Africana women, I have observed and acknowledged, have always been Africana womanists. It's just that prior to my initiative to reclaim, name, define and refine a paradigm reflecting that reality, it was virtually non-existent. Consequently, Black women resorted to simply settling for an already existing concept, feminism, thinking that modifying it with appending their identity to it, "black," would be sufficient. Untrue, for "When the Black feminist buys the White terminology, she also buys its agenda" (Hudson, "Cultural and Agenda Conflicts" 188). The alternative to that would naturally be to create your own terminology and concept. Thus, with that, according to Afrocentric scholar Ama Mazama in the *Journal of Black Studies*:

> Clenora Hudson-Weems coined the term Africana Womanism in 1987 [earlier called Black Womanism] out of the realization of the total inadequacy of feminism and the like theories (e.g. Black feminism, African womanism, or womanism) to grasp the reality of African women, let alone give us the means to change that reality.
>
> *(Mazama 400–401)*

This chapter will discuss the basic features/descriptors of the Africana womanist, dating back to Africa and antiquity, as the actual practice itself represents a continuum of the rich legacy of Africana women in antiquity, continuing their roles as culture bearers at home, Africa, the cradle of civilization, and then carrying it forth to the African diaspora, via Africana-Melanated people throughout, in the Caribbean, the United States, and the list continues.

Self-namer

Nommo—The generative and productive power of the spoken word.
(Asante, The Afrocentric Idea *17)*

In the above quotation, Molefi Kete Asante, renowned Afrocentric scholar who named and conceptualized the concept of Afrocentricity, defines the African cosmological term that has dominated the academic scene for about three and a half decades. According Paul Carter Harrison in *The Drama of Nommo*: "*Nommo*, in the power of the word ... activates all forces from their frozen

state in a manner that establishes concreteness of experience ... in a way that preserves humanity" (Christian, pp. 157–158). And literary critic, Barbara Christian, in *Black Feminist Criticism*, answers to both name and definition: "It is through *nommo*, the correct naming of a thing, that it comes into existence" (157–158). Clearly Christian knows the importance of *nommo*; however, she fails to adhere to it herself in accepting a term that is merely an extension of someone else's identity or political persuasion. In a 1993 interview with her and myself, she surprisingly stated early in the interview that perhaps "feminism" was not the right term for her thinking. To be sure, no matter what form of feminism one may identity with, be it mainstream, cultural, radical or Black feminism, the term "feminism" itself is firmly etched in the ideology or theoretical concept, carrying the common root meaning, which replicates a dominant Eurocentric perspective.

The Africana womanist, on the other hand, in realizing and properly accessing herself and her movement, properly names herself and her movement. This is a key step, which many women of African descent have unfortunately failed to address for various reasons. Granted while there are some who have taken the initiative to differentiate their struggle from the White woman's struggle, such as African feminists who differ from the Africana womanist in name only, they have yet to give their struggle its own name. For example, Filomina Chioma Steady in her introduction to *The Black Woman Cross-Culturally* presents her case for African feminism, which she calls "a less antagonistic brand of feminism" for Black women (23). She fails to see the problem of naming the movement of Africana women after the White feminist movement, thereby creating complexities in the Africana movement that would not otherwise exist. Steady admits that:

> Regardless of one's position, the implications of the feminist movement for the black woman are complex ... Several factors set the black woman apart as having a different order of priorities. She is oppressed not simply because of her sex but ostensibly because of her race and, for the majority, essentially because of their class.
>
> *(23)*

Needless to say, she is her own person, operating according to the forces in her life, and thus, her name must reflect the authenticity of her activity, not that of another culture. Always a self-namer, even during American slavery when the White slave owners labeled the Black woman as a breeder, the Africana womanist insisted upon identifying herself as mother and companion. Even though her children and her spouse were often taken from her, a common slave phenomenon, she did not relinquish her identity, and thus, a grieving mother and companion, she often held to the memories of her family. She knew that regardless of how the dominant culture viewed her, her "humanness," even though it was denied her in a technical sense, contradicted their opinion of her. Thus,

Sojourner asserts, "I have born'd five children and seen 'em mos' all sold off into slavery, and when I cried out with mother's grief, none but Jesus heard and ain't I a woman?" (Truth 104). Despite all, she was a woman and a mother and her white owners had no real control over her personal assessment of her worth nor her human response to her opinion.

Self-definer

> Definitions belonged to the definer, not the defined.
>
> *(Morrison,* Beloved*)*

In defining herself and her reality, the Africana womanist is, indeed, a self-definer, even if her definitions do not reach the broader global public arena. Hence, the term feminism does not work for the Black woman, although it is quite workable within the constructs of the dominant cultural matrix out of which it was first conceived and defined by its own. Black psychologist, Julie Hare, wife of Black psychologist, Nathan Hare, chair of the nation's first Black Studies Department, San Francisco State University, insisted in a 1993 issue of *Black Issues of Higher Education* that:

> Women who are calling themselves Black feminists need another word that describes what their concerns are. Black Feminism is not a word that describes the plight of Black women. In fact ... Black feminists have not even come together and come to a true core definition of what Black feminist is. The white race has a woman problem because the women were oppressed. Black people have a man and woman problem because Black men are as oppressed as their women.
>
> *(Hare 15)*

A year earlier, Sofola had issued a rationale as to why Black women traditionally practiced reluctance in properly handling this gender identity problem. She contended the following in the Foreword to *Africana Womanism*:

> For fear of being intellectually alienated from what they call the mainstream of thought, the Afrocentric position is seen by even some African scholars as anathema. Thus, under the pressure of intellectual harassment by Eurocentric solipsists, many African scholars incline toward a resignation to the prevailing order, believing that Afrocentric cosmology would make little difference in the world order.
>
> *(xvii)*

Nonetheless, from an historical perspective, the Africana woman has always managed to eke out a separate, private reality for herself and her family, regardless of

the fact that she has been ill-defined by others. A close look at John Blassingame's classic, *The Slave Community*, reveals much evidence that the slaves, both men and women, and their activities have always been by and large collective. In fact, Blassingame contends that: "The family, while it had no legal existence in slavery, was in actuality one of the most important survival mechanisms for the slave" (*The Slave Community* 151). Hence, they defined themselves and their community in terms of their African cultural experiences, retaining the African ways in African-American culture. White feminist Sharon Welch in her book, *A Feminist Ethic of Risk*, admits "I cannot speak for African-American women or offer a definitive interpretation of the moral tradition expressed in their lives and in their writings" (16). Thus, the Africana womanist defines her own reality, with no particular allegiance to existing ideals. Indeed, our cultural identity, our collective presence, supersedes individualism. On a final note, it must be noted that Black women, too, have the right to engage in intellectualizing issues relative to gender and how we interpret it, without our being classified as feminists. Let it be known, as I reiterate, that the feminist has no exclusive on gender issues.

Family-centrality

A major cornerstone of Africana womanism is the centrality of the family. Unquestionably, the Africana womanist is more concerned with her entire family, including her male counterpart and her children, our future generations, rather than with just herself and her sisters. In a paper entitled "Feminism and the Psyche of African Womanhood," presented at the 1992 International Conference on Women in Africa and the African Diaspora, Sofola makes that point: "The world view of the African is rooted in the philosophy of holistic harmony and communalism rather than in the individualistic isolationism of Europe. The principle of relatedness is the *sine qua non* of African social reality."

The survival of her family is penultimate; however, for the mainstream feminist, her emphasis is female-centered. On that same note, another paper, "Love and the Feminist Utopia in the African Novel," was presented at that same conference by Acholonu, revealing that "feminism in this regard subscribes to exclusive individualism, which is a philosophy of life alien to Africans and, therefore quite antithetical to our communal way of life." Nonetheless, even the most conservative feminist seeks to replicate the individualism of White patriarchal capitalism, a self-centered phenomenon that threatens the very fabric of Africana life and culture.

While the eradication of female subjugation on all levels of society is of great concern for women in general, the problem of liberating an entire people— exploited, repressed and oppressed solely on the basis of race—is an even greater one. Admittedly, the Africana womanist does not have the luxury of centering just herself as victim in society when the victimization of her entire community is at stake. She realizes that her individual safety, her struggle for survival, are interconnected with the overall status of her community. Hence, until her entire people are free, she is not free. Even if she does overcome the battle of sexism

through a collective struggle of all women, she will still be left with the battle of racism facing both her family and herself.

Finally, according to Leland Hall in "Support Systems and Coping Patterns," "The family is where the Black male obtains his initial exposure to an environment of support, love and affection" (161). Historically, the peculiar predicament of the Africana community since American slavery has necessitated her participation in the workplace for survival. Only recently has she been able to entertain the notion of spending more time at home with her family, either quantitatively or qualitatively. In fact, it has been conjectured that Africana males were disallowed stable employment within the capitalist system, and Africana women were allowed gainful employment as a tactic by the dominant culture to further emasculate Africana men, thereby causing confusion and disharmony within the Africana family structure. Africana men were often left with the insecurity of joblessness, which did nothing for their self-esteem. In a traditional male-dominated society, men have always been expected to be the bread-winners, not the women. Since the reverse became the reality in the Africana family, the end result was the ultimate breakdown of the Black family and spirit. In spite of this reality, the greatest concern of the Black woman has always been her family. Therefore, unlike the feminist, the Africana woman is less inclined to focus primarily on herself and her career at the expense of the family and its needs. Granted, she is concerned about her career, as it is the very means by which she can contribute to the support of her family. However, self as a primary issue, rather than family, is incompatible with the reality of the Africana woman.

In concert with males in struggle

Long before the inception of the Women's Liberation movement and feminism, and certainly before Black women were invited to join the women's movement, Black men and women had been in it together in the global struggle for their human rights. Is it sane, then, for a people to drop that long-existing struggle for another, even though their goals have yet to be realized? That question is rhetorical, for we must know that to abandon one's own, the family, which includes men, women and children and our future generations, is to commit not only senseless homicide, and unspeakable filicide as parents of our future generations, but unforgivable suicide as well. Of course, some may think that this analogy is a bit extreme, but the fight for freedom and survival is also extreme, in the sense of the extreme to which one is willing to go to acquire that ultimate goal. Make no mistake that the true Africana womanist has not given up the liberation struggle, for she knows that the future of her children rests in the fruition of the collective goals of Africana people. Thus, she continues in concert with her male counterpart in the global struggle for racial parity. The intertwined destiny of all Africana people speaks volumes to the dependence upon the participation of the male sector in the Africana womanist's struggle. Unlike the mainstream feminist, whose struggle is characteristically independent of and oftentimes adverse to

male participation, the Africana womanist invites her male counterpart into her struggle, as this struggle in general has been traditionally the glue that has held them together, thereby enabling them to survive, to some degree, in a particularly hostile and racist society.

A close look at the dynamics of feminism clearly reveal some rather shocking, disconcerting and even threatening consequences if left unaddressed, particularly in regards to Africana women. Given the obvious and not-so-obvious tensions resulting from sexual inequity or gender competition, grounded in a traditionally White-male-dominated society, feminism does ostensibly offer a possible solution to the problem confronting females in general. However, the possible solution, as perceived by the feminist, to the long-existing and neglected threat to the freedom and dignity of the woman does not come without sacrifices to her community. For example, the numerous appendages to the term feminist, including post-structural feminist, suggest a quasi-exclusive membership, one that often exudes an intolerance of men in general. According to Nicholas Davidson in *The Failure of Feminism*: "The feminist perspective imposes a one-dimensional interpretation on all aspects of human life, namely, that evils of the world can all be traced to men oppressing women. It generates female chauvinism and sex-hate mongering" (296).

For the White feminist, separation from the male sector, psychologically, emotionally and physically, is essential in order for her to become whole. This is not the case for the Africana womanist, as Paula Giddings observes that

> A … disquieting aspect of the women's movement was the shrill tone it adopted against men. Inherent in this, of course, was the prevailing attitude among White women that sexism was the enemy. Black women, far more concerned about the impress of racism on their lives, believed that racial oppression was the root of their problems.
>
> *(309)*

The notion of challenging the applicability and viability of feminism as it relates to and operates within the constructs of the Africana woman's experience and her family does not mean that Africana women and white women do not share critical gender issues that need be resolved, since they are both heiresses of patriarchy. Nor is it to suggest that confronting these concerns in general (particularly in terms of the manner in which the feminist handles them, which too frequently erupts into alienation from the opposite sex), is to be interpreted as anti-feminist. The critical concern here is how the problem is to be resolved, with specific reference to the exclusion of the very instrument of female subjugation, the male, who, in the final analysis, obviously needs himself to be corrected and redeemed. Africana women, instead of excluding Africana men in addressing relational conflicts between themselves, work toward resolving the tension via working together with mutual respect, with a realization that Nigerian businesswoman, Ajai, comes to, which is that Africana women's "emancipation is unattainable until the basic rights are provided all people" (quoted in Ntiri's *One Is Not a Woman, One Becomes* 6).

While the White man may very well be the enemy of the White woman in her struggle, the Africana man does not necessarily hold that position with the Black woman. An Africana Womanist Movement, then, could possibly close the gender gap and heal the wounds of both genders so that they could more collectively work toward ameliorating the life-threatening social ills for Africana people in particular and people in general. Considering the worsening collective plight of Black people, they cannot afford to have their attention deflected or focus to gender issues only. This is not to say that there is no room for discussion of issues relating to interactions between Africana men and women, for Africana men have unfortunately internalized the White patriarchal system to some degree. Ultimately, the collective survival of Africanans should be the primary concern. If Samuel Yette's observations of the inevitability of Black genocide in *The Choice* were to come true, then it is doubtful that a situation would develop whereby only Africana men or only Africana women would be taken to concentration camps and the other gender spared. Just to universalize the issue, the dominant culture is not likely to distinguish between the sexes where annihilation of an entire race is the issue. Africana men and women share a similar space as oppressed people, and therefore, they cannot afford this division based solely on gender.

Flexible role players

Flexible role-playing, particularly given its controversial nature dating back to American slavery, when neither partner was free to act out the defined roles of men and women, as set forth by the dominant culture, was always a given reality in the Black community. The Africana woman has never been restricted or limited to the home and household chores, and her male counterpart more often than not has shared the role as homemaker, particularly when he found it difficult to hold a job for an extended period of time. Thus, the roles in the Africana community have always been virtually indistinguishable, as Black women, unlike white women, have not always had the "privilege" of being homemakers exclusively. Africana men, too, have not had the consistent experience or the luxury of upholding the traditional role of the male as the head of the household. In a traditional patriarchal system, the male is expected to fulfill the responsibilities outside the home, such as earning money, while serving as the official head inside the home.

Things, however, have changed. Today the mainstream feminist dismantles, or better still topsy-turvies the traditional roles in general, thereby redefining the male and female roles in society as anything but traditional. Redefined sexual roles for feminists remain at the forefront of their movement. On the other hand, to some degree, the Africana womanist accepts the traditional roles, some of which are valid and appropriate, since obviously there are some distinctions between the sexes, including on the base level, the biological difference between men and women, since women clearly do not share that biological role as child-bearer, and moreover, since men are still considered the protectors in most circles, thereby expected to uphold the family and defend both their women and

children on any and all levels if need be. While Africana women do believe in and respect traditional roles, it must be remembered that those roles have never been as clear-cut in the Black community as they are in the White community.

Genuine sisterhood

An asexual relationship between women, there has always been this bonding that cannot be broken—genuine sisterhood. This sisterly bond is a reciprocal one, one in which each gives and receives equally. In this community of women, all reach out in support of each other, demonstrating a tremendous sense of responsibility for each other by looking out for one another. They are joined emotionally, as they embody empathic understanding of each other's shared experiences. Everything is given out of love, criticism included, and in the end, the sharing of the common and individual experiences and ideas yields rewards. There is no substitute for sisterhood, and while the traditional family is of key importance to the Africana womanist, she recognizes her need for this genuine connection between women, one that supports her in her search for solace in her time of need and offers insight in her time of confusion. These sisters confide in each other and willingly share their true feelings, their fears, their hopes, and their dreams. Enjoying and supporting each other, women friends of this sort are truly invaluable.

Strong

Strength is very important for the survival of a people. And the Africana womanist comes from a long tradition of both physical and psychological strength. She has endured centuries of struggling for herself and her family, the perfect example being how she survived slavery, during which time she suffered the unimaginably cruel enforced separation from her family. In addition, she has witnessed the powerlessness of her male companion and his inability to fulfill the traditional role of the man as protector, resulting in his emasculation. And through it all, she continues to demonstrate her strength and steadfastness in protecting the vulnerabilities of her family. Reflecting upon her historical strength, particularly during slavery, she embraces the rich legacy of her sisters' fortitude to endure, no matter the pain, with a deep love for her family.

Male compatibility

It is no question that the Africana womanist in general desires positive male-female companionship, a relationship in which each individual is mutually supportive, which is an important part of a positive Africana family. Of course, this is not to rule out any other forms of positive relationships. That said, according to African writer Elechi Amadi, "men and women need each other emotionally and, of course, for survival" (71). In the Africana community, neither women nor men can afford to conclude that the other gender is irredeemable and, therefore, undesirable. Such

a stance of totally disregarding or dismissing the other gender could resort in racial suicide for Africana people. Note that in the midst of the experiences of strong Africana women being abandoned by men, there are millions of Africana women with entirely different experiences, those who praise their hardworking husbands and fathers who got no recognition. These stories or cases have somehow been overlooked in the historical perspective, but are now coming to the forefront.

To be sure, positive male companionship is of great interest to the Africana womanist in general, for she realizes that male and female relationships are not only comforting but the key to perpetuating the human race. Without each other, or at the very least, the male-female connect either at home or at the sperm bank, the human race becomes extinct. Moreover, the Africana womanist also realizes that, while she loves and respects herself, she also ultimately desires a special somebody in her life who makes her complete. Novelist Terry McMillan comments on such a desire for male compatibility, describing the void that many experience every day:

> We don't have a husband or a steady man in our lives, though most of us would like to. We spend too many precious hours on the phone, over dinner—everywhere—discussing the problems and perils of wanting, loving and needing black men.
>
> *(McMillan, "Hers")*

The quest for positive relationships is, indeed, a top priority for both the Africana man and woman. The question is what does it take to realize that dream? More to the point, how does one go about achieving it? The first thing is the list, which identifies the positive-negative tenets of male-female relationships.

Table 4.1

Fifteen positive-negative elements of male-female relationships

1. Love	1. Contempt
2. Friendship	2. Rivalry
3. Trust	3. Distrust
4. Fidelity	4. Infidelity
5. Truth	5. Deception
6. Mutual Respect	6. Disrespect
7. Support	7. Neglect
8. Humility	8. Arrogance
9. Enjoyment	9. Mean-Spiritedness
10. Compassion	10. Callousness
11. Sharing/Caring	11. Selfish/Egotism
12. Complimentary	12. Negative Criticism
13. Security	13. Insecurity
14. Interdependence	14. Dependence
15. Spirituality	15. Non-Spirituality

(Reprint, Chapter VI, *Africana Womanist Literary Theory*, 2004, 79–97)

It must be noted that the list is a plausible and workable one, thus, there is no need to feel compelled to merely settle for any relationship just for the sake of having a man. Once this is understood, then one should truly work hard, beginning with God and prayer, to bring these things to fruition. Really believing in the ideal, and asking for God's guidance and blessings, should ultimately bring forth the inevitable, which is a wonderfully positive male-female relationship.

Respected and recognized

Before we can expect love and respect from others, we must first recognize the need to care for and respect our own, ourselves. When this is done, the world will then understand that that people will do whatever is necessary to maintain its earned stature in society—its demand for proper security and recognition. Further, the Africana womanist demands respect for and recognition of herself in order to acquire true self-esteem and self-worth, which in turn enables her, among other things, to have complete and positive relationships with all people. According to Crooks and Baur in *Our Sexuality*, "when people feel secure in their own worth and identity, they are able to establish intimacy with others" (238). If the Africana woman lacks self-love, which can result from accepting the White standard of beauty, she will inevitably exude a negative sense of herself, thereby assuming a "zero image." This negative self-image could possibly result in her allowing herself to be disrespected, abused and trampled on by her male counterpart. Because this sometimes happens, no one can realistically deny that gender issues do not constitute critical concern in the Africana community. By the same token, no thinking Africana person can disagree with Doreatha Drummond Mbalia in *Toni Morrison's Developing Class Consciousness* "that the gender oppression of African (Africana) women is the result of the African (Africana) male's class exploitation and race oppression" (17). We are, after all, still both Africanan and people, operating within the constructs of a basically White patriarchal system and, thus, we are not free from contamination of female oppression. But it cannot be over-emphasized that the Black woman must seek feasible ways of combating this triple problem from within her own community. Sexism is clearly not the most critical issue for her.

Unquestionably, the salient phenomenon that plagues the Africana community is poverty, in which racism plays a major part, and out of this poverty come crime and death. Be that as it may, whether it is a problem of race, class or sex, the Africana woman must insist upon both respect of her person and recognition of her humanness so that she may more effectively fulfill her role as a positive and responsible co-partner in the overall Africana struggle. The Africana man, too, must do his part, beginning with total respect for his female counterpart. If he disrespects his women, he disrespects self in a real sense.

Whole and authentic

The true Africana womanist seeks both wholeness (completeness) and authenticity (cultural connection) in her life. Understandably by now she wants it all, or at least as much as she can assist in achieving. That means she wants her home, her family and her career, neglecting no one of these for the others. Granted, the family does come first in priority for the Africana woman, but the other things are very much needed and extremely important, as they come together to ensure harmony and security in the home. In acquiring wholeness, the Africana womanist demonstrates her desire for a positive male companionship, for without her male counterpart, her life is not complete in a real sense. She needs male companionship and, likewise, he needs female companionship. Both are essential to the survival of the human race. Her sense of wholeness is necessarily compatible with her cultural consciousness and authentic existence. As an authentic being, her standards, her acts and her ideals directly reflect those dictated by her own culture. Hence, her true essence complements her culture, thereby denying any room for an inauthentic self. Collectively, wholeness and authenticity are powerful tenets of the Africana womanist; her heritage also strongly stresses the importance of an entire family unit.

Spirituality

> Trust in the Lord with all your heart and lead not of your own understanding; in all your ways acknowledge Him and He shall direct thy paths.
>
> *(Proverbs 3:5–6)*

The Africana womanist demonstrates a definite sense of spirituality, a belief in a higher power, Our Heavenly Father, whose presence transcends rational ideals. From this point of reference, she acknowledges the existence of spiritual reality, which brings into account the power of faith, healing and the unknown. A natural phenomenon, spirituality cannot be omitted from the experiences of Africana women. In almost every aspect of the Africana womanist's life, she bears out and bears witness to, either consciously or subconsciously, this aspect of African cosmology. When one looks at her in making everyday decisions, one senses her reliance upon the inner spirit or mind, the voice of God, the Father. In the area of health care, she frequently goes back to folk medicine and spiritual healing, such as the laying on of hands, which entails her placing her hands on another while praying to God for his or her healing. Moreover, she is connected and protected, for she is the child of God who loves her. In African cosmology, the physical and spiritual world coexist and, hence, both realities complement each other in working for the good of all in the universe according to God's will.

> The Lord is my light and my salvation; whom shall I fear? The Lord is the strength of my life; of whom shall I be afraid?
>
> *(Psalm 27:1)*

To be sure, Our Savior, Jesus Christ, is the Alpha and the Omega, the beginning and the end. Thus, the first and the last belong to Him.

Respectful of elders

This is a major aspect of the character of the Africana womanist, for she holds the elders in high esteem. The true African womanist respects and appreciates them, insisting that her youths do the same. To be sure, our elders have served as seminal role models and have paved the way for future generations, thus, deserving of ultimate respect. The appreciation for our elders is a continuum of African culture, which Africana women still insist upon in their everyday lives. They protect their elders and seek their advice, as the wisdom of elders is indisputable.

Elders, in general, have been an integral part of Africana family-hood, and have themselves continued to strengthen the family by physical and/or spiritual participatory activities. As a spiritual and religious people, Africana women have been taught to practice the greatest regard for elders, for they are the mothers and fathers of our community. If one cannot respect the parents, one cannot be expected to respect anyone, self included. Thus, Black women out of habit and consciousness have deep reverence, genuine love and profound compassion for elders.

Adaptable

The true Africana womanist demands no separate space for nourishing her individual needs and goals, while in the twentieth-century feminist movement, there is the White feminist's insistence upon personal space. One of the leading mainstream feminists, Virginia Woolf, insists that women must have their separate space, "a room of one's own," preferably a place away from home, in order for them to be truly creative. A woman must have, she feels, a room of her own, a place to escape to, for success and creativity. This could allow the intellectual freedom that depends upon material things, which comments upon the necessity of economic freedom. A separate space for most Africana women, as well as for lower-working-class women in general, is not only impossible but inconceivable. These women in general often have limited funds. Taking those funds to defray expenses for a separate space, which necessarily means renting a place and hiring a sitter for the children in most cases, would in effect mean taking the necessities from the family. Nonetheless the absence of a separate space does not render her non-creative, nor does it render her unsuccessful.

Ambitious

Ambition and responsibility are highly important in the life of the Africana womanist, for her family, too, depends on these qualities in her. From early on, the Africana woman is taught the importance of self-reliance and resourcefulness,

and hence, she makes a way out of no way, creating ways to realize her goals and objectives in life. The sense of responsibility she has for her family is paramount and so she creates a private space for herself in the midst of chaos, confusion and congestion, even while washing dishes, feeding the baby or cooking dinner. It may be in a tiny room, or a closet, or it may be in the wee hours after bedtime for her family, but not a totally separate space away from her family. Whatever the case, the Africana woman, with ingenuity, provides herself with whatever is necessary for her creative energies to soar. Thus, within the walls of some Africana homes lurk many perceptive and creative Black women writers, workers, without rooms of their own, who explore their myriad experiences in attempts to create some artistic semblance of their realities, perspectives and possibilities. Indeed, the Africana womanist is her own person, fully equipped with her own problems, successes and truly her own set of priorities.

Mothering and nurturing

Finally, the Africana womanist is committed to the art of mothering and nurturing, her own children in particular and humankind in general. This collective role is supreme in Africana culture, for the Africana woman comes from a legacy of fulfilling the role of supreme Mother Nature—nurturer, provider and protector. There is a historical emphasis on the importance of motherhood in Africa, based upon the overall structure of the family in many countries. Historically, the role of mother was more important than the role of wife and the Africana woman operates from within these constructs. Unlike many White feminists quoted in Davidson's *The Failure of Feminism*, such as Kate Millet (who calls for the abolition of the traditional role of the mother), Germaine Greer (who expounds upon the crucial plight mothers), Betty Rollin (who contends that motherhood is none other than a concept adopted from society by women) and Betty Friedan (who pleads the case of pathology in children of careerless, overprotective mothers), the Africana womanist comes from a legacy of dedicated wives and mothers, thus, according to Algea Harrison:

> Black women have consistently indicated that they value the role of mother and consider it an important aspect of their sex role identity. Indeed, there was evidence that Black women sometimes prioritized the mother role over wife and worker roles.
>
> *(204)*

To be sure, the Africana womanist is committed to loving and caring for her own, which extends to the entire Africana family. And, of course the caring and nurturing her children entail making sure that an overall healthy environment is intact. Without question, mothering and nurturing mandates that the mother provide the preparation of a basic food regiment for her children, which is a necessary prerequisite for the making of a well-developed body and mind. This will

better enable the children to grow up as responsible human beings and contributors for our society, thereby making this requirement advantageous, indeed, for all. It naturally extends itself to an overall holistic health regiment as well, for a health-conscious mother must at all times first seek nature's God-created answers to any health issues that may befall her family. In the final analysis, as she enjoys her role as mother and nurturer, she both protects and encourages her own while unselfishly sacrificing herself in executing her ultimate duty to humankind. She must remain consistent in doing what must be done for the survival of the entire family, a commitment solidly grounded in and realized through a positive sense of history, family-hood and security, all of which true mothering and nurturing provide.

In conclusion, the key descriptors of the Africana womanist are very important, as they ultimately bring forth an overall holistic environment and existence for both the Africana womanist and her entire family. Clearly refining a paradigm relative to who the Africana womanist is and has always been, and could conceivably enable us to better resolve the existing conflict between Africana women and particularly the gap characterizing modern day male/female relationships. An end to the gender divide must now come forth! Envisioning this could possibly be the answer to a conceivable resolution for all humankind via the belief in the ultimate salvation of all: "For faith is the substance of things hoped for, the evidence of things not seen" (Hebrews 11:1).

PART II
Five Africana womanist novels

Africana Womanism is a plausible and workable concept, a theoretical framework useful in expressing the reality of the Africana woman within the context of the Africana community. A constant salient concern of the Africana woman has been the security of her family, and that concern has been represented time and again in her writings. Many have debated the question of whether Africana Women's Studies should fall under the Women's Studies or Black or Africana Studies programs or departments. Given that ethnic identification precedes gender identity in the name Africana Women's Studies, it seems plausible that the race factor is more crucial. Therefore, the consensus of many that Africana Women's Studies should fall under the umbrella of Black or Africana Studies seems more valid.

Many feel that Africana women fiction writers have a critical mission to accomplish, which is to "tell it like it is." And since literature in general should reflect life, it is important that the literature of Africana womanist writers speak the truth—the whole truth. When the Africana womanist writes about male-female relationships, for example, she must present them in all dimensions. She must explore the dynamics of the relationships, which go far beyond the mere surface interaction between the man and the woman. She must realistically and objectively examine the dominant forces at play, forces that dictate the very nature of the conflicts and the ways they are handled. These forces, in many instances, are deeply rooted in economics, particularly the economic failure of the Africana man.

When one looks at the economic problems within the Africana family, one invariably comes back to the problem and interference of racism, which strongly impacts upon the economic realities of the Africana family and community. Thus, while the Africana womanist writer should not make blanket justifications for the failures, frustrations, undesirable behavior and financial predicament of some of her menfolk, which are oftentimes interconnected, she is not expected

to abandon them or badger them with the too-frequent generalization that all Africana men are no good and irredeemable. Such a personal self-serving mis-labeling inevitably ends in an unjustifiable and relentless lashing out at men in general, thereby sentencing them to perpetual verbal and emotional castration by their women.

The true Africana womanist novel is the manifestation of the Africana woman in literature. Most of the earlier cited features of the Africana womanist can be found in the main characters in these works. While the female characters are depicted in search of wholeness and authenticity, these characters are also concerned with the destiny of their family, be it their immediate or extended family, including the men. Moreover, while some of them aspire to material gains (a natural inclination, given the reality of living in a capitalistic society) they do not expect their male counterparts to single-handedly provide for all their financial whims. Instead, they participate in efforts to realize their needs and wishes by working along with their partners. When their partners become unable to assist them in this area (they may become unemployed from time to time), the Africana womanists try to stand by their male counterparts and help them maintain their sense of pride. However, while they may very much love their male companions, they love themselves also—enough to not allow themselves to become their companions' scapegoats in their moments of despair, degradation and low self-esteem. If it becomes necessary to give their male companions space or even give them up altogether for their own self-esteem, they do so, thereby providing the male companions the opportunity to redeem themselves.

One of the biggest bonuses of reading a true Africana womanist novel is gaining the renewed strength and encouragement to do what must be done. In many Africana womanist novels, the protagonists rescue themselves from defeatism and doom within circumstances that have created their victimization. For example, Janie Mae Crawford of Hurston's *Their Eyes Were Watching God* rescues herself from two pathetic unfulfilled marriages with chauvinist husbands before she finally discovers "Mr. Right," the one man who can respect her as his equal. Mariama Bâ's *So Long a Letter* dramatizes how external forces from other cultures, such as non-traditional African religion and European colonialism, have disrupted what 'Zulu Sofola refers to as the original "dual-gender system of socio-political power line fully developed by peoples of Africa." According to Sofola, this disruption of the system of co-rulership has resulted in the "dewomanization" of the African woman's psyche, which the protagonist, Ramatoulaye, embodies so well in this novel. In Paule Marshall's *Praisesong for the Widow*, Avey Johnson, in her quest for authenticity grows to truly become what she was named and destined to be—Avatara—freed from the domination of Westernized cultural ideals and imbued with the full acceptance and appreciation of her African heritage and her birthright mission to hand down the rich legacy of her Ibo ancestry. Sethe in Morrison's *Beloved* ultimately learns to appreciate herself, taught by her male counterpart that she is her "own best thing." In addition to Sethe's newfound self-esteem, she embodies the family-centered nurturer

for her children. Finally, McMillan's *Disappearing Acts* presents the female protagonist, Zora Banks, as the supreme paradigm of the Africana womanist, one who commands respect, thereby making possible salvation for her man, her child, and herself. Each of these protagonists exemplifies some of the basic characteristics of the Africana womanist.

Without question, the Africana woman and *Africana Womanism* address issues critical to the entire Africana community, many of which we are able to see dramatized through the characters in the above-mentioned Africana novels. The characters are able to rise above adversities after coming to grips with the realities in their communities as Africana women. One can surmise that *Africana Womanism* has definite possibilities. If given the respect it deserves, we could possibly begin witnessing the bridging of the existing gap between women in particular and people in general. Inevitably, then, we may all begin to move more expeditiously toward ameliorating tension, strife and injustices in today's restless, complex and ever-changing society. The five Africana novelists have succeeded in offering representations of a movement toward this ideal through their main characters, all of whom prove to be true Africana womanists in concert with their families and communities in the ongoing struggle for their birthright privileges as human beings.

5

HURSTON'S *THEIR EYES WERE WATCHING GOD*

Seeking wholeness

For over a decade, scholars have been rereading and reconsidering the elements and nuances of Africana culture as reflected in the works of Zora Neale Hurston. Hurston's most popular and most highly acclaimed novel, *Their Eyes Were Watching God*,[1] has inspired tremendous interest. In their interpretations of the text, scholars almost invariably mislabel Hurston a "pre-feminist." This label is inappropriate, as the novel lacks the true characteristics espoused by feminist theory and ideology. In Hudson-Weems' "Tripartite Plight of AfricanAmerican Women as Reflected in the Novels of Hurston and Walker," she asserts that:

> Hurston's novel abounds in female subjugation, although her strong indictment of racism cannot be overlooked. The very title of the novel is taken from a scene expounding on racism, not sexism nor classism, which strongly suggests that the author regards this as a critical issue.
>
> *(193)*

For mainstream feminists, racism is not a priority, as they are more concerned with the empowerment of women. They attempt to place the woman in total control of her life, oftentimes without participation on the part of her family (males included) in this endeavor. Generally speaking, mainstream feminists aspire to divorce themselves from familial responsibilities as a priority.

While the quest for wholeness of Hurston's protagonist, Janie Mae Crawford, could be ostensibly linked to feminist thought, her individual quest is more closely akin to the position of the Africana womanist since it is inextricably linked to positive male companionship. The Africana womanist recognizes her triple plight (racism, classism and sexism, respectively) and realizes that her struggle has been intertwined with that of her male counterpart from early on. Together they have had to combat the various forms of oppression in society.

There are several main components of the Africana womanist characterized by Janie's quest in *Their Eyes Were Watching God*. Among them is the protagonist's desire to name and define herself; which is demonstrated throughout the work. For example, Janie ignores the opinion of others regarding her chosen male companion, Vergible "Tea Cake" Woods. She decides for herself who or what is good for her. She chooses Tea Cake, in spite of what society says or believes about him, for she defines herself in her own terms, despite the stares and harsh words of her neighbors. In her unconventional behavior, she is unrepentant, thereby demonstrating self-actualization. Janie's discovery of self is made possible by relinquishing her past dependence on her grandmother and her first two husbands, Killicks and Starks. She evolves into a self-defined figure who embraces her independence, encouraged by her last husband, Tea Cake. She says to her best friend, Pheoby, "Two things everybody's got to do fuh theyselves. They got tuh go tuh God, and they got tuh find out about livin' fuh theyselves" (285). As Cheryl A. Wall observes, "with Tea Cake as her guide, Janie has explored the soul of her culture and learned how to value herself" (389).

Also characteristic of the Africana womanist in Hurston's novel are the protagonist's family-centeredness and her uncompromising concern with the welfare of her immediate family, Tea Cake and herself. Demonstrating her great regard for family, which extends to her guardian-grandmother, Nanny, who is very close to her, Janie marries Logan Killicks so Nanny can die and rest in peace. In a conversation between Nanny and Janie, Nanny makes the following request: "Ah can't die easy thinkin' maybe de menfolks white or black is makin' a spit cup outa you: Have some sympathy fuh me. Put me down easy, Janie, Ah'm a cracked plate" (37). Shortly after that, Janie hastily marries Logan.

There is also a strong respect for elders depicted in the novel as demonstrated by Janie's relationship with her grandmother, Nanny. Janie goes against her will and better judgment to marry her grandmother's choice for her, Logan Killicks. All that she knows, she learned from her grandmother, the elder, and so she trusts her grandmother's advice. "Yes, she would love Logan after they were married. She could see no way for it to come about, but Nanny and the old folks had said it, so it must be so" (38). Out of true reverence for Nanny, Janie obeys her grandmother's wishes, burying her own desires of finding true love.

Later in the novel, Janie leaves Logan and marries Joe Starks, determined to give this new marriage all she has and wanting very much to have a happy family. Although this marriage goes sour, too, she ultimately does find the right man for herself, Tea Cake. Until his unfortunate death, she shows in her commitment to him and their marriage that she appreciates familyhood and that she will go to any lengths to maintain her life with her loved one. She works unceasingly to keep her little family together, and even when her true love dies she is loyal to the memories of the happy marriage they shared.

Sisterhood is another element in the character of the Africana womanist that can be seen in Hurston's novel. This is found in the genuine friendship between the protagonist and her confidante, Pheoby Watson. Janie trusts Pheoby and

confides her true feelings about not mourning her second husband's (Joe Starks') death. One senses the essence of this strong bond between the women in the opening conversation when Janie returns to her hometown:

> "Hello, Janie, how you comin'?"
> "Aw, pretty good, Ah'm tryin' to soak some uh de tiredness and de dirt outa mah feet." She laughed a little.
> "Ah see yo. is. Gal, you sho looks good. You looks like youse yo' own daughter." They both laughed. "Even wid dem overhalls on, you shows yo' womanhood."
> "G'wan! G'wan! You must think Ah brought yuh somethin'. When Ah ain't brought home a thing but mahself."
> "Dat's a gracious plenty. Yo' friends wouldn't want nothin' better."
> "Ah takes dat flattery offa you, Pheoby, 'cause Ah know it's from de heart."
> *(14)*

Indeed, Pheoby is the only one who welcomes Janie home while the other women in the community have nothing but harsh words to say. Unlike the others, Pheoby does not condemn Janie for her acts and her choices in men and, like a true friend, she attentively listens to the story that Janie must tell. Janie is able to confide in Pheoby because, as she says, "we been kissin'-friends for twenty years, so Ah depend on you for a good thought. And Ah'm talking to you from dat standpoint" (19). Toward the very end of the novel when almost all has been said and after all that Janie has gone through, including the tragic death of her last husband, "Pheoby hugged Janie real hard and cut the darkness in flight" (285).

Another dominant quality of the Africana womanist portrayed throughout Hurston's novel is that of strength. Janie survives three ill-fated marriages, the first two with male chauvinists, and the last one tragically ending in her husband's unfortunate death. Demonstrating true inner strength, Janie returns to her hometown of Eatonville with her head up, in spite of the vicious petty gossip of the townspeople:

> When she got to where they were she turned her face on the bander log and spoke. They scrambled a noisy "good evenin'" and left their mouths setting open and their ears full of hope. Her speech was pleasant enough, but she kept walking straight on to her gate. The porch couldn't talk for looking.
> *(11)*

This strength is earlier evidenced shortly after Janie's marriage to Tea Cake when for a while she fears that he has abandoned her:

> The thing made itself into pictures and hung around Janie's bedside all night long. Anyhow, she wasn't going back to Eatonville to be laughed at and pitied. She had ten dollars in her pocket and twelve hundred in the bank.
> *(179–180)*

After she goes through Tea Cake's painful death with him, she accepts things as they are, her heart satisfied that she had done everything humanly possible to save her loved one before finally resorting to killing him in self-defense. Indeed, this took a lot of strength—to kill one whom she loved more than any other man before him.

The Africana woman's desire for positive male companionship is also described in Hurston's novel through Janie's unyielding quest to find it. She epitomizes this quest, for throughout her life she demonstrates her desire for emotional support from a man. Beginning with her childhood when she ponders the idea of true love under the pear tree, she dreams of the perfect male companion, one who will love and cherish her and regard her as his equal. She finds this in Tea Cake, who respects her intellect as she wants. She wants a man as an integral part of her life, that is, one who can complement her and make her whole, such as Tea Cake, who is her lover, her friend, her protector. He is her true companion. He treats her as his equal, teaches her to play chess, teaches her to drive a car and shoot a gun. Janie finds it all in Tea Cake, a man who makes her laugh and cry, who makes her want to do the things she had not cared to do before, a man who enables her to realize her full potential as a woman, for the first time, fully aware of her femininity and the limits of her sexuality. Janie, in demonstrating her desire for positive male companionship, shows her need to find a true soul mate. Janie speaks to God about her fear of losing Tea Cake:

> But oh God, don't let Tea Cake be off somewhere hurt and Ah not know nothing about it. And God, please suh, don't let him love nobody else but me. Maybe Ah'm is uh fool, Lawd, lak dey say, but Lawd, Ah been so lonesome, and Ah been waitin', Jesus. Ah done waited uh long time.
>
> *(180)*

Generally speaking, a White mainstream feminist would not take the position of needing and depending on male companionship for wholeness. On the other hand, an Africana womanist can admit to such a need and desire. Without it, she is incomplete, as is suggested in Janie's mental despair and physical immobility (overburdened, she retires to bed) from being without her ultimate male counterpart. Janie demonstrates her eternal love for her companion, even after his death, as his spirit continues to motivate her:

> Then Tea Cake came prancing around her where she was and the song of the sigh flew out of the window and lit in the top of the pine trees. Tea Cake, with the sun for a shawl. Of course he wasn't dead. He could never be dead until she herself had finished feeling and thinking. The kiss of his memory made pictures of love and light against the wall. Here was peace. She pulled in her horizon like a great fish-net. Pulled it from around the waist of the world and draped it over her shoulder. So much of life in its meshes. She called in her soul to come and see.
>
> *(286)*

The notion of role-playing in the family structure is another issue for the Africana womanist in Hurston's work. Janie operates within a flexible or relaxed role environment, which is demonstrated when she and Tea Cake show their willingness to share the chores equally, both inside the home, where he shares the household chores, and outside the home, where she works alongside her husband in the fields:

> So the very next morning, Janie got ready to pick beans along with Tea Cake ... But all day long the romping and playing they carried on behind the boss's back made her popular right away. It got the whole field to playing off and on. Then Tea Cake would help get supper afterwards.
>
> *(199)*

Indeed, Janie and Tea Cake unite here, abandoning the traditional male or female roles established by the dominant culture to become equal partners. Janie, a new spirit for the woman, abandons the traditional female role, and ultimately emerges as emancipated and unshackled from the limitations her society impose on her. This new component of her personality is carried a step further through male-female collective participation in Janie and Tea Cake's struggle against oppression in the novel, which we see when they are allies against bigotry.

One thing that rings out loudly in the novel is Janie's search for both wholeness and cultural authenticity, as represented in her quest—both recognizing her needs as a woman and acting according to the dictates of her own culture in regard to her role as woman. She searches for wholeness in both herself and in her marriages but finds it only in her last marriage to Tea Cake. After giving her that great scare, Tea Cake returns home and Janie, contented and complete, looks down upon her sleeping loved one, feeling now "a self-crushing love. So her soul crawled out from its hiding place" (192).

To be sure, Janie ultimately demands respect and recognition. When she is denied it, she leaves (as was the case with Logan Killicks who disrespects her because of his own insecurities) or she calls a halt to the relationship in some way (as with her marriage to Joe Starks, who also acts negatively toward her out of insecurity, mostly about his age). However, with Joe, she is forced to verbally castrate him when he publicly humiliates her:

> Stop mixin' up mah doings wid mah looks, Jody. When you git through tellin' me how tuh cut up plug uh tobacco, then you kin tell me whether mah behind is on straight or not ... Yea, Ah'm nearly forty and you'se already fifty. How come you can't talk about dat sometimes instead of always pointin' at me? ... Naw, Ah ain't no young gal no mo' but den Ah ain't no old woman neither. Ah reckon Ah looks mah age too. But Ah'm uh woman every inch of me, and Ah know it. Dat's uh whole lot more'n

you kin say. You big-bellies round here and put out a lot of brag, but 'tain't nothin' to it but yo' big voice. Humph! Talkin' 'bout me lookin' old? When you pull down yo' britches, you look lak de change uh life.

(122–123)

Later, she comes to his deathbed and insists on giving him a piece of her mind before he dies from both failing health and mental depression:

Ah knowed you wasn't gointuh lissen tuh me. You changes everything but nothin' don't change you—not even death. But Ah ain't goin' outa here and Ah ain't gointuh hush. Naw, you gointuh listen tuh me one time befo' you die.

(133)

And so Janie lives alone until she meets one who can give her both love and respect, Tea Cake. Only when she achieves these things can she be content with herself and her mate. Only then can we sense her true inner peace.

Ambition is another quality of the Africana woman found in Hurston's novel. One can see Janie's ambition in her undaunted quest for the right man, her soul mate. Unlike many women who too frequently succumb to just the idea of a man, failing to see his many shortcomings, Janie continues her search for some twenty-five years until she is successful.

Finally, there is strong evidence of the Africana womanist as nurturer embodied in both Janie and her grandmother. In caring for and protecting her granddaughter, Nanny demonstrates the nurturer perhaps at her best. She sacrifices all to ensure Janie's security. When Janie's classmates humiliate her for living with her grandmother in the home of her White employers, for example, Nanny saves her money and buys land for them. When she later advises Janie to marry Logan, a man of some property, Nanny does so only out of her maternal instincts and desire to ensure Janie's happiness and security. Nanny says, "'Tain't Logan Killicks Ah wants you to have, baby, it's protection" (30). There is also a beautiful passage with Nanny and Janie rocking in a chair, and Nanny realizes that soon Janie must be left to live her own life. With unconditional love, she heaps upon Janie mothering love and devotion, making possible for her the opportunities she was herself denied as a slave and ex-slave woman.

Janie, too, displays nurturing qualities, for she is unyielding in her tender care for Tea Cake earlier in the novel after he is bitten by a rabid dog and goes mad. Insisting on taking care of her husband—and refusing to admit him to a hospital, she shows herself to be a nurturing and loving woman, a devoted wife. "Tea Cake began to cry and Janie hovered him in her arms like a child. She sat on the side of the bed and sort of rocked him back to peace" (267).

Hurston's *Their Eyes Were Watching God* is prophetic in its anticipation of both a new kind of novel and a new kind of woman—the Africana womanist. With all these qualities, the protagonist ultimately is able to find herself, as she goes

through her *rites de passage*[2] from girlhood to womanhood. Indeed, Janie comes across as a true Africana womanist, and hence, the novelist, too, should never again be mislabeled as a pre-feminist writer.

Notes

1 Zora Neale Hurston, *Their Eyes Were Watching God* (Urbana: University of Illinois Press, 1978). All subsequent references to this work will be given by page number only.
2 For further discussion on the rites of passage, see Arnold Van Gennep's *The Rites of Passage* (1960).

6

BÂ'S *SO LONG A LETTER*

A family affair

Mariama Bâ is a renowned Senegalese writer whose novel *So Long a Letter* received the distinction of winning the first African publishers' Noma Award. Bâ is considered a pioneer writer of African women's rights, as she is rightly considered a woman within the context of the women's movement. Her contribution to womanhood in this respect comes from her exclusive treatment and in-depth study of legalized polygamy in the Islamic community, a key feature of the Islamic religion that places the women in a subservient position. In her novel, Bâ examines the education of the Africana female child, which directly reflects the European system of female subordination, a system introduced to African life via colonialization. These foreign influences of polygamy and education of female children can be viewed as obvious manifestations of racial oppression, the primary problem for Africana women. Because polygamy, a legal practice in a patriarchal Islam society, is the most critical source of oppression for the female in Bâ's novel, it is important to comment on the origin of its pervasiveness on the African continent. According to Cheikh Anta Diop:

> monogamy was the rule at the level of the mass of the people, particularly in Africa. In so far as Africa is considered to be the land of polygamy, it is important to emphasize this face. In sculptural and pictorial representations, the monogamy of the people is proved by the numerous couples depicted.
>
> It seems that this was so in all Africa during the late Middle Ages, until the tenth century, which marks the extension of Islam to the native populations, through the Almoravidiaus. Polygamy tended in this way to become general without ever ceasing to be a sign of social rank.

(126)

Diop explains how polygamy came to be a widespread custom in Africa, now practiced not only by the members of the elite, as was the case early on in other parts of the world, but by the masses as well. But this widespread practice of polygamy in Africa was evidenced to have occurred only after Islam, a religion in which female subjugation is inherent, was introduced to the African continent.

Bâ's attack on a polygamous society that subjugates women, and her interest in the rights of Africana women in *So Long a Letter* does not justify categorizing it as a feminist novel. To begin with, the author dedicates the book "To all women and men of good will,"[1] thereby demonstrating her natural inclination to include men as a very important part of women's lives. Moreover, it is not so much the subject itself of female subjugation in the novel, but rather the way in which the protagonist treats the problem that distinguishes the novel from typical feminist writings. According to Acholonu, feminist fiction "aims essentially at establishing a feminist kindom which spurns compromise between the sexes."[2] However, instead of attacking the male directly, the author attacks the patriarchal system, one to which the male, too, becomes subject. But more important, it must be reiterated that the concerns for women and women issues are not the exclusive venue of the feminist alone. Quite the contrary, the Africana womanist, too, is interested in the welfare and position of the woman; however, her treatment of those issues is different. For instance, the Africana womanist does not treat the woman as one divorced from the need for a traditional family nucleus, which is, after all, tantamount to traditional Africana society. Instead, the Africana womanist presents the woman, even though oftentimes victimized, as one who is inextricably connected to a family unit, which ultimately defines her true meaning and purpose in today's world, ridden with chaos and confusion.

In the foreword to Bâ's novel, it is written that "She believed that the 'sacred mission' of the writer was to strike out 'at the archaic practices, traditions and customs that are not a real part of our precious cultural heritage.'" The Islamic society in *So Long a Letter* is inauthentic in that it is not fully representative of that society's traditional values and religious beliefs. According to Taiwo Ajai, the first editor of a magazine for African women, *African Woman*:

> In traditional African societies there was much less scope than now for discrimination between the sexes. Since there was no formal education and no complex technical and administrative skills to be acquired, there was no opportunity for a great gulf between developing men and women ... The dependence of women was brought to Africa in part, like so many other "benefits" of Western civilization, by Europeans—the colonial administrations and the missionaries. When education was first introduced, it was initially for boys only. This was the case with higher education and jobs in government and business. If girls were permitted to get on the ladder at all, it was always

several rungs below their brothers. In all this of course, our colonial masters were simply reproducing the system they had operated in Europe.

(78)

The practices of female subjugation prevalent in Bâ's novel can be attributed to major historical external influences, two of which are the Middle East religion of Islam, which, much like the European religion of Christianity, holds that women are a commodity, and European Colonialism, an intrusive political system forced upon the Africana people. Both of these forces, with particular emphasis on religious influence, contribute significantly to the suppression and oppression of women, which the writer strongly and justifiably addresses in the novel.

Beginning with the religious influences, it is clear that the dominant force in *So Long a Letter* is Islam, a religion that holds that the woman is subject to the needs of the man, and therefore vulnerable. Clearly outside influences have taken shape in this African society, which disrupts and destroys the original balance between the African man and the woman, a powerful force that directly interconnects with the issue of race imposition as an underlying theme in the novel. It describes the efforts of the female protagonist, Ramatoulaye, a victim of male chauvinism, to find new meaning in her life. She battles with the feelings of powerlessness, insecurity and rejection when her husband, Modou Fall, takes on a new and younger wife, Binetou, the former classmate and friend of their daughter, Daba. Ramatoulaye experiences humiliation in her new status as neglected and displaced spouse. She is confronted with the difficult decision of divorcing her husband, which both her children and best friend, Aissatou, want her to do, or remaining the legal wife of one who ignores her and her children. The unexpected death of her husband resolves this decision for Ramatoulaye; however, more problems ensue and she is forced to make decisions in her new role of widow and single parent. Through it all, the protagonist emerges as an Africana womanist, committed to her family above all, and dedicated to the proposition of upholding the true legacy of the Africana woman as a strong, proud culture bearer. Her destiny is inextricably intertwined with that of her family. It is impossible for her to put anything above the welfare of her family.

Ramatoulaye embodies many characteristics of the true Africana womanist, the most obvious ones being genuine in sisterhood, strong, self-defined, demanding of respect, family-centered, male compatible, authentic, whole, mothering and nurturing. Beginning with the epistolary novel form of the work itself, its shape takes the form of letter writing between friends. It therefore displays a strong and reliable friendship, thereby demonstrating a genuineness in sisterhood. Within the friendship the protagonist finds a strong support system that enables her to withstand adversity. The very form of the novel commands that strong trust bond between writer and receiver, which we witness in operation between the protagonist Ramatoulaye and her confidante Aissatou.

A survivor, Ramatoulaye totally confides in her life-long friend. In the lengthy letter in which she pours out her agony in the painful process of resolving her dilemma, she opens:

> I am beginning this diary, my prop in my distress. Our long association has taught me that confiding in others allays pain … My friend, my friend, my friend. I call on you three times. Yesterday you were divorced. Today I am a widow.
>
> *(1)*

Ramatoulaye further comments on the similarities between their experiences: "Friendships were made that have endured the test of time and distance. We were true sisters, destined for the same mission of emancipation" (15). Here she is alluding to the fact that they will share the status of single mothers and that they will share the mission of addressing the issues of women within this context. But the kind of friendship these women have goes beyond confiding in one another and sharing commonalities. Not only do they share their feelings, they share material things as well. Ramatoulaye recounts the unselfish and sacrificing gesture of Aissatou when Aissatou discovers that her dear friend Ramatoulaye and her children have no means of transportation after Modou deserts them:

> I shall never forget your response, you, my sister, nor my joy and my surprise when I was called to the Fiat agency and was told to choose a car which you had paid for, in full. My children gave cries of joy when they learned of the approaching end of their tribulations, which remain the daily lot of a good many other students.
>
> Friendship has splendours that love knows not. It grows stronger when crossed, whereas obstacles kill love. Friendship resists time, which wearies and severs couples. It has heights unknown to love.
>
> You, the goldsmith's daughter, gave me your help while depriving yourself.
>
> *(53–54)*

But there is more. Beyond the sharing is the total empathy that genuine sisterhood brings. While many are able to sympathize with the suffering of others, few are able to truly empathize with another's pain. The protagonist relates this level of friendship shortly after the car incident:

> I've related at one go your story as well as mine. I've said the essential, for pain, even when it's past, leaves the same marks on the individual when recalled. Your disappointment was mine, as my rejection was yours. Forgive me once again if I have re-opened your wound. Mine continues to bleed.
>
> *(55)*

Indeed, the sisterhood apparent in the relationship between these two women in the novel cannot be questioned. It is a much needed relationship and one that provides the strength needed to endure and to withstand life's suffering. A relationship which, above all, enables the women to put life into proper perspective and establish order in their lives.

The protagonist is also depicted as both self-defined and demanding of respect. Ramatoulaye alone defines her reality. This is demonstrated in her insistence upon maintaining her status as wife of Modou, in spite of the fact that he has scorned her and that all advise her against remaining in the marriage:

> Daba's anger increased as she analyzed the situation: "Break with him, mother! Send this man away. He has respected neither you nor me. Do what Ante Aissatou did; break with him. Tell me you'll break with him. I can't see you fighting over a man with a girl my age."
>
> … But the final decision lay with me [Ramatoulaye].
>
> *(39)*

While the protagonist chooses to remain married, as it is important to her for her children to have a father, her choice points at victimization resulting from the alien religious practice as well, which encourages polygamous marriage even if one is not inclined to such a marriage.

> From then on, my life changed. I had prepared myself for equal sharing, according to the precepts of Islam concerning polygamic life. I was left with empty hands.
>
> My children, who disagreed with my decision, sulked. In opposition to me, they represented a majority I had to respect … He never came again; his new found happiness gradually swallowed up his memory of us. He forgot about us.
>
> *(46)*

Be that as it may, this was to be her status until the unexpected death of Modou. Upon Modou's death, the custom called for the deceased's younger brother to assume the place of new husband to the widow. Here Ramatoulaye demonstrates her right to define her own reality and a demand for respect as well. Not only does she assume the unpopular position of refusing the custom of marrying her brother-in-law Tamsir, she later refuses to "settle" for another, Daouda Dieng. This is clearly an act of selfdefinition, since Islamic society holds that a woman must remarry. In anger she rejects Tamsir's proposal:

> "You forget that I have a heart, a mind, that I am not an object to be passed from hand to hand. You don't know what marriage means to me: it is an act of faith and of love, the total surrender of oneself to the person one has chosen and who has chosen you." (I emphasized the word "chosen".) … "No, Tamsir!"
>
> *(58)*

She later rejects Daouda in a letter: "It is with infinite sadness and tear-filled eyes that I offer you my friendship. Dear Daouda, please accept it. It is with great pleasure that I shall continue to welcome you to my house" (68). In both instances, Ramatoulaye decides what is right for her and insists upon seeing that those choices are respected. Toward the end of the novel, she advises her daughters that "Each woman makes of her life what she wants" (87). Indeed, Ramatoulaye ultimately creates her own reality.

While Ramatoulaye is concerned with herself and her future, it is only as she exists as a part of a family unit. Her children are a very important part of that family unit and they are essential to her existence. "My love for my children sustained me. They were a pillar; I owed them help and affection" (53). It is clear that her decisions are due largely to her commitment to her children's well-being. In the process of keeping her family as a complete family unit, albeit a legal reality only, the protagonist somehow sacrifices her own best interests. But the family includes not only females. It needs males as well. And Ramatoulaye recognizes and admits her need and desire for male companionship, a point devalued by feminists in general:

> I am one of those who can realize themselves fully and bloom only when they form part of a couple. Even though I understand your stand, even though I respect the choice of liberated women, I have never conceived of happiness outside marriage ... The truth is that, despite everything, I remain faithful to the love of my youth. Aissatou, I cry for Modou, and I can do nothing about it.
>
> *(56)*

She obviously misses male companionship and confesses:

> To be a woman! To live the life of a woman!
> Ah, Aissatou!
> Tonight I am restless. The flavour of life is love.
> The salt of life is also love.
>
> *(64)*

Clearly the sense of a total family unit makes Ramatoulaye whole. Without a man she is incomplete.

The Africana womanist is at all times cognizant of and committed to motherhood, which includes both mothering and nurturing:

> One is a mother in order to understand the inexplicable. One is a mother to lighten the darkness. One is a mother to shield when lightning streaks the night, when thunder shakes the earth, when mud bogs one down. One is a mother to love without beginning or end.
>
> *(82–83)*

She places the needs of her children before her individual needs and supports them, even when they make mistakes that society may frown upon. For example, when one of her younger daughters, Farmata, becomes pregnant, Ramatoulaye does not abandon her out of shame. Instead, she sticks by her daughter and supports her during this trying time:

> I could not abandon her, as pride would have me do. Her life and her future were at stake, and these were powerful considerations, overriding all taboos and assuming greater importance in my heart and in my mind ... One is a mother so as to face the flood. Was I to threaten, in the face of my daughter's shame, her sincere repentance, her pain, her anguish? Was I?
>
> I took my daughter in my arms. Painfully, I held her tightly, with a force multiplied tenfold by pagan revolt and primitive tenderness. She cried. She choked on sobs ...
>
> Farmata was astonished. She expected wailing: I smiled. She wanted strong reprimands: I consoled. She wished for the threats: I forgave.
>
> *(83)*

As Ramatoulaye closes a letter to Aissatou, commenting on her daughter, her daughter's new husband Ibrahima, and future generations, she delivers one of the most powerful and positive commentaries on male/female relationships within the context of human existence and the role of familyhood:

> I remain persuaded of the inevitable and necessary complementarity of man and woman.
>
> Love, imperfect as it may be in its content and expression, remains the natural link between these two beings.
>
> To love one another! If only each partner could move sincerely towards the other! If each could only melt into the other! If each would only accept the other's successes and failures! If each would only praise the other's qualities instead of listing his faults! If each could only correct bad habits without harping on about them! If each could penetrate the other's most secret haunts to forestall failure and be a support while tending to the evils that are repressed!
>
> The success of the family is born of a couple's harmony, as the harmony of multiple instruments creates a pleasant symphony.
>
> The nation is made up of all the families, rich and poor, united or separated, aware or unaware. The success of a nation therefore depends inevitably on the family.
>
> *(88–89)*

Bâ emphatically stresses the importance of the family rather than that of the individual. The novel demonstrates the need to address the woman's concerns; however, at no point does it deemphasize the intertwined nature of the life of the

female protagonist and that of her entire family, males included. Ramatoulaye respects the idea of co-partnership between women and men in order to ensure the perpetuation of life. While all is not perfect in the affairs of the characters in *So Long a Letter*, Bâ

leaves the novel on a positive note, one that calls for the amicable cohabitation of future generations of men and women, which is particularly demonstrated by the protagonist's refusal to give up on the male sector. This is truly a goal of the Africana womanist. In the final analysis, notwithstanding all that Ramatoulaye has gone through—female subjugation, rejection, poverty, etc.—she has not surrendered her ideals concerning family. She optimistically ends her letter to her confidante: "I shall go out in search of it [happiness]. Too bad for me if once again I have to write you so long a letter ..." (89).

Notes

1 Mariama Bâ, *So Long a Letter* (London: Heinemann, 1989). All subsequent quotations will come from this edition.
2 This quotation comes from a paper presented by Rose Acholonu at the International Conference on Africana Women in Nigeria, July 1992.

7

MARSHALL'S *PRAISESONG FOR THE WIDOW*

Authentic existence

One of the more striking examples of the Africana womanist is found in the works of Paule Marshall, a prominent AfricanCaribbean writer. Her most successful novel, *Praisesong for the Widow*, set primarily in the Caribbean, demonstrates the strength and authenticity of the Africana womanist. In an earlier short story entitled "Reena," Marshall laid down the foundation for such a focus on her evolving protagonist. "Reena" presents its title character as one who bears the historical nuances of the socalled shortcomings of the Africana woman in relationship with her male companion. Reena asserts that the Africana man condemns and accuses his female counterpart "without taking history into account. We are still, most of us, the black woman who had to be almost frighteningly strong in order for us all to survive" (Marshall, "Reena" 131). The response of the narrator, Pauline, to this explication is extremely perceptive. Advocating a solution to the deteriorating relationship between the Africana man and woman, Pauline says:

> You would think that they would understand this, but few do. So it's up to us. We have got to understand them and save them for ourselves. How? By being, on one hand, persons in our own right and, on the other, fully the woman and the wife.

> *(131)*

This, of course, represents only the first step toward ameliorating the tensions between the Africana male and female, as it speaks directly to their complex, yet promising future.

Marshall's *Praisesong for the Widow*, first published in 1984, makes a qualitative leap from the focus on "the antagonisms between Black women and Black men" (Washington xii), which is a recurring theme in Africana women's fiction, to an

emphasis on the significance of cultural retention through the maturation of its protagonist. It is through spirituality that this quest for wholeness and authenticity is realized, three of the many tenets of the Africana womanist. Other qualities of the Africana womanist embodied in the protagonist in Marshall's novel include self-naming and self-definition, family-centeredness, strength, respect for elders, nurturing and mothering. In the course of the novel, readers witness the unpremeditated evolution of the character of "Avey, short for Avatara" (Marshall, *Praisesong* 251)[1] in search for her true self, which she finds after she has been widowed. She develops from the unconscious Avey to the conscious Avatara, assuming a new role as nurturer for the Africana family and moving toward an authentic existence.

In this work, Marshall artistically dramatizes the rebirth or cultural and spiritual awakening of a sixty-four-year-old middleclass Africana woman, Avey (Avatara) Johnson. From the opening of the novel, we recognize Avey as one who is consumed by material values on her annual excursion aboard the *Bianca Pride*. She is the supreme paradigm of the denial of African heritage, although her great-aunt Cuney, who effectively fills the traditional role of the "griot" (an African oral cultural historian), has introduced her, when she was but a child, to the mystical powers of her Ibo ancestors.[2] According to Keith Sandiforth:

> In her single person, Cuney united the functions of materfamilia to her extended family, griot and mentor to her great-niece, and priestess to the small community in exile in Tatem. By her acts, utterances and beliefs, she celebrated her relationship with the world of the living and the world of the dead. Thus she signified her identification with the Ibos, time and act, thereby becoming the author of her own history, the sole possessor and disposer of her own time, the high priestess of her own cult.
>
> *(375)*

Embodied in Aunt Cuney, now deceased, is the role of diviner, one who has a sixth sense and is thereby endowed with inspired insight. It should be noted that in African cosmology there is no dichotomy between the living and the living dead (the deceased who are still in contact with the physical world), for spirits of the dead in limbo both guard and communicate with the living. With her power of divination—which brings to focus the element of spirituality in Africana womanist writings—Aunt Cuney serves as intermediary between God and humans. Aunt Cuney's keen perception enables her to play a major role in her niece's transformation when Aunt Cuney comes back from the dead to communicate with Avey.

Avey remembers Aunt Cuney's ritualistic retelling of the story of her ancestors' strength and spirituality (a legacy of the sixth sense handed down to Aunt Cuney) and their defiant reaction to the new world, their refusal upon their arrival to succumb to the dictates of the Whites. Aunt Cuney relates:

> It was here [Ibo Landing] that they brought 'em. They taken 'em out of the boats right here where we's standing ... And the minute those Ibos was

brought on shore they just stopped, my gran' said, and taken a look around. A good long look. Not saying a word. Just studying the place real good. Just taking their time and studying on it.

　　And they seen things that day you and me don't have the power to see. 'Cause those pure-born Africans was peoples my gran's said could see in more ways than one. The kind can tell you 'bout things happened long before they was born and things to come long after they's dead ... And when they got through sizing up the place real good and seen what was to come, they turned, my gran' said, and looked at the white folks what brought 'em here ... They just turned ... and walked on back down to the edge of the river here ... They just kept walking right on out over the river ... Those Ibos! Just upped and walked on away not two minutes after getting here!

(37–39)

This passage is significant in that it demonstrates Aunt Cuney's powerful art of story-telling and her commitment to passing down the legacy of the ancestors. Her story relates the magical power of the Ibos in exile who are able to see into the past and the future and who are able to walk on water. This last power of "walking the water" artistically evokes the myth of the flying African that has been treated by African-Caribbean and AfricanAmerican writers alike (for example, Joseph Zorbel in *Black Shack Alley* and Toni Morrison in *Song of Solomon*).[3] The writers offer their unique exploration of the consuming and compelling desires and mystical abilities of Africans to soar back to their homeland. Marshall dramatizes the Ibos' refusal to surrender their African values through Aunt Cuney, the Africana womanist spiritualist. The Ibos were a strong, proud people, endowed with the mystical power to overcome the threats to their heritage. Indeed, the one thing that stands out in the passage above is the strength with which they hold to their ancestral spirit, which is the true legacy that Aunt Cuney hands down to Avey and that Avey herself later hands down to her grandchildren. Strength is important for the Africana womanist, for it has sustained her through generations of trials and tribulations.

　　Aunt Cuney also comes to visit Avey in an eerie symbolic dream, which the voice of Avey's subconscious calls her in her dream state to redeem her African heritage. In this recurring dream, which begins while Avey is on her third annual cruise with her two friends, the great-aunt is "standing there unmarked by the grave in the field hat and the dress with the double belts, beckoning to her with a hand that should have been fleshless bone by now: clappers to be played at a Juba" (40). Aunt Cuney is calling Avey back to Avey's roots, pleading with Avey, "Come! Won't you come!" Interestingly, Aunt Cuney's coaxing ends in a physical confrontation between herself and Avey, for when Avey awakes, she realizes that "it was the strangest thing but that morning her body had felt as sore when she awoke as if she had actually been fighting" (47). Marshall's incorporation of the recurring dream in the novel links Avey to her cultural past. Her great-aunt had taught her, during her childhood visits to the Caribbean island Tatem, the power

and the richness of her African heritage. Avey's childhood, embellished with her great-aunt's teachings of stories of her African ancestry, is the only time that she is truly in harmony with her heritage. As a child she led an authentic life. When she leaves Tatem for her home in New York at the end of the summer, she leaves her cultural consciousness behind as well. At the end of the novel, Avey comes to understand the true meaning of the dream designed to unearth her history. She is in actuality experiencing a rebirth, after an extended hibernation both in time (over fifty years) and in place (the Caribbean island among her people). In accepting her heritage, Avey becomes culturally authentic.

The novel abounds in spirituality as experienced by the female characters. In addition to the strange recurring dream of her great-aunt Cuney, which signals the beginning of Avey's journey toward her true identity and wholeness, Avey also experiences a spiritual visitation from her deceased husband, Jerome (alias Jay) Johnson. As she reflects upon her decision to abandon the cruise with her two friends, the spirit of Jerome interjects:

> "What the devil's gotten into you, woman? … Do you know what you're playing around with?"
> He meant the money: the fifteen hundred dollars she had just forfeited by walking off the ship; the air fare she would have to turn around and spend tomorrow; the cost of the hotel room tonight. From the anxiety in his voice, she could tell he was including other, more important things. "Do you know what you're playing around with?" said in that tone also meant the house in North White Plains and the large corner lot on which it stood, and the insurance policies, annuities, trusts and bank accounts that had been left her, as well as the small sheaf of government bonds and other securities which were now also hers, and most of all the part interest guaranteed her for life in the modest accounting firm on Fulton Street in Brooklyn which bore his name. The whole of his transubstantiated body and blood. All of it he seemed to feel had been thrown into jeopardy by her reckless act.
>
> *(87–88)*

Avey comes to realize that her formally socially accepted lifestyle as assimilationist and her traditional role as wife and mother in mainstream society did not make her whole. Her earlier life with Jerome had been more authentic before they moved from Halsey Street to the all-White neighborhood in North White Plains. Engulfed by an upper-middle-class White environment, Avey needs now to be culturally centered and authentic, even though she does not come to this realization until she is on the cruise, the turning point in her life.

Abandoning the cruise, Avey meets the nearly ninety-yearold "out-islander" named Lebert Joseph, and she is mesmerized by his alluring powers, another "connection between the material and spiritual world" (Sandiforth 338).[4] According to S.A. Nigosian in *World Faiths*, Africans in general see the spiritual and physical

worlds as one (248). In African cosmology, the lack of separation between the two worlds represents the cyclical nature of things in the universe, that is, birth, death and rebirth. African peoples are in contact with the spirits of their deceased relatives. It is important to note that this act of staying in touch with the dead is, in actuality, the linkage between the spiritual and the physical worlds. In Marshall's *Praisesong*, Lebert Joseph is a diviner, like Aunt Cuney, who impacts Avey's transformation. According to Giulia Scarpa, "Great-Aunt Cuney and Lebert Joseph are very much alike. This is why they can perform the role of Avey's spiritual parents. They are the essence of what the widow has yet to learn" (102).

In the unpremeditated meeting and conversation between Avey and Lebert on the beach, he convinces her to go with him to a cultural celebration at Carriacou, a tiny island off the coast of Grenada. A widely respected and well-attended festivity called "The Carriacou Excursion," this mystical event was so revered that not to attend was believed by most out-islanders to be unwise. Mr. Joseph warns:

> "Is the Old Parents, oui ... The Long-time People. Each year this time they does look for us to come and give them their remembrance. "I tell you, you best remember them!" he cried, fixing Avey Johnson with a gaze that was slowly turning inward. "If not they'll get vex and cause you nothing but trouble. They can turn your life around in a minute, you know. All of a sudden everything start gon' wrong and you don' know the reason."
>
> *(165)*

Thus, there is the desire to please the dead. According to Kristos, "everything must be done to please the dead. Should survivors forget or ignore their dead relative ... the dead will take a terrible vengeance" (Kristos 81). This reverence for the dead, the "Old Parents," is carried over to the living elders as well. Respect for the elders cannot be underplayed in the life of an Africana womanist.

Avey's experience on the island is both strange and compelling. The power that the "Old Parents" have to negatively affect the lives of those who do not pay homage to them, and, more immediate, the power of Mr. Joseph—"fixing Avey Johnson with a gaze" (165) while relating this fact—demonstrate elements of magic and spirituality. To be sure, Lebert Joseph has that sixth sense:

> Because the man already knew of the Gethsemane she had undergone last night, knew about it in the same detailed and anguished way as Avey Johnson, although she had not spoken a word. His penetrating look said as much. It marked him as someone who possessed ways of seeing that went beyond mere sight and ways of knowing that outstripped ordinary intelligence (*Li gain connaissance*) and thus had no need for words.
>
> *(172)*

But the real spirituality is yet to come. During Avey's entire experience, both aboard the tattered ship used for the voyage, and after their arrival at Carriacou

for the two- or three-day occasion, she reminisces about her past, remembering religious occasions and spiritual experiences. During this time, she undergoes a physical and spiritual catharsis, which comes initially in the form of nausea and ends in regurgitation and defecation. The physical catharsis symbolizes Avey's emptying herself of all of the pollution of Western material values.

Upon their arrival on the Carriacou, she is taken to the home of Mr. Joseph's daughter, Rosalie Parvay, who has been blessed with her father's sixth sense. With the assistance of the maid, Rosalie performs the symbolic baptism, the bath of Avey's rebirth, the final cleansing in preparation for Avey's ultimate rebirth. Here Avey experiences a spiritual healing, a literal laying on of hands:

> Immediately she felt the small hands from last night come to rest on her arm, on top of the sheet covering it. And they remained there, their light touch calling to mind the current of cool air that had come to rest on her head when she had staggered into the rum shop yesterday. A laying on of hands. Until finally, under their gentle pressure, she risked opening her eyes.
>
> *(217–218)*

Through this traditional cleansing ritual, the *Lave Tete*, Avey comes to appreciate her cultural heritage. This ceremony, which she must undergo in order to satisfy the dead, evolves into a spiritual awakening for Avey in which she discovers her true self. But before this, Joseph and his daughter prepare to honor the Old Parents or ancestors:

> On an old-fashioned buffet in the main room of the house lay the sacred elements: a lighted candle in a holder and, next to it on a plate, a roasted ear of corn fresh from the harvest ... the ground at the four corners had been liberally sprinkled with rum from a bottle of Jack iron ... The Old Parents, the Long-time People would be pleased ... they would slip unnoticed into the house and warm their chill bones over the candle flame and sample a few grains of the corn ... busy at the moment with the Jack iron sprinkled on the steps and at the corners of the large bungalow, busy tossing it down (before the sun dried it) through the pores of their skin, which was the same as the earth's dark cover.
>
> *(213–214)*

This is another element of spirituality and means of satisfying the dead, a practice that has been documented in traditional African religion.

During the honoring ceremony, Avey is magically compelled to join her people in a communally celebrated dance and song, with drumbeats to call upon and honor the spirits:

> What seemed an arm made up of many arms reached out from the circle to draw her in, and she found herself walking amid the elderly folk on the

periphery, in their counterclockwise direction ... Her feet of their own accord began to glide forward, but in such a way they scarcely left the ground ...

"And look, she's doing the 'Carriacou Tramp' good as somebody been doing it all their life!" ... She had finally after all these decades made it across. The elderly Shouters in the person of the out-islanders had reached out their arms like one great arm and drawn her into their midst ... She began to dance then. Just as her feet of their own accord had discovered the old steps, her hips under the linen shirtdress slowly began to weave from side to side on their own, stiffy at first and then in a smooth wide arc as her body responded more deeply to the music. And the movement in her hips flowed upward, so that her entire torso was soon swaying. Arms bent, she began working her shoulders in the way the Shouters long ago used to do, thrusting them forward and then back in a strong casting-off motion.

(247–249)

The ambiance of the island completely envelopes her. There is a receptive response of the islanders to her in the form of song and folk dance, which marked the end of Avey's long and unpremeditated journey to self-redemption:

One after another of the men and women trudging past, who were her senior by years, would pause as they reached her and, turning briefly in her direction, tender her the deep, almost reverential bow. Then, singing, they would continue on their way.

(250–251)

This ceremony represents their salute to Avey in her return to her origins. The experience symbolizes both cultural acceptance and moral redemption for her. Clearly ancestor worship, steeped in both religion and magic with the invocation to spirits, enables Avey to recover her identity.

The most obvious indication of Avey's rebirth is when she reclaims her identity through reclaiming her name, which magically reconnects her to her ancestry:

And as a mystified Avey Johnson gave her name, she suddenly remembered her great-aunt Cuney's admonition long ago. The old woman used to insist, on pain of a switching, that whenever anyone in Tatem, even another child, asked her her name she was not to say simply "Avey," or even "Avey Williams." But always "Avey, short for Avatara."

(251)

In African cosmology, it is the proper naming of a thing, *nommo*, that gives the thing existence. Indeed, naming, which has its roots in traditional African religions, particularly birth ceremonies, is of a spiritual nature. It enables one to establish spiritual growth and development, as in the case of Avey, short for

Avatara. Her rememory and recovery of her ancestry is demonstrated in this act of acknowledging her true name and redefining herself and her new role in life— key aspects of the Africana womanist.

As Avey discovers herself by reviewing her past connection with her African ancestry via Aunt Cuney, whose dream visitation forces Avey to embark on her quest for the recovery of her lost legacy, she becomes both whole and authentic. Through her aunt's persistence, both verbal and physical, Avey is compelled to recollect her past, her "primal self nurtured by Great-Aunt Cuney" (Sandiforth 381), and thus, the essence of the Africana womanist takes form.

In conclusion, one of the chief tenets of *Africana Womanism* in this novel is authenticity, although one cannot overlook the other obvious elements. The Africana womanist is culturally conscious, as her acts are grounded in her herit- age. What Avey experiences in the course of the novel bears out this assumption, but it is not until the protagonist "becomes a part of a huge wide confraternity" (191) that the authentic character is resurrected. It is interesting to note that the one responsible for the cultural reawakening of this Africana womanist is Lebert Joseph, an elderly Africana male spiritualist, a demonstration of the collective na- ture of the coexistence of the male and female. Moreover, Marshall demonstrates the reconnection with one's historical cultural ancestry via her female characters, who clearly embody elements of the Africana womanist in their culturally rich lives.

Notes

1 Paule Marshall, *Praisesong for the Widow* (New York: A Dutton Belisk Paperback, 1984). All subsequent citations of this work will be by page numbers only.
2 The term griot is used to refer to the oral Africana historian, the culture bearer who hands down the legacy by word of mouth.
3 The myth of the flying African is the belief that if one believes and longs hard enough, one can (or the spirit can) soar back to Africa, the homeland.
4 In Samuel Taylor Coleridge's narrative poem, "The Rime of the Ancient Mariner," the Mariner mesmerizes his listener so that he (in this case, the Wedding-Guest) is compelled to listen to his confessions, so that the listener will leave the moment, in the words of the speaker, "a sadder and a wiser man."

8

MORRISON'S *BELOVED*

All parts equal

> She is a friend of my mind. She gather me, man. The pieces I am, she
> gather them and give them back to me in all the right order. It's good, you
> know, when you got a woman who is a friend of your mind.[1]

The key to understanding a positive Africana man-woman relationship is de-
scribed in Morrison's *Beloved* in the assessment of the relationship of a male
character named Sixo and his woman, the Thirty-Mile Woman (wherein Sixo
explains to his friend, Paul D, the nature of his relationship with his lady). This
is significant, for Morrison, like many Africana woman novelists, demonstrates
a definite growth and development in the characterization of her characters,
both men and women. Of significant importance is how her female characters
demonstrate awareness of the significance of their interaction with their family
and their community. This becomes obvious as Morrison concentrates not only
on the reality of Africana life and culture—its richness, its strengths and its
weaknesses—but, more important, on that community's strategies for survival
in the concerted struggle of the men and women in the long-existing battle
against racism.

From Morrison's first novel, *The Bluest Eye*, to *Sula*, *Song of Solomon*, *Tar Baby*,
and finally to her fifth novel, *Beloved*, the author develops the roles of the male
and the female in this collective struggle. According to Mbalia in *Toni Morrison's
Developing Class Consciousness*:

> *Beloved* ... examines a critical historical period in the African's life in order
> primarily to demonstrate that African people have and thus can survive
> the most oppressive conditions by collectively struggling against them ...
> African people can survive their present day crisis through organization.

(27)

Hence, in Morrison's *Beloved* there is the struggle of Paul D and Sethe to have family unity of men, women and children. They, as well as the Africana community collectively, receive guidance from the "unchurched preacher" Baby Suggs, Holy at the Clearing (a place where they congregate in a ritual setting) to love, claim and redefine themselves; and of the community of women, in spite of their differences with Sethe, who come near the end of the novel to rid her of the evil ghost, Beloved, through an exorcism. All this and more bear out the notion of the undeniable significance of a communal struggle for the survival of the Africana family.

The focal point for Morrison's writing is the woman, the culture bearer, who must operate within the constructs of her own culture in order to lead an authentic existence. According to Samuels and Hudson-Weems: "The authentic individual in Morrison's world realizes that his or her rights; duties, and responsibilities in the neighborhood of humankind are to act, to choose. The individual must realize the absolute freedom to choose" (141). And for Sethe, her ultimate responsibility is to her children. Her decision to murder them (she succeeds in killing only one—Beloved) rather than have them experience the "unspeakable" evils of slavery of which she herself is well aware, demonstrates that responsibility. This depiction of the Africana woman in her commitment to her children and her family is present to some degree in all of Morrison's novels, but the true Africana womanist culminates in the Morrison canon in *Beloved*.

Beginning with Morrison's first novel, *The Bluest Eye*, we see the Africana womanist as she begins to evolve in the character of the child narrator, Claudia, who embodies authenticity. Unlike the other little girls, who accept the White standard of beauty and who love White baby dolls, Claudia, in her rejection of the "ideal beauty," confesses: "I was physically revolted by and secretly frightened of those round moronic eyes, the pancake face, and orangeworms hair. The other dolls, which were supposed to bring me great pleasure, succeeded in doing quite the opposite" (*The Bluest Eye* 20). A self-definer, Claudia accepts her own perspective regarding the standard of beauty relative to her culture.

In the second novel, *Sula*, the character most representative of the Africana womanist is Eva Peace, the grandmother of the title character. Both self-defined and family-centered, Eva is the supreme mother, one who loves her children so much that she sacrifices one of her legs in order to collect insurance money so that she can take care of them. Thus, as Samuels and HudsonWeems aptly contend, "Eva (Eve) provides the ideal, for she is the archetypal 'Great Mother'" (38). But the role of mother for Eva does not limit itself to her children. It extends itself to the entire community, for she cares for her granddaughter, the orphaned Dewey boys and others in her community who need her assistance in any way.

In *Song of Solomon,* the true Africana womanist is Pilate. A pariah and the granddaughter of the legendary Solomon, the African who could fly, Pilate has a positive sense of her African ancestry, which was handed down to her by her father, Jake. Like Eva, Pilate defines life for herself and hers. But unlike her brother Macon, Sr., who believes that material things in life are superior to spiritual and cultural things, she leads a truly authentic existence, one in which her historical

and cultural self supersedes, and in an African tradition, she hands the legacy of her rich ancestry down so that her nephew Milkman, like herself, may come to appreciate and lead an authentic existence in his beliefs and acts.

In order to identify the Africana womanist in *Tar Baby*, one must look to the community of women. Here we find a collective character that comes later in the novel, in the women's attempt to nurture one of the protagonists, Jadine, who is the supreme example of inauthenticity: "the night women simply want to nurse Jadine into a healthy mental attitude toward her culture" (Samuels and Hudson-Weems 91). Like the Africana womanist, the community of women collectively serves as the nurturer and the culture-bearer. The women must assist their race in the struggle for existence, but as true Africana women they must insist that the lives of their people be both authentic and holistic. It is in the author's fifth novel, *Beloved*, that we witness the author's supreme Africana womanist characters—Sethe and Baby Suggs. But Morrison does more. For the first time, she fully develops a whole and completely positive male character, Paul D, in concert with his female companion who clearly represents the flip side of the coin—the Africana man. Collectively Sethe, Baby Suggs, and Paul D represent the sum total of a true Africana person. But the true Africana womanist is the focus here. She is one who demonstrates the following positive attributes: self-namer and self-definer, family-centered, female companion in collective struggle, strong, spiritual, respectful of elders, and holistic, authentic and nurturing. It must be noted that the lives of these major characters are intricately intertwined with the lives of others of the community. Thus, they are concerned with more than themselves; for it is only through a sense and appreciation of others that an Africana womanist is able to find true meaning in life.

Early in the novel, Sethe is depicted as one who learns that she must claim herself: "She had claimed herself. Freeing yourself was one thing; claiming ownership of that freed self was another" (95). But it is much more than self that she is concerned about. A family-centered woman with strong maternal instincts, the welfare of her children is of utmost importance to her. For the dignity of having her deceased child's name, Beloved, placed on her tombstone, for example, Sethe sacrifices herself, having sex with the engraver in exchange for an inscription: "'Ten minutes,' he said. 'You got ten minutes I'll do it for free. Ten minutes for seven letters'" (5). Later, when she is reunited with her children after her escape from the Sweet Home plantation, "Sethe lay in bed under, around, over, among, but especially with them all" (93). There is no doubt that Sethe loves her children, so much so that she is willing to kill them all rather than have them go back to slavery and experience what she as a slave woman had experienced—"the unspeakable." Declaring her great love for her children, she says:

> I have felt what it felt like and nobody walking or stretched out is going to make you feel it too. Not you, not one of mine, and when I tell you you mine, I also mean I'm yours. I wouldn't draw breath without my children.
> *(203)*

Demonstrating the collective male-female struggle and companionship, Morrison focuses on the relationship between Sethe and Paul D, which is based upon a shared history and mutual respect. In attempting to convince Sethe that they could have a beautiful future together, he says:

> Sethe, if I'm here with you, with Denver, you can go anywhere you want. Jump, if you want to, 'cause I'll catch you, girl. I'll catch you 'fore you fall. Go as far inside as you need to, I'll hold your ankles. Make sure you get back out ... I have been heading in this direction for seven years ... I knew it wasn't this place I was heading toward; it was you. We can make a life, girl. A life.
>
> *(46)*

It does not take long for Sethe to realize that Paul D is, in fact, an agent for her healing: "She knew Paul D was adding something to her life ... Now he added more: new pictures and old rememories that broke her heart" (95). They are one, for together they struggle to transcend their painful past as fellow slaves.

Sethe and Paul D unquestionably share a common bond, as "her story was bearable because it was his as well—to tell, to refine and tell again" (99). They have both been victimized in similar ways—both used as work horses and abused as grantees of the sexual whims of their oppressors. As readers are well aware that the women in *Beloved* represent the victims of "the 'unspeakable' fate to which most female slaves were heiresses," so are readers aware that this fate is one not experienced by the slave woman alone (Samuels and Hudson-Weems 94). On the contrary, Africana men, too, experienced sexual exploitation by their slave-holders, thereby validating this author's thesis that sexual exploitation and racism more closely identify the dynamics of the Africana experience during slavery than does the notion of sexual exploitation and gender. One need only to pit one of Sethe's experiences of sexual exploitation with one of Pau D's to demonstrate the commonality of their victimization. The following is a conversation between Sethe and Paul D describing both the violation of her womanhood and her humanity:

> "They used cowhide on you?"
> "And they took my milk."
> "They beat you and you was pregnant?"
> "And they took my milk."
>
> *(17)*

The oppressor both physically brutalized her and, in stealing her milk, deprived her child of its food.

Now here is the story behind what made Paul D tremble. Paul D was sent to Georgia to work on a chain gang for attempting to kill his new slaveowner. He recounts his deplorable experience there, including those of his fellow workers

who were placed in situations in which they were forced to grant White oppressors sexual favors.

> Chain-up completed, they knelt down … Kneeling in the mist they waited
> for the whim of a guard, or two, or three. Or maybe all of them wanted it.
> Wanted it from one prisoner in particular or none—or all.
> "Breakfast? Want some breakfast, nigger?"
> "Yes, sir."
> "Hungry, nigger?"
> "Yes, sir."
> "Here you go."
> Occasionally a kneeling man chose gunshot in his head as the price,
> maybe, of taking a bit of foreskin with him to Jesus. Paul D did not know
> that then. He was looking at his palsied hands, smelling the guard, listening
> to his soft grunts so like the doves', as he stood before the man kneeling in
> mist on his right. Convinced he was next, Paul D retched—vomiting up
> nothing at all. An observing guard smashed his shoulder with the rifle and
> the engaged one decided to skip the new man for the time being lest his
> pants and shoes got soiled by nigger puke.
>
> *(107–108)*

The common plight of both Sethe and Paul D is a case in point of the oneness of Africana men and women in the sense of a common history and a common struggle for survival, one that far exceeds the commonality of the feminist struggle of women in general against female subjugation. Sethe and Paul D represent the concerted struggle of Africana men and women.

Toward the end of the novel, the two come to an agreement. Paul D offers his commitment to work toward creating a better life for the two of them, and Sethe seems certain to accept it: "He wants to put his story next to hers. 'Sethe,' he says, 'me and you, we got more yesterday than anybody. We need some kind of tomorrow'" (273). With Paul D's assistance, Sethe can now begin to appreciate herself. Paul D tells her, "You your best thing, Sethe. You are" (273).

Another element of the Africana womanist is that of spirituality. In this novel, the author lures her readers into the magical world of her characters where ghosts are alive and physically interact with the living. Mysticism and spirituality are so much a part of Morrison's world that Samuels and Hudson-Weems have observed:

> Morrison's spellbinding prose/poetry ("Sifting daylight dissolves the memory, turns it into dust motes floating in the light" [*Beloved* 264]), coupled with the mysticism, black folklore, and mythology wove into her fictional worlds have led many critics to append the label "Black Magic" to her craftsmanship. Beginning with her first novel, she has captivated audiences with such conjured worlds as Medallion and the Bottom, Darling and Not Doctor Streets, Isles de Chevaliers, and most recently 124 Bluestone Road; places

where blackbirds appear unexpectedly, family remains are kept indoors unburied, warrior spirits gallop on horseback, and a ghost becomes flesh and blood. Even the names of her characters work like charms: Pecola and Cholly Breedlove, Eva and Sula Peace, Pilate and Milkman Dead, Shadrack, Guitar, Son, Jadine, Sethe, Paul D, Stamp Paid, Baby Suggs, and Beloved.

(ix–x)

From the author's first novel to her most recent one, spirituality reigns:

There is, for example, Soaphead Church, a spiritualist who uses magic to ostensibly grant Pecola her desired blue eyes in *The Bluest Eye*. There are Eva's dream book of numbers, her superstitions about attending a wedding in a red dress and about the flock of blackbirds that marked Sula's return to the Bottom, and Ajax's conjuring mother in *Sula*. There is the navelless shaman Pilate who keeps her dead father's bones in her house and communicates with the dead in *Song of Solomon*. And there are the visitations experienced by Valerian Street in *Tar Baby*.

(Samuels and HudsonWeems 135)

None of these works, however, develops this theme so dramatically as does *Beloved*. The very existence of the title character in this novel evolves magically:

A fully dressed woman walked out of the water. She barely gained the dry bank of the stream before she sat down and leaned against a mulberry tree. All day and all night she sat there, her head resting on the trunk in a position abandoned enough to crack the brim in her straw hat ... Nobody saw her emerge or came accidentally by. If they had, chances are they would have hesitated before approaching her. Not because she was wet ... but because amid all that she was smiling ... She had new skin, lineless and smooth, including the knuckles of her hands.

(50)

Although it is obvious at the outset that the woman is mysterious, the extent of her powers becomes more apparent as time passes on. When Paul D asks the strange newcomer her name, she responds "Beloved," but the response is in a voice that "was so low and rough each one looked at the other two. They heard the voice first—later the name" (52). But unlike the ghosts in other Morrison works, Beloved has physical contact with the living characters. She implants her destructive spirit and power, for example, into her grandmother Baby Suggs (Sethe's mother-in-law). Here the spirit of Beloved directs her revenge upon her mother for killing her:

The fingers touching the back of her neck were stronger now—the strokes bolder as though Baby Suggs were gathering strength. Putting the thumbs at the nape, while the fingers pressed the sides. Harder, harder, the fingers

moved slowly around toward her windpipe, making little circles on the
way. Sethe was actually more surprised than frightened to find that she
was being strangled. Or so it seemed. In any case, Baby Suggs' fingers had
a grip on her that would not let her breathe. Tumbling forward from her
seat on the rock, she clawed at the hands that were not there. Her feet were
thrashing by the time Denver got to her.

(96)

Not only does Beloved—a shape-shifter who is able to change her form from
baby to twenty-one-year-old woman—have a physical encounter with her
mother, Sethe, she revengefully engages in an affair with Sethe's lover, Paul D.
Paul D cannot understand the power she possesses that compels him to have sex
with her against his will and better judgment. His rationalizations about sleeping
with this girl have merit in his reality, but he would scarcely be able to convince
Sethe. He thinks thoughts he cannot bring himself to verbalize. Practicing what
he would like to admit to Sethe, however, he says:

> it ain't a weakness, the kind of weakness I can fight 'cause 'cause something
> is happening to me, that girl is doing it, I know you think I never liked
> her nohow, but she is doing it to me. Fixing me. Sethe, she's fixed me and
> I can't break it.

(127)

Just as Beloved is able to enter the mind and body of Baby Suggs, thereby controlling
her action, she is also able to enter Paul D's mind and body, making him respond to
her the way she wants, helping her get revenge on her mother. Indeed, the living and
the living dead come together to carry out the action in this narrative.

Later in the novel, we learn that Beloved has no lines in her hands, a folk-
belief indication that she is a ghost. This is revealed in a conversation between
Ms. Janey Wagon and Denver, who is seeking work to aid her ill mother to man-
age the household and to assist in caring for their "visitor."

> "Tell me, this here woman in your house. The cousin. She got any lines
> in her hands?"
> "No," said Denver.
> "Well," said Janey. "I guess there's a God after all."

(254)

There is another level of spirituality in the novel, related not to ghosts, but to the
unexplainable powers of the living. Sethe talks about the magic surrounding her
living daughter, Denver:

> Nothing bad can happen to her. Look at it. Everybody I knew dead or gone
> or dead and gone. Not her. Not my Denver; Even when I was carrying

her, when it got clear that I wasn't going to make it—which meant she wasn't going to make it either—she pulled a whitegirl out of the hill. The last thing you'd expect to help. And when the schoolteacher found us and came busting in here with the law and a shotgun … I wasn't going back there. I don't care who found who. Any life but not that one. I went to jail instead. Denver was just a baby so she went right along with me. Rats bit everything in there but her.

(42)

A mysterious power engulfs Denver, protects her, even controls her survival. Since before her birth she has been shielded against all dangers and threats to her life. Despite Beloved's intrusions and attacks, Denver survives. Despite Beloved's ability to alienate Sethe from Denver (who loves and fears her mother with equal intensity), Denver survives. Her magical protective shield, as real and powerful as anything else in the universe, embraces her, thereby enabling her to withstand the common and not-socommon dangers in life.

There seems to be yet another level of spirituality operating for the Africana womanist in *Beloved*. While spirituality as interpreted earlier reflects more of the mystical quality, there are instances of spirituality in the novel that reflect the power to heal. And that is exactly the power Baby Suggs possesses. Her daughter-in-law Sethe escapes slavery to join her in Ohio and arrives in terrible physical state. She must be healed to pull through, and it is, of course, Baby Suggs who nurtures her back to good health, giving her herbs and rubbing her body, her feet in particular, to bring her out of her pain. Much in the same tradition as "the laying on of hands" that many spiritualists use in healing the sick, Baby Suggs does a sort of "laying on of words," if you will, in healing the minds and attitudes of the people in her family and community. Deemed the "unchurched preacher," she goes to the "Clearing," an open area in the woods, and leads her people in a nontraditional sermon, teaching them the power of loving themselves in order to save themselves:

> "Here," she said, "in this here place, we flesh; flesh that weeps, laughs; flesh that dances on bare feet in grass. Love it. Love it hard. Yonder they do not love your flesh. They despise it. They don't love your eyes; they'd just as soon pick en out. No more do they love the skin on your back. Yonder they flay it. And O my people they do not love your hands. Those they only use, tie, bind, chop off and leave empty. Love your hands! Love them. Raise them up and kiss them … And all your inside parts that they'd just as soon slop for hogs, you got to love them. The dark, dark liver—love it, love it, and the beat and beating heart, love that too. More than eyes or feet. More than lungs that have yet to draw free air. More than your life-holding womb and your life-giving private parts, hear me now, love your heart. For this is the prize."

(88–89)

Baby Suggs emerges, as a giving Africana womanist, whose concern for her entire family, the Africana community, is her ultimate purpose in life.

A kind of universal mother for Africana humankind, Baby Suggs successfully fulfills her role as nurturer, spiritualist and activist for her people—the greatest attributes of an Africana womanist. Sethe, too, fulfills her role in life. Like Baby Suggs, she is consistent in her love and commitment to her family. Many may not agree with how she went about protecting her children—she slashes Beloved's throat in her tender act of mercy killing to spare the tot from the horrors of slavery—but none can truly believe that Sethe did not act out of true love. In an interview with Charlene Hunter Gault, the author herself contends that while Sethe did what was right, she did not have the right to kill Beloved.[2] To be sure, the Africana womanist reigns high in these two admirable characters, Sethe and Baby Suggs. They are undaunted in their sense of family and community (including the inclination toward positive male companionship), and they exude a tremendous sense of spirituality and nurturing that unquestionably makes them truly authentic in their ongoing quest for wholeness through freedom.

Notes

1 Toni Morrison, *Beloved* (New York: Alfred A. Knopf, 1987), 272–273. All subsequent references to this novel will come from this printing.
2 Interview with Charlene Hunter Gault, "MacNeil/Lehrer News & World Report."

9

MCMILLAN'S *DISAPPEARING ACTS*

In it together

> He thinks I have absolutely no concept of what he might be feeling. And
> on the other hand, he seems to think that this problem is his alone. But it's
> not. It's ours.[1]

Of all the captivating, realistic portrayals of female protagonists in contemporary
Africana womanist writings, Terry McMillan exceeds the works of others such as
Zora Neale Hurston, Mariama Bâ, Paule Marshall and Toni Morrison. McMillan's
chief concern is the desire for a positive male companion—a cornerstone for the
Africana womanist and a critical issue, as male and female interaction is the only
means by which the perpetuation of the human race can be ensured. Zora Banks,
McMillan's protagonist who is the supreme paradigm of the total Africana wom-
anist, possesses most of the main qualities. She exudes a naturalness in her acts
and mannerisms, almost effortlessly carrying out the appropriate motions in her
everyday life in order to secure peace, harmony and success in both her home-
place and her workplace. When one speaks of one's life in the homeplace and
workplace, one invariably evokes the primacy of the family, including the male
counterpart and how one's life fits into those constructs (as in the above quotation,
Zora expresses that she shares her male companion's emotional pains).

Among many things, Zora Banks is self-naming and selfdefining, family-
centered and compatible, flexible with her roles and ambitions, demanding of re-
spect and strong, reverent of elders and authentic, and, last but not least, nurturing
and mothering. The author defines the Africana womanist in this portrayal, taking
into consideration many of the complexities surrounding men as well as women.
It must be noted that the dynamics of the Africana woman cannot be placed in
proper perspective without consideration of her male counterpart: "More and
more we believe smart women are discovering that self fulfillment cannot be re-
alized through career and self mastery alone. Neither can it be gained from love
alone. Self-realization comes from the achievement of both love and mastery"

(Cowan and Kinder 13). This ideal is precisely what Zora is attempting to work out during the course of the novel. And in order for her to do this, she realizes first that her relationship with Franklin, the father of her child, is of key importance.

Given the external pressures inflicted upon Zora and Franklin's relationship, let us concentrate on the dynamics of Franklin, for a moment. He portrays many of the internal flaws brought on by external circumstances, such as limited job opportunities due to racism. Franklin must work through these issues himself, as all Africana men must do. It is through Franklin and his frustrations that one is better able to understand the Africana man's reaction to the devastating sense of no control. One sees his need for respect and acceptance from the Africana woman. Too often Franklin's goals in life are stunted, unjustly defeated by racist stereotypes about who he really is. For example, when Franklin is unsuccessful in getting a taxi to stop for him and resorts to having Zora get one for them, which she does in only a few seconds, he responds:

> If you big and black in America, that's two strikes against you—did you know that, Zora? They think all black men is killers and robbers and that we gon' cut their throats, then take all their fuckin' money. Ain't that right, sir?
>
> *(124)*

His rhetorical question to the taxi driver shows that he doesn't expect equality for himself and Africana men in America. According to Janet Blundell, "the repeated blows the oppressive white society dishes out make him increasingly depressed and hostile" (109). Be that as it may, the Africana man "is subjected to societal opprobrium for failing to live up to the standards of manhood on the one hand and for being super macho on the other" (Staples 2). Since all good relationships are based upon sharing—and Franklin is unable to give his share because of his limited resources—one senses that a breakdown in Zora and Franklin's relationship is inevitable. The obvious ensues; his ego is damaged. To restore himself and save his relationship with Zora, Franklin must work on self-mastery, which he does when he goes back to school. In going back to school, Franklin increases his marketability, which could enhance his finances. Only after taking the first step—school—can he go back to Zora, a confident man on equal terms with her. Without question, he needs to feel good about himself.

Zora, on the other hand, seems to have it together for the most part. To begin with, she both names and defines herself. In the very first chapter she states, "One thing I can't stand is people telling me what to do" (14). She decides for herself who she is, her worth, and what she wants in life, even though she knows she is not perfect.

> None of this is to say I'm perfect. I just know what I've got to offer—and it's worth millions. Hell, I'm a strong, smart, sexy, good-hearted black woman, and one day I want to make some man so happy he'll think he hit the lottery. I don't care what anybody says—love is a twoway street.
>
> *(17)*

Her acts, too, demonstrate Zora's insistence upon naming and defining herself. One instance in particular bears out this fact. When Zora tells her best friends, Marie, Portia and Claudette, about Franklin and his profession as a contractor, she is not dissuaded by the negative things Portia, in particular, has to say about him: "Honey, if he don't have at least two major credit cards, a modern car, a one-bedroom apartment, and a college degree, I say leave his ass alone—he ain't going nowhere in life" (55). Instead, Zora holds to her own values and standards and when it is time to do so, she makes those things that were important to her very clear to her friends: "Well, let me put it this way. I'll take happiness and love over money any day" (56).

Zora also demonstrates a strong sense of family-centeredness. A career in music means everything to her, but she still puts family needs and concerns first. She wants very much to have a family with Franklin, to marry him and to have his children. She wants a complete family, not just him, not just a baby: "Lots of women are having babies these days without being married, but I never imagined myself giving birth without having a husband to go along with it. I can take feminism only so far" (144). But more important, Zora unselfishly puts the welfare of Franklin's two sons above her own desires, and she refuses to put her longing for a piano, which could certainly advance her musical pursuits, above their needs, in spite of Franklin's offer: "Franklin you can't be serious. You shouldn't be giving me all this money … What about your kids? The piano can wait" (101). When Franklin receives another large check, which does not happen very often, he proudly comes to her with it. Again she takes a similar stance:

"You don't have to give me this … What about you kids? … Christmas. I know you plan on giving those kids something … So that's what we'll do with this money" (187). Franklin is reminded of just how special Zora is to him. She is totally in his corner, in concert with him in their struggle to make a good life together:

> Hell, when you meet a woman who likes you 'cause you you, not because of how much money you bring home … tells you she wants to be in your corner a hundred percent and means it; asks you about your dreams … I mean, she asked me what did I see myself doing five, ten years from now? Ain't no woman never asked me no shit like that. I told her the truth. Damn, it felt good being able to tell somebody. Felt good being able to talk to a woman about some real shit for a change. To tell the truth, we ended up doing more talking than fucking. Which was cool. A real nice change … I told her my dreams, all right. That I was tired of working construction, never having no money. That one day in the near future I was planning on being my own boss. And she listened. Asked questions. Didn't laugh or think I was being outrageous and shit. A man needs a woman who makes him feel like he can do anything.

(70)

And Zora is, indeed, all that he says and more. She not only listens to him, but she makes him feel and believe in himself, notwithstanding the obstacles that confront him again and again. She goes an extra mile to help him realize his dreams: "Zora bought me one of those books on how to be a carpenter, plus she sent away for all kinds of information from the Small Business Association on how to start my own business" (98).

She is, without question, committed to him, to their relationship. She had said at the outset, "So yes. I would like a man to become a permanent fixture in my life for once" (15). And now that she has found him, she is more than willing to do her part in preserving the relationship. In a discussion with Franklin about his education and employment, Zora suddenly has this epiphany:

> Damn, not only was he black as midnight and my kind of handsome, but it just hit me that he's my man. I love him. I don't care if he never goes to college. I don't care how many kids he has. As long as he makes me happy, makes me feel glad I'm a woman, and as long as he keeps his word and gets his divorce, I'll be here forever. So far, he's been the only man I've seen beside me when I have dreams that happen twenty years from now.
>
> *(96)*

Clearly Zora has a definite need and respect for positive male companionship.

Not only is Zora connected with her loved one, she is also connected with her roots, her cultural past, via literature, music and the church. And Franklin is, too. Both have their book collections and both enjoy reading Black books and listening to Black music, be it gospel, blues, jazz or modern Black music. Zora admits she finds strength in the Black church and asserts, "I'm going back to church and sing where it's always made me feel best. And I'll write music" (381). Feeling at peace and in harmony with Black culture and the Black community demonstrates Zora's authenticity. Zora is made whole with all these things, along with her man, her job, family and self-love.

Zora knows too well, though, that good things come from discipline and strength. In spite of her love for Franklin, she cannot let him take out his frustrations and feelings of failure on her. She has to be strong, strong enough to stand up to him and insist that he respect her. After a disappointing birthday—Franklin walked out on her in frustration because he had no money to celebrate her birthday—Zora concludes:

> I know one thing—I can not handle him taking his frustrations out on me, and I don't even want to think about popping phenobarb again, just so I can cope with him being all stressed out. No way. And the lying. There's nothing I hate more than a liar. I'll just tell—simple as that. I don't need this kind of shit, and if we're going to get through this—through everything—he's going to have to find a better way of dealing with disappointment. Period.
>
> *(126)*

So Zora continues to struggle with Franklin, paying the rent, buying the groceries, paying the tab for extra-curricular activities, all because Franklin does not have the funds to do so. She does all this without regrets, knowing that whenever Franklin does have the funds, he gladly and anxiously assumes responsibility.

Zora becomes the primary breadwinner, and Franklin necessarily has to take care of the house, which he does well. In one of her reassuring conversations with Franklin, Zora tries to make him feel comfortable with things as they are:

> Things may be a little lopsided right now, but it comes with the territory, doesn't it? Look Franklin, as long as I know you're trying, I can be patient. I love you, and I'll hang in here as long as you don't give up.
>
> *(140)*

Franklin tries to accept their situation for the time being, but, of course, he has a difficult time not maintaining the traditional role of breadwinner.

Disappointments in job retention continue for Franklin. He becomes more frustrated and ultimately resorts to drinking. With drinking comes abuse, and it isn't long before Franklin physically attacks Zora. In spite of his apologies, Zora holds strong, demanding her much-deserved respect:

> Promise me something ... That you'll cut down all this drinking ... And this I'm not asking. If you ever so much as raise your hand to me again, if I don't kill you first, your ass is going to jail. I mean that from the bottom of my heart.
>
> *(293)*

More disappointments follow, and finally Zora feels so uncomfortable with Franklin that, for both her safety and her baby's security, she ends the relationship. Zora's concern seems to be more for the baby than for herself, though it is clear that she fears what Franklin may do to her, too. The child is her responsibility, and as a mother, Zora is the one who must nurture and protect him. In spite of her love for Franklin, she loves herself and the child enough to insist, with the help of the police, that he leave. It takes a lot for Zora to come to this decision, but she realizes that this is the only way Franklin can save himself and their relationship. He has to redeem himself. She is not able to do it for him, although she has tried so many times before.

In the end of the novel, Franklin does redeem himself, vowing three things shortly after he is forced out of their home:

> Number one, I was gon' have to cut out all this fuckin' drinking. Number two, I was going back to school. And number three, even though I missed Zora and my son already, I wasn't gon' show my face over there until I felt strong enough to look her in the eye and tell her that I was sorry.
> It took three months.
>
> *(371)*

Out of true love for Franklin, Zora does not scorn him when he comes back to visit her and the baby. Instead, she shows her concern for his welfare, her approval of his change, and her continued love for him and what they had shared together. It is, after all, the relationship between the male and the female that is crucial in this novel, as it is in life in general. Through it all, Zora remains the loving, strong and committed Africana womanist, realizing that she has presented herself in the right way, and that love, respect and loyalty will ultimately come back to her, as it must naturally do. Thus, the Africana womanist triumphs, sacrificing neither her family, her community nor her character.

Note

1 Terry McMillan, *Disappearing Acts* (New York: Viking, 1989). All subsequent citations from this work will be given by page number only.

PART III

From Africana Womanism to Africana-Melanated Womanism

This new section offers new materials for new insights into the natural evolution of Africana Womanism to Africana-Melanated Womanism, convincingly presenting a rationale that explicates the basic commonalities existing between all melanated women. Initially creating Africana Womanism as a realistic paradigm for all women of African descent in particular, addressing the underlying message within the context of our own cultural, historic and current matrix, I now move to a broader collective, including other women of a more diverse backgrounds whose identity is also rooted in blackness. Hence, since the inception of Africana Womanism in the mid-1980s, it now hails as a more overt inclusive terminology reflecting its more inclusive concept. In short, it has become the embodiment of inherent conceptual and terminological inclusivity. Aubrey Bruce, founder of *Urban Pulse Network* and senior sports columnist for *New Pittsburgh Courier*, who co-hosted, with his late wife, Jennifer, the 1st National Africana Womanism Symposium in 2009, asserts the following:

> As we access the needs of the global woman of color, that mission has now pulled back the layers to reveal a rainbow and myriad of colors, revealing and accentuating an already pre-existing, inclusive, and diverse paradigm birthed from Africana Womanism and now extending to Melanated Womanism.

> *(Bruce)*

Over the years, global women of diverse ethnicities have come to identify with the terminology, Africana Womanism, and its overall agenda. Consequently, they have often requested to be included in a concept that extends itself to a better means by which the lives of an extended global Africana-Melanated woman can exist freely, without compromise. As a result, a terminological evolution has boldly come forth, Africana-Melanated Womanism.

10

AUTHENTICATING AND VALIDATING AFRICANA-MELANATED WOMANISM

A global paradigm for human survival

> Hudson-Weems, having engaged in serious scholarly research on these matters [the African heritage and gender question], dares to challenge the Eurocentric *status quo* ... For the first time, the African position on gender issues is fearlessly presented with a global spread, leading from African roots to the diaspora, while the author x-rays and analyzes her own identity, realities and multifarious dimensions in family life, social organization and history, as well as in her reflections of herself in her creative writing.
>
> *(Sofola, Foreword xvii–xviii)*

The above quotation comes from the continent of Africa via the distinguished scholar, Dr. 'Zulu Sofola. Here, she acknowledges the first Africana Womanism book, entitled *Africana Womanism: Reclaiming Ourselves*, which debunks traditional Eurocentric tools of analysis for Africana people, marginalized in their acceptance of inauthentic analyses in their quest for acceptance and legitimacy. Her assessment serves as a prelude to an important commentary some fifteen years later by Mark Christian, Africana European scholar of Liverpool, England, who is Professor and Chair of the Department of Africana Studies at Lehman College, City University of New York. In that volume, *Contemporary Africana Theory, Thought and Action: A Guide to Africana Studies* (2007), the critic acknowledges the importance of Africana Womanism in the Afterword wherein he draws the following conclusions:

> No longer should African agency be examined, explained, and enhanced via postmodernist analyses. To be sure, the approaches to Africana phenomena in this book provide us with cogent intellectual resources that go far beyond the current propensity toward essentially Eurocentric postmodernist perspectives ... We, therefore, require such a blueprint [Africana

Womanism], as here presented, one that is both effective and resolute in its attempt to dislodge the continued domination of white European intellectual canons in the Academy.

(464)

From Africa to Europe and now to America, scholars have embraced the global theory of Africana Womanism. According to Dr. Patricia Liggins Hill, Professor Emeritus at the University of San Francisco, who was the General Editor of *Call and Response: The Riverside Anthology of the African American Literary Tradition*:

> The first African America woman intellectual to formulate a position on Africana Womanism was Clenora Hudson-Weems, author of the 1993 groundbreaking study, *Africana Womanism: Reclaiming Ourselves*. Taking the strong position that black women should not pattern their liberation after Eurocentric feminism but after the historic and triumphant woman of African descent, Hudson-Weems has launched a new critical discourse in the Black Women's Literary Movement.

(1811)

For over three decades, Africana Womanism, earlier called Black Womanism in the mid-1980s, has been authentically operating and working from a family-centered perspective within a cross-cultural and multi-disciplinary context for global Africana women and their families. Having always insisted upon the need for properly naming and defining women of color as part of an overall collective movement, Africana Womanism distinguishes itself with its prioritization of race, class and gender. Appearing in *The Western Journal of Black Studies* in 1989, "Cultural and Agenda Conflicts in Academia: Critical Issues for Africana Women's Studies" was the first call for Africana women to name and define themselves within the framework of this distinct agenda. Subsequently, the first Africana Womanism book, entitled *Africana Womanism: Reclaiming Ourselves*, and its sequel, *Africana Womanist Literary Theory*, were released in 1993 and 2004 respectively. To be sure, the journey toward refining a paradigm tailored to meet the demands of Africana women was a long one, detailed with its own authentic agenda emerging from the unique experiences of its subject.

Going back to 1985, during my first semester as a doctoral student at the University of Iowa, it again came to my attention that Black women were being identified or labeled as feminists, with which I, like most Black women, found it difficult to agree. Prior to going to Iowa, one colleague, who was a politician in the state of Delaware, had commented on my accomplishments as laudable, for I had joined the faculty at Delaware State University as an Assistant Professor of English, barely twenty-five, and soon after spearheaded a Black Studies Task Force, which ultimately led to the creation of the university's Black Studies Program, serving successfully as director. She summarized my activities as representative of an independent, vocal career woman who was obviously a

feminist, to which I responded that I was not. I added that while I was all those things and more, that that did not make me a feminist, as the feminist has no exclusive on active, productive model women in general. I simply dismissed the notion, correcting it via rejecting the label, but failing to offer an alternative name to classify or identify myself outside of that paradigm. Clearly, I had not come to the realization of the critical need for creating an alternative identifying label, outlining its specific agenda and priorities, for non-White women.

Taking this to another level during my earliest period at the University of Iowa, I became involved as a doctoral student in many dialogues and debates both in and out of the classroom, specifically on the question of Black women within the context of the modern feminist movement. During that particular time, Black women were excited with the idea of their own paradigm. Thus, they accepted without hesitation Alice Walker's new terminology, Womanism, as a plausible alternative to feminism for Black women. However, for me, that was still insufficient, as Walker had offered only a short commentary on the term in the Introduction to her collection of essays entitled *In Search of Our Mothers' Gardens*, contending that a womanist is

> A black feminist or feminist of color ... who loves other women, sexually and/or nonsexual. Appreciates and prefers women's culture ... [and who] sometimes loves individual men, sexually and/or non-sexually. Committed to survival and wholeness of entire people, male and female ... Womanist is to feminist as purple to lavender.
>
> *(xii, xii)*

Her interest was clearly in the woman, not the whole family, to which I am totally committed. Her agenda was the same; only a slight difference in shade distinguishing the two. This was not a well-developed, well-defined piece on the meaning of her terminology, although many quickly seized it in their willingness to have another identifying label for themselves with the realization that feminism was not totally accurate in its representation of the true agenda of Black women.

That was not the beginning for me and my extensive journey toward establishing a legitimate theoretical methodology for the identification and existence of an authentic Africana paradigm. The model for this paradigm was my mother, Mary Cohran Pearson, whose persona was the supreme embodiment of the true Africana womanist. Her character represented the characteristics of the true Africana womanist, exuding her vision, "in it together," which she bequeathed to me. It has been over three decades and Africana Womanism has galvanized many, both men and women, who have come forth from far and near, including not only the United States, but Africa, the Caribbean, Europe, Cuba, South America, Canada, India, New Zealand, and Asia, to name a few. Books and articles on Africana Womanism have been translated into Greek and Portuguese and its longevity is, indeed, promising. The collective family continues, as does the dialogue on the subject. We reach out to each other and to those of other

ethnicities, actively anticipating the ultimate coming together with a clearer understanding of the true meaning of cultural diversity, specifically Africana-Melanated Womanism as explicated in this section.

Africana-Melanated Womanism, rooted in blackness, reflects the persuasion of many diverse women, who have found the Africana Womanism theory more compatible with their level of existence. These women identified with both the terminology and its agenda, later embracing the overall essence of Africana Womanism, which holds that the natural mindset of Black women worldwide, along with their male counterparts, must first address racial dominance on all fronts for the well-being of their families. Clearly, we have been too long in a world that has systematically marginalized us in the long-existing efforts in maintaining an unjust global system of racial dominance. Because of the critical need to refine a paradigm based upon the true level of existence and struggle of that oppressed group, from which the global Africana-Melanated woman comes, manuscripts were, and must continue to be, written as templates for documenting and assessing the obvious. "We need our own Africana theorists, not scholars who duplicate or use theories created by others in analyzing Africana texts" (Hudson-Weems, "Africana Womanism and the Critical Need" 79). Critics are needed for evaluating the merits of those works, which could be invaluable in establishing authentic, acceptable tools of analysis for the lives and experiences of an authentic Africana people.

Delores P. Aldridge, Grace T. Hamilton Professor Emerita and Chair of Africana Studies at Emory University, asserts in the Foreword to *Africana Womanist Literary Theory* that the sequel is

> an expansion of ideas presented in *Africana Womanism: Reclaiming Ourselves* (1993). It provides an extensive and thorough understanding of the concepts, *nommo*/self-naming and self-defining. Hudson-Weems believes nothing is more important to a people's existence than naming and defining self. It comes as no surprise, then, that the work takes to task those who have ignored, distorted, or misappropriated all or parts of the theory that she has articulated.
>
> *(xii)*

Given our past lives as an enslaved people in America from the sixteenth to the mid-nineteenth century, during which time we were both named and defined by the other, the dominant culture, it is crystal clear that it is now past due for us to name and define ourselves. In the Afterword to *Africana Womanist Literary Theory*, Molefi Kete Asante, the conceptualizer of the term Afrocentricity, which is the placing of Africa at the center of the analysis of all things relative to Africana people, states the following:

> Africana Womanism is a response to the need for collective definition and the re-creation of the authentic agenda that is the birthright of every living

person. In order to make this shift to authenticity, Hudson-Weems has called us back to the earliest days of African cultural history. In this antiquity she has discovered the sources of so much commonality in the African world that there is no question that Africana womanism has a distinct and different approach to relationships [with their male counterparts] than, say, feminism.

(138)

The key to the true meaning of Africana Womanism is its mandate for inclusion of the whole family, men included, while highlighting also the very presence and role of the Africana Womanist in concert with her male companion in the ongoing cooperative struggle against racial dominance. Indeed, a cornerstone in the priorities of Africana Womanism, the race factor is primary in the scheme of things—race, class and gender—and, thus, must be properly placed within our own historical and cultural matrix.

According to international scholar and founder of the first African American holiday, *Kwanzaa*, Maulana Karenga, in *The International Journal of Black Studies*, Hudson-Weems is, in fact, "the founding theorist of Africana womanism [and] holds a central place in contributing to the discourse on African-centered Womanism within Black Studies and the National Council for Black Studies" (32). Expounding on the dynamics of the term and the concept, Afrocentric scholar, Ama Mazama, asserts in *Journal of Black Studies* that "the term Africana Womanist itself is the first step toward defining ourselves in setting goals that are consistent with our culture and history. In other words, it is the 1st step toward existing on our own terms" (400–401). Editors, Itia Muwati, Zifikile Mguni, Tavengwa Gwekwerere and Ruby Magosvongwe, in *Rediscoursing African Womanhood in the Search for Sustainable Renaissance: Africana Womanism in Multi-Disciplinary Approaches*, contend that "Africana Womanism liberates the enslaved and distorted African cultural space and draws pedagogically nourishing perspectives on African womanhood and gender that can be utilized by people of African descent in their attempts to deal with challenges affecting their existence" (xvii).

Africana women in general operate from within the perspective above, thereby validating the observation and assessment of international scholar, Filomina Chioma Steady, in *Women in Africa and the African Diaspora*: "For the majority of black women poverty is a way of life. For the majority of black women also racism has been the most important obstacle in the acquisition of the basic needs for survival" (18–19).

However, it goes further. Even white feminist, Bettina Aptheker, daughter of renowned Harvard historian Professor Emeritus, Herbert Aptheker, whose seminal work on Blacks, slave insurrections and noted twentieth-century iconic, Dr. W.E.B. Du Bois, who in turn had no doubt sensitized her to issues on race relations, clearly understands the need for women of color to prioritize the race factor:

When we place women at the center of our thinking, we are going about the business of creating an historical and cultural matrix from which

women may claim autonomy and independence over their own lives. For women of color, such autonomy cannot be achieved in conditions of racial oppression and cultural genocide [and] cannot take place unless the communities in which they live can successfully establish their own racial and cultural integrity.

(13)

She highlighted this difference between Black and White women in 1981, which strongly echoes the earlier position of Linda LaRue five years earlier (1976), explicating the obvious difference between the two:

Blacks [including women] are oppressed, and that means unreasonably burdened, unjustly, severely, rigorously, cruelly and harshly fettered by white authority. White women, on the other hand, are only suppressed, and that means checked, restrained, excluded from conscious and overt activity. And this is a difference.

(LaRue 218)

Some eight years later, Audre Lorde comments further on this position, differentiating the Black versus White woman's historical and political essence:

Black women and white women are not the same. For example, it is easy for Black women to be used by the power structure against Black men, not because they are men but because they are Black. Therefore, for Black women, it is necessary at all times to separate the needs of the oppressor from our own legitimate conflicts within our communities. This same problem does not exist for white women. Black women and men have shared racist oppression and still share it ... Out of that shared oppression we have developed joint defenses and joint vulnerabilities to each other that are not duplicated in the white community.

(118)

Be that as it may, however, although we are clearly more concerned with family than with gender exclusively, Africana Womanism and the Africana womanist have always been both political and inclusive. This goes back to African antiquity, and particularly for us in the United States, it calls for us to consider the inception of the African American literary tradition. The slave narratives, like Olaudah Equiano's masterpiece, *The Interesting Narrative of the Life of Gustavus Vassa, the African*, originated back in Africa when he and his sister were kidnapped, followed by Frederick Douglass' *The Interesting Narrative of the Life of Frederick Douglass*, and Harriet Jacob's (Linda Brent's) *Incidents in the Life of a Slave Girl*. In fact, Equiano's narrative signaled the beginning of the Africana American literary tradition, which was naturally political. Indeed, Black literature of the sort by its very nature was didactic, written with the motive of teaching or delivering a

moral lesson. This was only one literary form, but there were more, such as the novel, whose accurate interpretation depended upon an interpretation rooted in the culture out of which the story line emerged. Thus, for Blacks, that would be from an Afrocentric, rather than a Eurocentric, perspective, which would not advocate a forced name or identification appendage of the critic to mainstream theoretical constructs, usually resulting from academic pressures of needing or aspiring to belong to an existing, legitimate theoretical school of thought.

I accepted the mission of self-naming and self-definition for all Africana women, naming it Africana Womanism, which in a basic way represents an Africana continuum of the legacy of African-American literature as both artistic and political. Indeed, this was a natural for me, having been mentored by the noted Black aesthetic critic and scholar, Richard K. Barksdale, author of *Praisesong for Survival*, in which appeared the seminal chapter, "Critical Theory and the Problems of Canonicity in African American Literature," earlier delivered as the Banquet Keynote Address for the 1989 Langston Hughes Society, which he founded. His journey to literary prominence evokes that of twentieth-century icon, W.E.B. Du Bois, author of his signature 1903 book, *Souls of Black Folk*. Dubois had challenged the conservative acceptance of a mainstream academic persuasion later in his 1938 publication, "Criteria of Negro Art," appearing in *The Crisis*, which he had delivered as the Keynote Address at the NAACP Annual Convention in Chicago. In that address, he called for art as a political act, as opposed to *l'art pour l'art*, which many of his contemporaries, like Alaine Locke and Nick Arron Ford, supported.

> All art is propaganda and ever must be despite the wailing of the purists. I stand in utter shamelessness and say that whatever art I have for writing, has been used always for propaganda, for gaining the right of black folk to love and enjoy ... The ultimate judge has got to be you.
>
> *(854)*

Likewise, Barksdale, too, later in the anthology, *Black Writers of America: A Comprehensive Anthology*, which he co-edited with his colleague, Keneth Kinnamon, at the University of Illinois at Champaign-Urbana, had veered away from the trend of Eurocentric ideas and methodology. He was now offering a relatively new kind of anthology, a Black Aesthetic anthology, with its own Black literary canon. In that huge volume, considered the first Black Aesthetic anthology, Barksdale admitted that "we were more on fire with political energy than inspired by literary insight ... Kinnamon and I forged a black literary canon full of political content ... For me a literary act is a political act" (Barksdale, "Critical Theory" 34). But it was over a decade and a half later, in his seminal piece, "Critical Theory and the Problems of Canonicity in African American Literature," that he pulled out all the stops, admitting that earlier Black scholars were intimidated in more ways than one into succumbing to mainstream dictates:

> Not only did we meekly accepted the canon presented to us as fixed and immutable, but we became career generalists and specialists within

the fixed parameters of that canon. We also accepted very restricted notions about the meaning and function of literature. Literature, we were informed, had moral, emotional, and spiritual meaning; it was stimulating, inspiring, ennobling; and it was thought that those who lived and studied literature moved on a higher plateau of humanistic concern than lesser folk who merely invented or engineered or even more, politicked. Thus, literature had no political meaning or political content; if there were political content then that was not literature; that was propaganda.

(Barksdale, "Critical Theory" 33)

Advancing his thoughts on the matter to that of disclosing the negative effects that such a practice of assimilation, which Black aestheticians were known to challenge, would have on future Africana literature and criticism, was, indeed, his awakening. In thoroughly examining the dynamics of the dilemma of Black scholars and their works in the academy, he perceptively and analytically explored their peculiar predicament relative to the creation and survival, or demise, of authentic scholarship, its representations and interpretations. In the end, he strongly cautions against succumbing to the demands in the academy for assimilation at the risk of annihilation:

So, as we contemplate expanding and broadening our African American Literary canon in preparation for an exciting new century, what recognition will we, or must we give to continental critical theory? My recommendation is that, as we broaden our canon, we ignore deconstruction, post structural textual exegesis, and continental hermeneutics. African American literature cannot effectively survive critical approaches that stress authorial depersonalization and the essential unimportance of racial history, racial community, and racial traditions.

(Barksdale, "Critical Theory" 37–38)

What is particularly key in Barksdale's assessment of and recommendation for a true Black literary canon is that we "utilize the politics of survival" (Barksdale, "Critical Theory" 38). In other words, no matter the price, "the awesome politics of employment and publications, as well as one's credibility, visibility and viability in academe," must coexist if we are to be really true to ourselves ("This above all, to thine own self be true"—Shakespeare's Polonius), to our people, and to life in general for total human survival (Hudson-Weems, "Africana Womanism and the Critical Need").

Africana-Melanated Womanism, indeed, grows out of this powerful tradition and commitment. Be it known that the stakes for taking the unsafe, nonmainstream route are high, which is why so many Black scholars continue to allow the dominant culture to dominate the academy. In any event, the choice is left up to the individual, with the realization that it is a chance that we must take, indeed, the Africana Womanism response. Unless such an action takes place,

we will ultimately fall into a bottomless pit of inauthentic existence. And that commitment continues today, for there are other Black scholars, too, who see the problems associated with accepting inauthentic paradigms for Africana literary texts, such as literary critic, Adele S. Newson-Horst. She takes the matter ever further than Barksdale in her criticism of the inaccurate naming and claiming Black women scholars in particular as some sort of feminist, even when they act authentically as family-centered Black women:

> In the last few decades feminism and Black feminism have gained such a stronghold in the Academy that the activities of most all of the important women writers have been stamped as feminist enterprises. While feminism provides a refreshing alternative to patriarchal hegemonic discourse, it is nevertheless inadequate to account for the numerous and varied works produced by Africana women. This is especially true when one considers that the masses of Africana women do not identify themselves as feminists. Hence, the appropriation of Africana women writers, that is the naming of them as feminists, emergent womanists, prototypical feminists, or pre-feminists, is, indeed, a disturbing trend, sanctioned by some of our most visible critics and theorists. This inherent contradiction, an ahistorical impulse, in defining a Black tradition and a theoretical and preoccupation as feminist, commands that a distinction be made between feminist impulses and feminism.
>
> *(Newson-Horst, "Mama Day" 359)*

On the matter of the contradictions in agendas relative to feminism and Blacks, and the flaw in embracing an alien, Procrustean paradigm, we must take a closer look at the underline priorities of the women of the dominant culture, who clearly were not discriminated against on the basis of their race, like other minorities. What is revealed is that their priorities were the polar opposite of ours. For example, in the venomous origins of feminism, white women represented a Eurocentric posture:

> stanch conservative suffragist leader Carrie Chapman Catt and other women of her persuasion insisted upon strong Anglo-Saxon values and white supremacy. They were interested in banding with White men to secure the vote for pure Whites, excluding not only Africanans but White immigrants as well. Historians Peter Carrol and David Noble quoted Catt in *The Free and the Unfree* as saying that "there is but one way to avert the danger. Cut off the vote of the slums and give it to [White] women." She continued that the middle class White men must recognize "the usefulness of woman suffrage as a counterbalance to the foreign vote, and as a means of legally preserving White supremacy in the South" (296).
>
> *(Hudson-Weems, Africana Womanism 21)*

To be sure, the above quotation represents the exclusivity of a paradigm that supports only a minuscule group and their concerns, those of "Anglo-Saxon values," in its exclusion of others, non-Whites, consequently leaving Blacks in particular with the responsibility of finding or creating their own authentic space or paradigm.

Now taking a quantum leap into the heart of the twenty-first century and the future of Africana paradigms, specifically Africana Womanism, Mark Christian, in the Afterword to *Contemporary Africana Theory, Thought and Action: A Guide to Africana Studies* (2007), also holds that

> African centered thought and practice must co-exist on equal terms. The collective role of Africana women [and men] scholars, then, is to ensure that this part of the mission reaches fruition … The next generation of Africana scholars have the potential to become key players in providing the necessary knowledge needed to combat what could be deemed "technological racism" and the exclusion of Africana paradigms in mainstream cyberspace. Our collective work ought to foster an acknowledgement that there is an "information war" taking place with regard to the creation of knowledge. Without being fully cognizant of this, Africana scholars may pay the ultimate price of continued marginalization and exclusion in the Academy.
>
> *(464–465)*

Herein, he, while focusing on the future of Africana thought and practice for the destiny of Africana people, makes a point to include the Black women and the need to make Africana Womanism truly a global presence in the twenty-first century, the age of the computer. But it starts with the family and Christian's commentary echoes the very *raison d'être* of the family, whose overall responsibility is protecting each other in securing the ultimate survival of the global community. Hudson-Weems' "Africana Womanism: An Historical, Global Perspective for Women of African Descent," in *Call and Response: The Riverside Anthology of the African American Literary Tradition*, addresses this, wherein she puts forth a challenge for victory on all fronts:

> If Africana Womanism is allowed to reach its full potential, that of reclaiming Africana women via identifying our own collective struggle and acting upon it, then Africana people the world over will be better for it. Moreover, whenever a people take control over its struggle, tailoring it to meet the collective needs and demands, success is almost invariably inevitable. When success in one's goals is realized, it makes for a more peaceful reality for all. Further, one is more inclined to a wholesome and amicable relationship with others, knowing that the concerns of their people are respected and met.
>
> *(Hudson-Weems, "Africana Womanism: An Historical,*
> *Global Perspective" 1815)*

Now, for the moment, just imagine the victory you would receive as you reflect on all the positive rewards underlined in the above quotation. What do you have if global Melanated Womanism is realized? Goals realized and ultimate success. How reassuring is that! Peace via a wholesome, amicable presence! What a relief from stress, followed by relief from physical and psychological diseases of all sorts! To be sure, "Africana Womanism: A Global Paradigm for Women of African Descent" offers an accurate application, analysis and explication of a challenging authentic paradigm designed for the study and assessment of the lives and works of women of color. The message reflects both our individual and cultural lives, including our dreams, aspirations and acts. Echoing the essence of Africana Womanism, the editors of *Call and Response* assert that Africana Womanism, and by extension the Africana Womanist,

> is a black woman activist who is family centered rather than female centered and who focuses on race and class empowerment before gender empowerment. Of all the theoretical models, Hudson-Weems' best describes the racially based perspective of many black women's right advocates, beginning with Maria W. Stewart and Frances W. Harper in the early nineteenth century.
>
> *(Hill 1379)*

Unquestionably, the top priority for the Africana woman is her family and her community, thereby insisting that our struggle is a collective one.

Finally, Africana Womanism has been used as a theoretical tool of analysis globally since the early 1990s. In 1992, I was invited to speak at the First International Conference for women of Africa and the African Diaspora at the University of Nigeria-Nsukka. There I met many engaging Africana scholars, both men and women, and was very well received by the audience of well over a thousand attendees. At the close of the conference, a headline story, entitled "[Africana] Womanism: Beyond Bra Burning," appeared in the major newspaper, *The Nigerian Daily Times*. One scholar in particular, 'Zulu Sofola, distinguished as Nigeria's first female playwright, and Professor and Head of the Department of Performing Arts at the University of Nigeria-Ilorin, who was highly revered by all, set the tone for a memorable gathering of minds, with men and women sharing ideas and working together. She later wrote the Foreword to *Africana Womanism: Reclaiming Ourselves* (1993) in which she proclaims:

> *Africana Womanism: Reclaiming Ourselves* is not simply a scholarly work, one of those in the mainstream, but our own. It is a new trail blazed with incontrovertible relations on the African heritage and gender question. Hudson-Weems bravely takes the bull by the horns, confronts the Eurocentric avalanche of words on questions of gender, and puts forward the Afrocentric point of view.
>
> *(xvii)*

Another scholar I met there was Daphne Ntiri, former delegate for the United Nations, who wrote the Introduction to that first Africana Womanism book, wherein she drew the following conclusions relative to the dynamics of terminology and concept. The following is a quotation from that text, in which she offers a possible resolution regarding Africana Womanism as a very plausible paradigm for all Africana women:

> If African feminism admits to the alienation and marginalization of the African woman within mainstream feminism, "what we have then is not a simple issue of sex or class differences but a situation which, because of the racial factor, is caste-like in character on both a national and global scale" (Steady 1981:18–19). And if Black feminism recognizes its peripheral status and clearly espouses a move "from margin to center" (Hooks, 1984), then Africana Womanism as proposed by Clenora Hudson-Weems is timely, theoretically fitting and intrinsically advantageous to the Africana woman. It charts a new course for self-naming and self-control and fills a void created by the disassociation of Africana women from movements that foster inequality and keep them on the fringe. This novel advocacy solidifies the commonality of political and socioeconomic goals, gives legitimacy to our claim for equality, demonstrates clarity of mission and purpose in our Africanness, and adds originality to the collective voice of Africana women.
>
> *(Ntiri, "Introduction" 5)*

That collective voice has now been expanded, as Africana Womanism now has modified its name, a terminological evolution from Africana Womanism to Africana-Melanated Womanism.

11

AFRICANA WOMANISM'S RACE, CLASS AND GENDER

Pre-intersectionality

> Clenora Hudson-Weems' work provides a theoretical construct that boldly restores meaning within historical and cultural contexts that are peculiar to the African and African Diaspora woman's experiences. It offers an element historically denied such women: a choice. Moreover, her application of the Africana womanist theory to Black life and literary texts proves to be both accurate and useful as we search for appropriate theories and methodologies for Africana writers.
>
> *(Newson-Horst, jacket blurb)*

In the above quotation is the 2004 book endorsement of *Africana Womanist Literary Theory* by Newson-Horst in which she acknowledges the uniqueness of Africana Womanism as an authentic theoretical tool for analyzing Africana texts and action. Used in analyzing Black life, it could very well prove to be a most effective way of contextualizing our unique experiences throughout the world. Adele points to the fact that for the first time, this theory gives Africana people their own unique paradigm, "a choice" that had not been traditionally offered them, as Blacks were forced to assimilate into White culture and values. Thus, many bought into the White concept of feminism, which historically did not have Blacks in mind or on its agenda. The critic, therefore, concludes that in both identifying and correcting the long-existing problem of inadequacy and inequality in interpretations in academe, we need expansion and inclusion. Needless to say, the ongoing attempts to erase positive inclusive efforts in this regard have posed some unnecessary problems, unfortunately evolving in an academic battle for turf regarding the question of the woman and specifically the Black woman within the context of the feminist movement.

Africana critic, Valethia Watkins, perceptively expounds on the consequences of such limitations, which ultimately serves no one in the final analysis:

> Compulsory Feminism promotes an unacknowledged movement to make feminism, as a unit of analysis, the only authentic and legitimate explanatory framework and lens to determine how research on gender and by extension women is framed and analyzed.
>
> *("Africana Gender Studies"* 67)

She pin-points the domination of feminist theorization, as she offers a perceptively accurate terminology, Compulsory Feminism, to name and explicate its end results. A disturbing practice of racial domination on the part of mainstream feminists, it forcefully obtrudes a limiting mandate upon all to adopt. In the theorization of critical issues confronting Black women and their families in their communities, both inside and outside academia, the practice of racial dominance is evident, despite the fact of its inherent unconstitutionality, indeed, one of many distasteful acts to which non-Whites have been forced to succumb if they hope to achieve the recognition their work deserves. Today, the current emphasis on the relativity of feminist activity, called "intersectionality," which was introduced by race theorist Kimberle Crenshaw in 1989, has enhanced the dominance of the application of the Eurocentric tool of analysis for Black life. Clearly this is not necessary, as an Afrocentric tool of analysis for Black life, particularly relative to Black women and their families, was already in place with the earlier advent of Africana Womanism. Thus, it is crucial to first know the correct dates for the inception of certain ideas and paradigms in order to accurately discuss how or if a paradigm was influenced by others. Although the first edition of *Africana Womanism: Reclaiming Ourselves* was published in 1993, the second chapter of all three books on Africana Womanism, "Cultural and Agenda Conflicts in Academia: Critical Issues for Africana Women's Studies," was initially published in *The Western Journal of Black Studies* in 1989, following several presentations at national conferences, hence, pre-dating "intersectionality."

This information is very important and is probably why and how the dominant cultural gender-based construct, feminism, and by extension Black feminism, have been more successfully dominating the scene. Clearly there is an ongoing conscious move to "silence" the Africana womanist voice, which has been effected by what Jacob Carruthers identifies as being in operation in Henry Louis Gates' *Loose Canons.* Carruthers asserts that in attempting to silence the Afrocentric voice, "Gates wages his battle against the African-centered discourse through the time-tested strategy of nonrecognition" (204). Molefi Asante, too, is cognizant of this practice, and calls it out in the Afterword to Hudson-Weems' second Africana Womanism book, *Africana Womanist Literary Theory* (2004):

> Perhaps one of the most important challenges facing Africana womanism, much like challenges we have seen in other Afrocentric ventures, is keeping

clever writers from siphoning off ideas and then claiming that those ideas really belong to feminism or to some other Western construction. What the African community has come to applaud is the clarity with which Hudson-Weems speaks about African women. She has often pointed out, as she does in this volume, that many women authors try to suggest that the self-definition, self-determination, and centering that she has articulated is really a part of some feminist movement. In fact, what has usually happened is that those writers have found the Afrocentric ideas and concepts developed in Hudson-Weems' Africana womanism significant and, therefore, have sought to appropriate them without proper attribution. I believe that this exists because they do not want to admit that their concepts were first conceived in the writings of the Africana womanist school.

(138)

To be sure, Africana Womanism has been on the scene since the 1980s, insisting that "most Africana in general do not identify with the concept in its entirety and thus, do not see themselves as feminists" (Hudson-Weems, *Africana Womanism* 17). In making feminism more inclusive, while appealing to a larger audience, intersectionality was strategically introduced. Traditional feminism since its inception, until the terminology intersectionality was introduced in 1989, was gender exclusive, which now advocates an interest in racism and classism, too.

A close look at the meaning of the very popular term "intersectionality" reveals even in *Wikipedia*'s definition that it clearly echoes Africana Womanism, particularly in its opening definition including "race, class, and gender," indeed, an obvious element of prioritization not heretofore seen in feminism's former gender-exclusive posture, as well as Black feminism's "gender, race and class" posture.

> The interconnected nature of social categorizations such as race, class, and gender as they apply to a given individual or group, regarded as creating overlapping and interdependent systems of discrimination or disadvantage.
>
> "Through an awareness of intersectionality, we can better acknowledge and ground the differences among us."
>
> *Intersectionality* (or *intersectional* theory) is a term first coined in 1989 by American civil rights advocate and leading scholar of critical race theory, Kimberlé Williams Crenshaw. It is the study of overlapping or intersecting social identities and related systems of oppression, domination, or discrimination.
>
> *Intersectionality* is a concept often used in critical theories to describe the ways in which oppressive institutions (racism, sexism, homophobia, transphobia, ableism, xenophobia, classism, etc.) are interconnected and cannot be examined separately from one another.
>
> *(Wikipedia)*

What happened here is clearly an expansion in the inclusion of more areas of discrimination than previously called out in Africana Womanism, in its prioritization of race, class and gender, although it has always insisted upon the cross-cultural (global), gender-inclusive (male and female), and interdisciplinary (all areas of study, etc.) nature of the inherent struggles of Africana women from its inception. The problem is that the feminists' covert implication that the notion of "intersectionality" in actuality is a new phenomenon, which explicates the interrelatedness of all people and issues, is somewhat misleading, as they fail to point out that their notion of inclusion, race, class and gender, the cornerstone prioritization of Africana Womanism pre-dating intersectionality, only answers to some similar earlier concerns for Black women. Audre Lorde, for example, raised her concerns about the exclusion of Black women, as well as lesbians, while commenting on the interconnection between Black men and women whose commonalities "are not duplicated in the white community," which is exactly why her comment on this fact received less attention from the feminists than did her comments on the gender question (118). She called for a clearer positioning of the Black woman, indicating a more inclusive agenda than found in traditional mainstream feminism, although she never advocated for a separate name for identity clarity, nor did she call for the prioritization of race, class and gender that distinguishes Africana Womanism from any other female-based paradigm. Be that as it may, however, clearly, for her, the race factor was an obvious priority, which violated the earlier position of gender exclusivity on the part of the feminist.

Although intersectionality is a sort of expansion of an existing established practice of inclusivity, Africana Womanism, it would be nonetheless problematic to line the two concepts up side by side. To be sure, the intent behind the two are different, in that Africana Womanism was designed to name, define and refine an authentic paradigm explicating the role of the Black woman within her historical and cultural Afrocentric family-centered matrix. On the other hand, feminism, and its current evolution from gender exclusivity to intersectionality, was designed for and by White women, apparently for another reason, but now, its motive is perhaps as a means of swelling the numbers of supporters by expanding its agenda, or by addressing on some level its unjust practice of racial dominance. For example, in 1852, Sojourner Truth was hissed at and jeered at during the 1852 Women's Rights Convention in Akron, Ohio, because of her race, which she challenged in her "Ain't I a Woman" speech. She again challenged White feminists in 1858 at an event at Silver Lake in Indiana. However, it was not until 1975, well over a century later, that she was officially remembered by a white female group, *The Dinner Party*, and even then, it was an insult, as that recognition came in the form of a lone black female face in a collection of thirty-nine notable women, now including the Black token. According to sociologist Oyeronke Oyewumi:

> The first wave white women feminists, [were] the historical beneficiaries of the anti-racist abolitionist movements [during slavery] … This second

wave of feminism [occurred during the time of *The Dinner Party* event], which like the first, benefited from another phase of the black freedom struggle, the Civil Rights movement.

(Oyewumi 182)

Be that as it may, Truth's speech has been sadly and erroneously mislabeled or mis-claimed as the feminist manifesto, despite its self-actualization nature, which prioritizes race, class, and gender, like Africana Womanism.

Still, despite the difference in motives, Africana Womanism should be at least mentioned, a practice that one naturally expects in the academy. Granted, feminists have the right to build upon existing ideals, as theorists have done through the years, such as French psychoanalyst Jacques Lacan in his expansion on the meaning of "the Gaze," which was widely used by others before him, such as French existentialist philosopher Jean-Paul Sartre. While the latter focuses on the relevancy of "the gaze" as it reflects on the receiver, which is object, the former, Lacan, focuses on its significance relative to the subject, in terms of what it says about the very one who initiates or creates "the gaze" in the first place. Today, contemporary theorists and interpreters, such as Ellie Ragland, internationally renowned Lacanian scholar, in advancing Lacan's philosophy, necessarily cite Sartre in the psychoanalytical and philosophical evolution of theory, thought, and practice. Such is true scholarship that leads to a profound solid practice.

Needless to say, while the various types of feminists, now realizing the interconnected factors of race, class, gender and even more now in their evolution, have finally embraced the fact that gender exclusivity is not enough and that other factors must coexist with gender oppression, they have yet to acknowledge the obvious practitioners before them and should, therefore, correct their omission. As evidenced in the past, one can be just as guilty by omission, as in the case of those who did nothing to contest the crime of enslavement, as by commission, which is the ultimate crime of participation. Unlike White abolitionists, such as John Brown, a true abolitionist, to whom W. E. B. Du Bois dedicated his seminal essay, "Resolutions at Harper's Ferry," many Whites stood in silence, watching the abominable crime go unchallenged, thus, serving as accomplices, so to speak, of the formidable crime against nature, indeed, the violation of the humanity of one's fellow humankind. To be sure, there is much to be gained by all on both sides when "the other" involves himself/herself in correcting the dehumanization of a fellow human being. For example, Harriet Beecher Stowe, also a true abolitionist and author of the classic nineteenth-century novel, *Uncle Tom's Cabin*, demonstrates how slavery not only dehumanizes Blacks, but Whites as well, via her characterization of one of the main protagonists, Simon Legree, whose white privilege reduced him to a subhuman level, a monster.

That said, Black scholars, too, have been remiss in what they acknowledge and how they place, label and interpret Black women writers and activists within mainstream ideals. They indiscriminately claim all Black women as feminists solely on the basis of gender, an observation that Valethia Watkins and few others, including

myself before her, concluded. Her position is resounded in "Contested Memories: A Critical Analysis of the Black Feminist Revisionist History Project."

> One Africana studies scholar who has raised questions about this practice is Clenora Hudson-Weems. She persuasively argues that the imposition of the feminist label serves to de-emphasize and recast the agenda of African women of the nineteenth and early twentieth century. The agenda of these women, according to Hudson-Weems, was to address the life-threatening conditions facing Africans as a group, both genders together.
>
> *(Watkins 277–278)*

This assertion was earlier cited in Hudson-Weems' *Africana Womanist Literary Theory*, which contended that this practice must be corrected (Watkins 9–10). Clearly Black women scholars stood "silent," as their larger issue, racism, remained not a priority, but rather an obstacle to be simultaneously treated or addressed—gender, race and class. According to the editors of *Call and Response: The Riverside Anthology of the African American Literary Tradition*:

> Although these women differ on various issues, a *Black feminist* is, in general, a woman who insists on the simultaneity of gender, race, and class even though her obvious alignment with feminism is dictated by the fact that most of her energies go into the gender question.
>
> *(Hill 1378)*

With that in mind, an excellent example of correcting one's error is Betty Friedan, a major shaper of mid-twentieth-century feminism, whose feminist position evolved from Susan B. Anthony's original women's suffrage posture during the nineteenth century. The publication of her signature book, *The Feminist Mystique*, indeed, very timely and popular, made its grand debut during the pinnacle of the Women's Liberation movement of the searing 1960s. At that time, she strongly separated the concerns of the opposing parties, the White male and female, with the latter demanding "I want something more than my husband and my children and my home" (27). Her sentiments no doubt heavily influenced Sylvia Ann Hewlett's radical feminist proclamation in her 1986 publication, *A Lesser Life*, in which she dismissed the traditional responsibilities of the woman in her condescending attitude toward mothering and nurturing the children, our future generations. She calls motherly duties "tasks for feeble minded girls and eight-year olds," tasks that are no doubt the very foundation for successful child-rearing, indeed, a major cornerstone for Africana-Melanated Womanism (Friedan 27). Friedan, the much-celebrated author-activist of the times, realizing at last that de-centering the family must be corrected, responded in *The Second Stage* by moving the family back to the center, in the forefront, a clear challenge to her earlier position of female centrality exclusively, indeed, the traditional major cornerstone of feminism (Friedan 27).

Clearly, within that family structure is the woman, the mother and the nurturer. For me, the model mother was my mother, Mary Cohran Pearson. Together, our vision via the ongoing dialogue of a collective family continues. As we embrace each other, we also reach out to others of other ethnicities, actively anticipating the ultimate coming together of all with a clearer understanding of the true meaning of cultural diversity. Robert L. Harris' endorsement of *Africana Womanism: Reclaiming Ourselves*, former director of the Africana Studies and Research Center and Vice Provost at Cornell University, accurately pinpoints the *raison d'être* and goal of Africana Womanism:

> In the triple marginality of black women, race rises above class and gender. With it, a reunion, a much-needed healing, a human philosophy emerge for men and women of African ancestry and ultimately for all caring men and women.

Here Harris praises the commitment of Africana womanists to each other in the struggle for the ultimate coming together of all races in a fair and just society that subjugates and discriminates against none.

The ultimate goal of Africana-Melanated Womanism, then, is to continue bringing all the factors together, addressing race, class and gender in all areas of female subjugation as experienced by all women of color, and by extension all women in general within the constructs of the family. To be sure, this modified label/name only suggests an evolution for a broader ethnic collective. This family-centered, race-empowerment paradigm cannot afford the luxury of slighting the common needs of women of color in particular. Their pervasive interconnected triple plight in a world that practices blatant racial dominance will not be alienated from the male sector in the senseless gender divide characterizing the battle of the sexes. Its dauntless quest for ultimate human survival via racial parity remains the long-existing goal of Africana/Africana-Melanated Womanism. However, it is refreshing to witness the evolution of feminism, too, which promotes now more than gender exclusivity. Instead, it emphasizes this interconnection surrounding Africana Womanism and the critical concerns for true diversity and justice for all into the new millennium. Moreover, the critical issues surrounding the continuing and changing roles of women in today's society are also highlighted, as we consider the dynamics of identity relative to race and ethnicity, culture and history, and community versus individuality for ultimate human survival and existence. Intersectional adds to this, in that it brings to the table other forms of discrimination, such as sexuality, sexual identity and preference. One final note. While I am not calling for a replacement of traditional, established paradigms, such as feminism, etc., for they were, indeed, created out of the needs of a particular group that had legitimate concerns or issues that needed to be addressed, I am nonetheless proposing for a broadening of the body of criticism to include yet another perspective or paradigm, which is Africana Womanism, now evolving to Africana-Melanated Womanism.

12

AFRICANA-MELANATED WOMANISM

Forging our way via securing each other (2019 Keynote Address—2nd International Africana-Melanated Womanism Conference)

> As a race, the most painful part of our experience with the Western world is the "dewomanization" of women of African descent. It is true that to successfully destroy a people its female component must be first destroyed. The female gender is the center of life, the magnet that holds the social cosmos intact and alive. Destroy her, and you destroy life itself.
>
> *(Sofola, "Foreword" xviii)*

The above quotation, coming from our own mother of Africa, Dr 'Zulu Sofola, represents profound insights into the nature of life and its players, including women, who have always been a very significant part of life's equation. Therefore, both the woman and her male counterpart must come to an agreement that each must respect and protect each other as a part of a necessary collective for the betterment of not only our communities, but for the world communities at large. Perhaps it would be helpful to have a clearer picture of the Africana woman in terms of her overall character and her role in society, which many have not come to fully appreciate as a given protection for not only the woman, but for us all, including our men and children.

This added feature, the established commonalities existing not only between Africana-Melanated women globally, but between Africana men and women as well, is acknowledged by a noted critic, activist and author, Audrey Lorde. She notes that Black men and women demonstrate that we have inherited a "shared racist oppression … joint defenses and joint vulnerabilities" (118). Clearly this assessment reveals that Black women and men have more in common than not, which too often is missed in assumptions made about our interrelationships. Admittedly, we are "In It Together" and our aspirations for ultimate positive human relations are evident. Our collective battle against the antagonistic forces reflecting our restless world of confusion and uncertainty will no doubt continue until basic freedom for all is realized.

Ramatoulaye, protagonist in Mariama Bâ's Senegalese eighty-nine-page epistolary novel, entitled *So Long a Letter*, passionately calls for a physical bonding via a spiritual commitment to each other in order for ultimate harmony and success:

> I remain persuaded of the inevitable and necessary complementarity of man and woman.
>
> Love, imperfect as it may be in its content and expression, remains the natural link between these two beings.
>
> To love one another! If only each partner could move sincerely towards the other! If each could only melt into the other! If each would only accept the other's successes and failures! If each would only praise the other's qualities instead of listing his faults! If each could only correct bad habits without harping on about them! If each could penetrate the other's most secret haunts to forestall failure and be a support while tending to the evils that are repressed!
>
> The success of the family is born of a couple's harmony, as the harmony of multiple instruments creates a pleasant symphony.
>
> The nation is made up of all the families, rich and poor, united or separated, aware or unaware. The success of a nation therefore depends inevitably on the family ... I shall go out in search of it. Too bad for me if once again I have to write you so long a letter.
>
> *(88–89)*

It is critical that within the family that we allow the components of the human equation, males and females, to play out their particular roles, with, of course, some flexibility. Ultimately they together constitute the family; of course, they have a critical place in the scheme of things relative to their assignment by God, who has Himself established the master plan and operational design for the continuation of the human race. Exemplifying the role-playing of the Africana women is the mother in *The Joys of Motherhood* by African novelist, Buchi Emecheta. Here, she focuses on the role of the woman, mothering and nurturing, which is not to suggest that this is the only role of the woman, although it has the position as being a top priority. Respecting roles is essential to harmony and success, as we also recognize and accept other roles that the woman may play. Moreover, let us not take for granted the role of the male counterpart, such as his role as the provider and protector of his family, for this certainty gives a more complete picture of the dynamics of the interaction and interconnection of the male and the female as a cooperative whole. Therefore, the true assignment of the Africana family structure, then, as reflected in literature, such as in Emacheta's novels, cannot be compromised as in the case of mislabeling her work outside of the cultural matrix: "My novels are not feminist ... I have not been relating well with Western feminists and have found myself at loggerheads with them from time to time" (Ravell-Pinto 50–51).

Indeed, she makes a poignant and revealing statement in the 1980s interview, contending that Black female writers should not be summarily categorized as feminists simply on the basis of their gender. Clearly, as indicated in the title of her novel alone, *The Joy of Motherhood*, she is concerned with other issues, thereby commanding a different category for her writings. She is addressing a defining role of the Africana woman, that of mothering and nurturing, crucial in the list of eighteen characteristics of the Africana Womanist.

With that said, clearly Africana Womanism, an established paradigm that insists upon addressing the specific concerns of Black women from a family-centered, race empowerment perspective, is in direct contravention to all other brands of feminism. The base of all feminisms is after all still feminism, and hence, the terminology dictates the inherent meaning. Needless to say, one must likewise insist upon an allegiance to the global Black community, for the commonalities of issues are visibly apparent, no matter the locale. For example, our concerns in the United States strongly echo the sentiment in the proclamation of South African activist, Ruth Mompati, in the midst of apartheid wherein the prioritization of race over gender was the key to the liberation struggle. In her poignant commentary, she graphically presents the sacrifice of countless young children, who bravely stood up against apartheid, and, moreover, who heroically died, leaving their decomposed bodies as a testimony of their support of the liberation struggle:

> The South African woman, faced with the above situation [decomposed bodies of children who were anti-apartheid demonstrators], finds the order of her priorities in her struggle for human dignity and her rights as a woman dictated by the general political struggle of her people as a whole. The national liberation of the Black South African is a prerequisite to her own liberation and emancipation as a woman and a worker.
>
> *(Mompati 112)*

To be sure, this experience for Blacks is global, for as we move from the continent of Africa to the United States of America, we witness the same kind of circumstance of racial violence and disparity wherein we have to exercise our own priority of race first, relative to the overall plight of the Africana-Melanated family. Consider Harriett Tubman, Underground Railroad conductor, who went down South nineteen recorded times, not just for her sisters, but for her Africana people in general—men, women and children. Consider also Ida B. Wells, anti-lynching crusader, who began investigating lynchings of Black victims with the lynching of her Black male friend, along with his two business partners, who opened up a grocery store in a Black neighborhood, thereby becoming competition to the White grocery store owner there. Indeed, these female figures were not interested in gender exclusivity; they were interested in doing their part to help to eradicate life-threatening circumstances of Blacks in general.

This leads us to another important factor that one must remember when speaking of success, which too frequently translates first into financial success. All too often, some want to romanticize about the issue and say that it's not just about the money, while at the same time factoring finances into one's personal decisions relative to selecting one's mate. Still, although it is true that it is not "just" about the money, it does play a very important part of the equation. Therefore, at all times, the Africana womanist must remember, in considering her options, that it is equally important that she

> realistically and objectively examine the dominant forces at play, forces that dictate the very nature of the conflicts and the ways they are handled. These forces, in many instances, are deeply rooted in economics, particularly the economic failure of the Africana man.
>
> *(Hudson-Weems, Africana Womanism 77)*

We must be sensitive to our male counterparts, realizing how helpless he must feel when he thinks that he is a loser and that he is letting down the family, assuming all of the responsibility for failure, and placing none of the responsibilities with the real culprits.

> When one looks at the economic problems within the Africana family, one invariably comes back to the problem and interference of racism, which strongly impacts upon the economic realities of the Africana family and community. Thus, while the Africana womanist writer should not make blanket justifications for the failures, frustrations, undesirable behavior, and financial predicament of some of her menfolk, which are oftentimes interconnected, she is not expected to abandon them or badger them with the too-frequent generalization that all Africana men are no good and irredeemable. Such a personal self-serving mislabeling inevitably ends in an unjustifiable and relentless lashing out at men in general, thereby sentencing them to perpetual verbal and emotional castration by their women.
>
> *(Hudson-Weems, Africana Womanism 77)*

With all that being said, it becomes even clearer that from the very beginning of times, even before the coming of Christ, we have had it on some level or another! From Religiosity to New Age Philosophy, from Patriarchy to Feminism, from Socialism to Democracy; and through it all, racism, and religion, too, ranking high in the scheme of things, remains unchanged. Beneath the surface, the abominable racism, a seemingly insurmountable phenomenon, still lurks at the base or the very foundation upon which many institutional systems rest. The trillion-dollar rhetorical question, then, remains the same: Did it work? Of all of the possible resolutions relative to racism in our everyday lives and how we fit into its structure, the resounding question yet remains. The rhetorical trillion-dollar answer, of course, is apparent: Absolutely not! And it will remain

unresolved until all these possibilities are factored into an historical and cultural matrix in which an all-inclusive paradigm for ultimate human survival can securely reside. To be sure, addressing critical underlying issues within the established political, social and economic structures is a sound approach, one which merits serious consideration. Africana-Melanated Womanism meets that demand as an appropriate global construct designed with that in mind. A family-centered paradigm that prioritizes race, class and gender, it offers truly an egalitarian solution to satisfying unbiased humankind in pursuit of a just human existence. And we will be successful, but only if Our Heavenly Father is in front, guiding His children, all of them—men, women and children, collectively executing the order of God's plan that He has so omnisciously put forth.

In 2009, I received an important and urgent correspondence from Itai Muwati, then Chair of the Department of African Languages and Literature at the University of Zimbabwe, who is currently Dean of the Faculty. I had just returned from the Presidential Inauguration of Barack Obama, America's first Black president, where I did a book signing at the Kenyan Embassy for my newly released book, entitled *Africana Womanism and Race and Gender in the Presidential Candidacy of Barack Obama*. The following day, I spoke at Howard University, a legacy among the historically and predominately Black institutions, on my Africana Womanism work. Dr. Muwati advised me that because of the significance Africana Womanism and its applicability worldwide in the face of widespread societal upheaval due to global racism, the university wanted to host the 1st International Africana Womanism Conference for that following year, 2010. Their mission would be to bring forth a meaningful global dialogue with people from all over the world, both inside and outside the academy, in order to ascertain possible solutions for human survival, indeed, an underlying goal of Africana Womanism. He insisted that a global conference on this paradigm was urgent and that it must be done before the first decade of the twenty-first century came to a close, thereby enabling international interdisciplinary scholars, activists, etc. to understand Africana Womanism more fully and, moreover, to understand how Africana Womanism, with the leadership of God, the Father, could assist us in our quest for authentic existence and ultimate freedom and survival.

The conference was held the last week of October 2010, which brought together over sixty-five presenters from both African universities, including the University of Zimbabwe and the Great Zimbabwe University, the University of South Africa, the University of Botswana, as well as US scholars from California State University, the University of Oklahoma, Delaware State University, the University of Missouri, etc. Speakers inside the academy included chancellors, deans and faculty; speakers outside the academy included the Honorable Joice Teurai Ropa Mujuru, Vice President of the Republic of Zimbabwe, who delivered the Opening Welcome, and others from the political arena. From that conference of hundreds of attendees, a book, entitled *Rediscoursing African Womanhood in the Search for Sustainable Renaissance: Africana Womanism in Multi-Disciplinary Approaches* (2012), and an Africana Womanism graduate program at the University

of Zimbabwe ensued. The topics for debate include issues addressing not only the need for an Africana Womanism discipline and program in the academy, but more specifically, for putting forth demands for ending de-womanization, de-feminization and de-humanization via self-naming, self-definition and genuine sisterhood, which became the subject of the opening chapter of the book publication. Moreover, the presenters discussed issues surrounding the educational system in general, the silencing of women in trade negotiations, the woman in face of health problems for her family, and much more. Thus, as stated in the book's Foreword, a global dialogue on Africana Womanism was at last taking place wherein together, men and women alike, were

> advancing to a higher plateau, the relativity of an important all-inclusive paradigm considering crucial global issues on all fronts ... actively engaging in the urgent struggle for human survival against the odds of race, class and gender oppression, the cornerstone for prioritization for Africana Womanism.
>
> *(Hudson-Weems, Foreword xvii)*

In naming, defining and refining a positive and workable paradigm for the Africana family, which establishes an authentic tool of analysis, realistically relative to who we are and how we go about our everyday lives as an integral part of the family and society, Africana Womanism demonstrates our brave, passionate and resolute mission and commitment to the legacy of Africana survival in particular, and human survival in general. It objectively comments on the relativity of our complex world, complicated by not only oppression on all fronts, but by the ongoing questions and challenges of twenty-first-century modernity. As we operate within a multi-leveled, multi-dimensional structure, we necessarily must create our own paradigms and tools of analysis, structured around our own set of priorities for ultimate existence if we hope to maintain and improve upon life as it currently exists. It is a serious mission for a serious matter: our children, our future generations. According to Muwati et al. in the book's Introduction:

> Because of the value of womanhood in Africa's development, women's activism and struggles need to be part of the broader effort to rid society of all injustices. Indeed, women need to broaden their struggles to go beyond female–centeredness and embrace, for example, a gender and family-centered perspective that tackles the human rights of the entire family. [A MAN!] Examples in Zimbabwe today include Women of Zimbabwe Arise (WOZA) and the recent family-centered struggles by the spouses of National Railways of Zimbabwe (NRZ) who protested against their husbands' employer's failure to pay them salaries on time. Viewed from the perspective of its strategic value, as championed in Africana Womanist thinking, African womanhood can become a potent resource in Africa's quest for liberation.
>
> *(xvii)*

And the use of Africana Womanism continues, as a foundational structure, a template upon which to erect positive models of successes on all levels, including economic improvements, as well as overall improved human relations and relationships.

Let us pause for an exemplar right here on the continent of Africa, the largest and richest continent in the world, although it ostensibly exudes the polar opposite in terms of finances and poverty. In addressing the issue of resolving the abject living conditions in some parts of the continent of Africa, Angela Cowser and Sandra I. Barnes, in a 2016 article appearing in the *Journal of Namibian Studies*, entitled "From Shack Dweller to Home Owner: The Power of the MBOP, Africana Womanism, and Self-Help Housing among the Shack Dwellers Federation of Namibia," share how the women in their particular area practiced and applied the tenets of Africana Womanism in their everyday lives, which made a significant change in their personal financial lives. The article explores how Hudson-Weems' Africana Womanism, a family-centered paradigm, played a major role in aiding the Shack Dwellers Federation of Namibia (SDFN), with the assistance of the Self-Help Housing and the Federation membership, ultimately bringing their goals to fruition. The defining attributes of African Womanism was said to have been behind their ultimate success, radically changing their status via developing leaders, thereby, converting shack dwellers into homeowners. The article highlights the basic characteristics of Africana Womanism, actively embraced by these women who emerged as role models. And I thank God for the vision.

One cannot underplay the fact that the very foundation of the Africana-Melanated Womanism paradigm and movement is the primacy of the family and the collective struggle of our men and women together for the future of our children. They are, indeed, the heirs of our rich Africana legacy, a family-centered, strong, authentic, God-loving existence, wherein all are committed to each other in the struggle for human parity, dignity and survival. It is, therefore, my sincere hope that the understanding and appreciation of the plight of the oppressed, an enlightenment needed to be experienced by all humankind (Black, white, red, and yellow), would ultimately bring about total human empathy among all. To be sure, the dominant culture would then be more appreciative of and sensitive to the true dilemma of others as shared by the insiders from an authentic Africana-Melanated perspective. Moreover, the oppressed, too, would be more informed, as they would be even more aware of the depths and/or roots of their oppression and could collectively come to a consensus as to what should be done to bring this abject existence to an immediate halt. God moves swiftly and once we know the whole story, we can more expediently move toward correcting the flaws and loop-holes. Finally, it is my desire that a welcoming open dialogue continues, as the total dismantling and removal of non-productive, discriminatory myths about the lives of other cultures are finalized. Ultimately this would represent a powerful emerging epiphany, for the realization of the intertwined destinies of all would be evident, facilitating a much-needed resolution. Indeed,

one can expect and enjoy the fruition of the vast boundless benefits of true human empathy as a prerequisite for ultimate victory for all.

In conclusion, the poem I wrote in 2009, dedicated to all Africana-Melanated people, says it all, particularly in respect of our prioritization of race, class and gender: "Africana-Melanated Womanism: I Got Your Back, Boo":

> Don't you know by now, girl, we're all in it together;
> Family-Centrality—that's it; we're going nowhere without the other.
> That means the men, the women, and children, too,
> Truly collectively working—"I got your back, Boo."
>
> Racism means the violation of our constitutional rights,
> Which can create on-going legal and even physical fights.
> This 1st priority for humankind is doing what it must do,
> Echoing our 1st lady, Michelle, "I got your back, Boo."
>
> Classism is the hoarding of financial privileges,
> Privileges we must all have now in pursuit of happiness.
> Without a piece of the financial pie, we're doomed to have a coup,
> Remember, each must protect the other—"I got your back, Boo."
>
> Sexism, the final abominable sin of female subjugation,
> Is a battle we must wage right now to restore our family relation.
> All forms of sin inevitably fall under one of these three offenses;
> Africana Womanism—"I got your back, Boo"—corrects
> our common senses.

Clenora Hudson-Weems, Ph.D.

Written/dedicated to all Africana-Melanated people, 2009

13

AFRICANA-MELANATED WOMANISM AND THE KING-PARKS-TILL CONNECTION

> For liberation to become a reality, and not just a mere goal, the next gen-
> eration of Africana scholars will require the varied [Africana] tools offered
> in this book ... to genuinely represent and empower African descended
> peoples, in terms of Academic excellence and social responsibility.
>
> *(M. Christian 463–464)*

The above quotation by Mark Christian frames the proper parameters wherein
resides true scholarship and activism, "social responsibility," which together cor-
roborate a fight to end the long-existing battle against racial dominance. Here we
witness a demonstration of how Africana Womanism advances itself and fits into
ideals expressed in the lives of major iconic historical figures, such as Dr. Martin
Luther King, Jr. and Rosa Parks, as well as Emmett Till, particularly as they repre-
sent those in defining incidents of great socio-political significance. Thus, we have
Africana Womanism and the King, Parks and Till connection, which specifically
addresses the subject of the civil rights of Blacks. This chapter details the political
debates surrounding burning controversial issues on not only the true inception
of the Civil Rights Movement, which at last has been proven to be the August 28,
1955 brutal lynching of a fourteen-year-old Black Chicago youth, Emmett Louis
"Bobo" Till, but more important, on the fact that it was a powerful movement
made possible by the participation of all in a concerted effort to remove many of
the legal shackles of racism, indeed, an Africana Womanist priority.

To begin with, like the previous chapters, which contribute to the history,
the *raison d'être* and the extended definition of a concept relative to the canon
of literature and literary criticism as a genre, this culminating chapter serves
as a necessary part of the overall narrative to explain the obvious political dy-
namics of the paradigm itself. Indeed, while this authentic paradigm facilitates a
workable tool of analysis for the interpretation of Africana literary texts, it also

facilitates its applicability to historical defining moments, such as the Civil Rights Movement of the searing 1950s and the 1960s. Hence, discussed here is one of the most noted movements in twentieth-century American history, the modern Civil [and Human] Rights Movement of the 1950s and the 1960s, a movement that commanded the participation of all—men, women and children. Moreover, it is an excellent representation of how "strides toward freedom," as Dr. King expounded upon in his book of that title, on the part of African-Americans, can be successfully orchestrated via inclusivity. Highlighted specifically here is the role of the Africana woman in the movement, who, together with her male counterpart and the whole family, was able to forge a way for our future generations.

A key cornerstone of the modern Civil Rights Movement of the 1950s and the 1960s, under the leadership of Dr. Martin Luther King Jr., the father of the movement, is the collectivity of the struggle—men, women and children, wherein the masses come together in their fight against racism. It was a national movement, a powerful one that galvanized people throughout the nation, North, South, East and West, Black and White, men, women and children, all determined to eradicate the abominable monster that had divided our country for centuries. However, that national Civil Rights Movement witnessed an evolution—from civil rights to human rights, from domestic issues to global concerns.

A few months before Dr. King's assassination on April 4, 1968 in Memphis, Tennessee, he introduced his final speeches in a collection called "The Canadian Massey Lecture Series." In these powerful speeches, Dr. King bravely spoke out against the Vietnam War, the interlocutory destiny of people worldwide, and finally economic parity, the last one being probably the most threatening to the establishment as we knew it. In his 1963 "I Have a Dream" speech in Washington, D.C. "Dr. King expressed the critical need for all of us to be fairly judged and not discriminated against on the basis of race or color, but rather on the basis of our character and heart" (Hudson-Weems, *Emmett* 68). Indeed, his audience and his subject were limited; however, it was not long before his political evolution became apparent:

> King moved on to the issue of international uprisings worldwide, including Africa and the United States, with demonstrators demanding their freedom. He comments on the commonality of the concerns of Blacks all over the world and concludes that it is rooted in economic disparity, which breeds world poverty. Further, King cautions that if this problem is not [properly] addressed, the world at large will ultimately be doomed. His strategy for bringing this focus to the forefront is via economic withdrawal, a collective refusal of individuals to participate in economic support.
>
> *(Hudson-Weems, Emmett 68)*

Unquestionably Dr. King was shifting to another plateau, from the domestic to the global concerns of the world and his people in particular. While integration

was a key concern in America during that earlier period for King, touching the lives of people all over the world was another reality, one that had promises of rocking the nation's system to which we had become accustomed. Needless to say, the need for a change had come, for domestic concerns exclusively, civil rights that is, were no more, and as we must know, we can never expect to get on to the floor of the United Nations, which is a powerful body that rules on global concerns, with a civil rights agenda. Indeed, as Malcolm had so poignantly warned us, our unjust and life-threatening circumstances would never reach worldwide resolutions which, were we given that opportunity, could possibly alter our Black world, at least to some degree.

But allow me to first interject this fact for a moment relative to King, Parks and Till. In the 1988 dissertation-turned-book, *Emmett Till: The Sacrificial Lamb of the Civil Rights Movement* (1994), it was noted that:

> We cannot adequately reflect on Rev. Dr. King, Jr., the symbol [Father] of the Movement, without reflecting on the established Mother of the Movement, Mrs. Rosa Parks. She heroically refused to relinquish her bus seat to a white man on December 1, 1955, which was the seed for the year-long 1956 Montgomery bus boycott. And likewise, we cannot adequately reflect on the Montgomery bus boycott without reflecting on and remembering the infamous lynching of Till, permanently etched in the American consciousness, could not die, thereby setting the stage for the boycott.
>
> *(xxxiv)*

Needless to say, Emmett Louis Till was the child of the movement, and hence, what we have is a TRILOGY of a sort. Clearly people responded without hesitation to the victimization of a child, Emmett in this instance. The child was the heart of the matter, for many Blacks had been sacrificed for racist ends; however, it becomes another whole story when one talks about the victimization of a child, especially for the simple act of whistling at a White woman, twenty-one-year-old Carolyn Bryant of Money, Mississippi.

Rosa Parks' demonstration, only three months and three days after Emmett's brutal murder on August 28, 1955, was unanimously established as the catalyst of the movement; however, as suggested, there was clearly something beneath the surface. No doubt, "Because Till's bloated face was the embodiment of the ugliness of American racism, America found the need and desire to attach itself to a more palatable incident" (*Emmett Till* xxxiv). Decades later, a 1988 Ford doctoral dissertation, entitled "Emmett Till: The Impetus of the Modern Civil Rights Movement," firmly challenged historians. Dr. John Blassingame of Yale University later admitted in the 1994 subsequent book jacket endorsement that "When you really think about it, Hudson-Weems is absolutely right. We historians missed it." Indeed, changing the catalyst of the movement from Parks to Till

was neither an easy nor desirable task. According to Dr. C. Eric Lincoln of Duke University, in the 1994 book jacket blurb, Hudson-Weems

> challenges the most sacred shibboleths of the origins of the Civil Rights Movement. Not everyone will want to agree with what she has to say. But few will lay the book down before she has had her say. And she says a lot America needs to hear again right now.

Moreover, while Parks' demonstration led to the 1956 year-long Montgomery bus boycott, Till's murder set the stage for it. When asked why she did not go to the back of the bus when demanded so, she admitted, "I thought about Emmett and I couldn't go back." Dr. King, too, alluded to the significance of Till to the movement in his book *Stride Toward Freedom*, contending that pressed in the minds of the Alabamans was the image of Emmett Till. Indeed, the three, along with the support and participation of the national community, bravely forged a movement of all times, changing the world forever via continuous challenges and resistance to laws and practices that sternly endorsed racial discrimination and injustices.

With that said, let us now reflect on the essence of Rosa Parks, a strong Black woman, a wife and the mother of many in her role as protector and nurturer of our culture. She is the embodiment of the Africana-Melanated woman, one who is family-centered, not female-centered, who embraces race empowerment before female empowerment, and who strives for racial equity first, rather than gender exclusivity, as Africana Womanism posture. The authentic global paradigm for Africana-Melanated women stared out in the mid-1980s as a national concept, much like King with the Civil Rights Movement, which started out with a national focus, then evolved to an international focus on human rights. Within six short years, it, too, evolved to a global concept, and thus, is very appropriate for the consideration of the role of women in the global struggle for human survival, offering eighteen distinct characteristics of the Africana womanist, all of which to some degree are in operation in our everyday lives. The Africana womanist is Self-Namer, Self-Definer, Family-Centered, Genuine in Sisterhood, Strong, In Concert with Male in the Liberation Struggle, Whole, Authentic, Flexible Role Player, Respected, Recognized, Spiritual, Male Compatible, Respectful of Elders, Adaptable, Ambitious, Nurturing and Mothering. Needless to say, in naming and refining a paradigm relative to who we are and how we go about coping with issues in our everyday lives, Africana Womanism, then, justifiably initiates an excellent theoretical construct for clarity and explication.

A case for a twenty-first-century modernization of the Civil Rights Movement can be possibly gleamed from a cursory consideration of the film *Black Panther*, although it is really not a "Black movie," which many assume it to be based upon the dominance of Black characters, etc. One thing in particular that the film did was to dispel the myth of the inadequacy of "Black movies" in generating large monetary returns as investments. The recent worldwide release grossed

within weeks into the billions, although the greatest financial benefactors were Whites. Yet, there is still this semblance of Black success, despite some short-comings largely due to the lack of a global conscious Black community. Unlike the legendary Civil Rights Movement in the United States, with Blacks in an actual struggle against racism and harsh discrimination, this film was situated in a fictionalized, imaginary land, and it consciously evokes, for some for obvious reasons, the revolutionary struggle of the searing 1960s relative to the Black Panther Party, historically situated in the midst the celebrated movement. Both the movement and the movie echo the struggles of a particular people in a particular land, engaging in a particular battle of fierce opposition to varied forces, thus, waging war against their particular missions and aspirations. In highlighting the role of the woman in particular, a very important constituent of that group, we see that she is that community of women, resolute and committed to the ultimate survival of the land and all its people via her relentless protective nature of mothers, wives and sisters. They represent the spirit of women dating back to strong Black women in antiquity, such as

> the powerful Queen Nzingha (1583–1663) of Matamba, West Africa. Nzingha, a powerful role model, demonstrate unquestionable persistence as an astute military strategist who fearlessly led her army of brave women warriors against Portuguese domination for forty years ... In the nineteenth century, we witness Queen Mother Yaa Asantewa of Ejisu, Ghana, who bravely led the Ashanti people against the British colonialist in the Yaa Asantewa War.
>
> *(Hudson-Weems, Africana Womanist Literary Theory 51–52)*

This is the Black woman, past and present, in concert with her male counterpart in the quest for ultimate humanity for all.

Because of the prominence of women in the Civil Rights Movement, Rosa Parks being a prime example of others like Mamie Till Mobley, Fannie Lou Hammer and Ella Baker, Africana Womanism is, indeed, appropriate for expounding on the role of women in the ongoing struggle for human rights. A family-centered construct, it represents the collective struggle of men, women and children, whose primary goal is to bring to fruition joy and security via total equity for all. Thus, committed to a harmonious world, the family represents the making of a just society, bearing out the promise of the American Dream for all via respect for the birthright of all—"life, liberty and the pursuit of happiness." Summarizing the spirit of a collective struggle, with men, women and children in it together, is the poem, "Africana Womanism: I Got Your Back, Boo," written and dedicated to all Africana-Melanated women, which demonstrates that the legacy continues. Moreover, specifically representing the struggle of yesterday in the Civil Rights Movement of the 1950s and the 1960s, and the many struggles we witness today, including the Africana Womanism Movement, and tomorrow, we vow to never cease until the mission is accomplished.

In closing, as a testimony of the ongoing quest of Africana people for solutions for eradicating racial dominance worldwide, a mission which Dr. Martin Luther King, too, sought to realize during his brief life on this earth, let us consider the very *raison d'être* of the upcoming 2nd International Africana-Melanated Womanism Conference (University of Zimbabwe, October 2019) reflected in the announcement below. Hosted again by the University of Zimbabwe and coordinated by Dr. Itia Muhwati, Dean of Faculty, it is evident that our presence and goals are, indeed, global, and moreover, that the international conference demonstrates how we collectively address the critical issues within the established historical, cultural, social, political and economic structures, insisting upon a truly egalitarian solution for the pursuit of a just existence for all humankind:

2nd International Africana-Melanated Womanism Conference: U of Zimbabwe (UZ)—POSTPONED

"Africana-Melanated Womanism: In It Together for Human Survival"

UNIVERSITY OF ZIMBABWE
MT PLEASANT HARARE

CALL FOR CONFERENCE PAPERS

The Council of Africana Womanism (UZ Chapter) is inviting all interested academics, members of the community, policy makers and cultural practitioners to submit abstracts between 250–300 words on the above theme for its 2nd International Africana-Melanated Womanism Conf. to be hosted this year at the U. of Zimbabwe in Harare. Papers should be related to the theme. The deadline for submission of ABSTRACTS is 27th SEPT, 2018. Provide your name and title, email address and institutional affiliation; mail to africanlangs@arts. uz.ac.zw or itaimuhwati@gmail.com (Dr. Itia Muhwati, Dean of Faculty, Conf. Coordinator)

KEYNOTE ADDRESS—"AFRICANA-MELANATED WOMANISM: FORGING OUR WAY COLLECTIVELY—IN IT TOGETHER"—Clenora Hudson-Weems, PhD

ABSTRACT—"From Africana Womanism to Africana-Melanated Womanism"

The first African America woman intellectual to formulate a position on Africana Womanism was Clenora Hudson-Weems, author of the 1993 groundbreaking study, *Africana Womanism: Reclaiming Ourselves*. Taking

the strong position that black women should not pattern their liberation after Eurocentric feminism but after the historic and triumphant woman of African descent, Hudson-Weems has launched a new critical discourse in the Black Women's Literary Movement.

(Hill, general editor, *Call and Response: The Riverside Anthology of the African American Literary Tradition* p. 1811)

For 3 decades, Africana Womanism has been operating from a family-centered position within a global cross-cultural and multi-disciplinary context, appropriately prioritizing race, class, gender.

Appearing in *The Western Journal of Black Studies* in 1989, "Cultural and Agenda Conflicts in Academia: Critical Issues for Africana Women's Studies" was the 1st call for Africana Women to name (*Nommo*) and define themselves. *Africana Womanism: Reclaiming Ourselves* (1993) and *Africana Womanist Literary Theory* (2004) followed. Today, the term has evolved to Africana-Melanated Womanism, for many of diverse ethnicities, rooted in blackness, have found the theory more compatible with their level of existence. The 18 characteristics are as follows:

Self-Namer, Self-Definer, Family Centered, Genuine in Sisterhood, Strong, In Concert with Male in Struggle, Whole, Authentic, Flexible Role Player, Respected, Recognized, Spiritual, Male Compatible, Respectful of Elders, Adaptable, Ambitious, Nurturing and Mothering.

(*AW*, 55–73)

In the 2004 book Jacket Endorsement of *Africana Womanist Literary Theory*, Dr. Adele S.

Newson-Horst proclaims the following:

Clenora Hudson-Weens' work provides a theoretical construct that boldly restores meaning within historical and cultural contexts that are peculiar to the African and African Diasporic woman's experiences. It offers an element historically denied such women: a choice. Moreover, her application of the Africana Womanist theory to Black life and literary texts proves to be both accurate and useful as we search for appropriate theories and methodology for Africana writers.

International scholar and founder of the first African American holiday, *Kwanzaa*, Dr. Maulana Karenga, stated in *The International Journal of Black Studies*, that Hudson-Weems is, in fact, "the founding theorist of Africana womanism [and] holds a central place in contributing to the discourse on African-centered Womanism within Black Studies and the National Council for Black Studies" (32). Expounding on the significance of the term and

the concept, Afrocentric scholar, Dr. Ama Mazama, says "the term Africana Womanist itself is the first step toward defining ourselves in setting goals that are consistent with our culture and history. In other words, it is the 1st step toward existing on our own terms." (400–1). Editors, Dr. Itia Muwati, et al. of *Rediscoursing African Womanhood: Africana Womanism in Multi-disciplinary Approaches,* notes "Africana Womanism liberates the enslaved and distorted African cultural space and draws pedagogically nourishing perspectives on African womanhood and gender that can be utilized by people of African descent in attempts to deal with challenges affecting their existence" (xvii).

Dr. Delores P. Aldridge, Grace T. Hamilton Professor Emerita and Chair of Africana Studies at Emory U, asserts the following in the Foreword to *Africana Womanist Literary Theory*:

> It provides an extensive and thorough understanding of the concepts, *nommo*/self-naming and self-defining ... The work takes to task those who have ignored, distorted, or misappropriated all or parts of the theory that she has articulated.
>
> (xii)

In the Afterword, Dr. Molefi Kete Asante, the conceptualizer of Afrocentricity, contends that

> Africana Womanism is a response to the need for collective definition and the re-creation of the authentic agenda that is the birthright of every living person. In order to make this shift to authenticity, Hudson-Weems has called us back to the earliest days of African cultural history. In this antiquity she has discovered the sources of so much commonality in the African world that there is no question that Africana womanism has a distinct and different approach to relationships [with their male counterparts] than, say, feminism.
>
> (Asante, 138)

14
CONCLUSION

> Hudson-Weems' Africana Womanism sent unaccustomed shock waves through the domain of popular thinking about feminism and established her as a careful, independent thinker, unafraid to unsettle settled opinion.
>
> *(Lincoln, book endorsement for Africana Womanism)*

Distinguished professor, the late Dr. C. Eric Lincoln of Duke University, offered the above 1993 book endorsement of the first Africana Womanism book, acknowledging that the work offered new bold insights into Black interpretations. Even before that publication, I, much like my mentor, the late Dr. Richard K. Barksdale, realized that it may be necessary at times to create new methodologies in analyzing Black texts, which may very well be the polar opposite of existing norms and shibboleths regarding the literary canon. Thus, in putting forth paralleling constructs, my 1986 article, "Toni Morrison's World of Topsy-Turveydom: A Methodological Explication of New Black Literary Criticism," offered such a strategy for a more accurate, authentic analysis of Black texts:

> In the Black world of topsy-turveydom (in which codes, values, and standards are [often] the polar opposite, the upside-down perspective of those set forth and accepted by the dominant culture), the unaccepted becomes accepted, the unexpected, expected, spirits live.
>
> *(Hudson-Withers 132)*

And so we have it, an analytical book of critical thought, perceptively imbued with an authentic theoretical paradigm, Africana-Melanated Womanism, created and designed for the ultimate existence and survival of all Africana-Melanated people worldwide. Although now a legitimate paradigm globally, which continue to stand headstrong and resolute in upholding the place of Africana-Melanated Womanists in the face of racist adversity, we must continue to highlight the needs for our own in

the global battle for humanity. To be sure, past and continuing debates that challenge its very need for existence, command that we remain ever vigilant in the acknowledgment of a concept that at last affords us a choice as Newson-Horst observes. With an authentic paradigm that answers to our particular needs as we strive toward realizing total equality and the life goals of Africana-Melanated people, we now observe a truly authentic existence and interpretations made possible via our lived and learned experiences.

Africana-Melanated Womanism strongly represents an historical legacy, firmly rooted in Black life. While theoretically expounding on its relativity to Black life, it also explains how it differs from all other female-based theories, such as feminism, Black feminism, Womanism and African feminism, "grounded in African culture ... [which] focuses on the unique experiences, struggles, needs, and desires of Africana women" (Hudson-Weems, *Africana Womanism* 24)

With this clarification, the authentic Africana-Melanated womanist, and her role in the life of her family, ultimately makes possibly a profound sense of respect and empathy from others for one's fellow human being, indeed, a powerful experience that far exceeds mere sympathy. To be sure, having a choice is, indeed, empowering, a cornerstone goal in any theory for women of any color. Africana-Melanated Womanism, then, prohibits us from having to choose among options that unfortunately do not meet the demands, concerns and priorities of our people worldwide, which is the continuous pursuit of our God-given birthright as a people—freedom, security and happiness. An Africana continuum, the theory strategically takes us back in history to discover true meanings in and resolutions to the lives of a people too often mistreated, too often misunderstood. An intriguing journey into the Africana world of men, women and children, who together continue the rich legacy of God's gift of life for all, is herein upon us, offering thought, commitment and political action for total human survival. As we comb through life's maze of joys and disappointments, be we ever mindful of not only "the politics of survival," as my mentor, Richard K. Barsksdale, reminds us, but moreover, the presence and power of God.

In conclusion, Africana Womanism, and by extension Africana-Melanated Womanism, is a wonderful global concept that brings all together—men, women, children; diversity in ethnic origins; all class levels, etc. This is something that we can truly appreciate as we review our history and the many experiences that we share with each other in our voyage to victory, all the way up to where we are today. Granted, we need to know our historical beginnings, but we also need to advance with the times in order to come out on top, realizing ultimately that we are all "in it together." This comes from the lessons we learn from our mistakes of the past—SANKOFA. Hence, Africana-Melanated Womanism can facilitate us in ways that we may not have been able to heretofore imagine. Its definition forces us to focus, thereby bringing clarity to our true mission in life as collective participants in making the world a better place. In short, practicing the concept demonstrates its applicability as a means by which we harmoniously work together for total parity and justice for all. The time is now! It is justice for all if we really expect to live our lives in peace and harmony.

AFTERWORD

Mark Christian

It is with great pleasure that I accept this offer to write the Afterword for Clenora Hudson-Weems' new edition of the acclaimed *Africana Womanism: Reclaiming Ourselves*. Indeed, in this age of rampant Black feminism that often harms communities of Africana heritage, her work is worthy antidote to the false promises offered in the various feminist perspectives. Most reasonable women and men know that we cannot survive unless we care for each other on an equitable basis. In academia Black feminists are usually allied with White feminists who generally do not share the best interest of Africana communities, as their concerns as White women are almost always directed at their particular needs surrounding sexism.

The current academic fad phrase is "intersectionality" as if those of us in Africana discourse never considered the myriad of issues encountered by our communities. "Race," class and gender, and the prioritization therein, have always been key issues for comprehending *Africana Womanism*. This by no means weakens the analysis of empowerment for Africana women, for it actually strengthens the analysis away from dividing Africana women from their men, whether it be spouses, brothers, nephews, cousins, uncles, fathers, and so on. We need *Africana Womanism* more than ever because the insidious divide and conquer tactics found in many female-based constructs is playing a key role in the demise of Africana communities. All things stated, the Africana world is under tremendous assault. We need to take firm responsibility for this, and that means individual and collective, men and women. Clenora Hudson-Weems pulls no punches. She is more than astute to the fact that women are at the center of most things in the Africana world. However, there is no need to denigrate and weaken further the overall spirit of Black men. Let us all find a common respect that allows women to be whatever they want to be in relation to aiding the collective advancement of their aspirations, which includes continuing to advance

their male counterpart in a manner conducive to the development of the entire Africana world.

Too often many Black feminists create a chasm that is rarely overcome, and too often we find ourselves ignoring the implicit misandry in the analysis, while they challenge misogyny as a given in all areas of the social world. Sexism exists, has existed, and while men and women interact, may continue to do so, as other forms of social discrimination will. There is no blinkered perspective being offered by Dr. Hudson-Weems. She is well aware of the sexism that can hold women back, but she does not destroy men while empowering women to overthrow it. She builds her community via a cultural paradigm that allows self-actualization and agency for both women and men. To suggest that her vision is conservative or male-centered is preposterous, for when Africana women reclaim themselves in reading this book, there is no denying of the power of women, the intellectual of women, and their collective wisdom for creating a holistic healthy Africana world.

What Dr. Hudson-Weems does not do, like a thousand and one "Diversity" programs have endeavored to do over the last forty years, is detract from the reality of racialization and the varied ways it has encumbered the Africana world. Nor does she play "identity politics" in a superficial sense. She simply identifies the problem of the Africana woman's necessity to improve herself for the benefit of her community. There are many social and cultural problems that we face in the Africana world, as Amilcar Cabral states in *Return to the Source*:

> History teaches us that, in certain circumstances, it is very easy for the foreigner to impose his domination on a people. But it also teaches us that, it can be maintained only by the permanent, organized repression of the cultural life of the people concerned. Implantation of foreign domination can be assured definitively only by physical liquidation of a significant part of the dominated population.
>
> *(39)*

When put to the acid test, Dr. Hudson-Weems' *Africana Womanism* is an imperative for reclaiming what may have been lost, stolen, or denied through the centuries of enslavement, colonialism, imperialism, and other forms of racialized hierarchical structures. Indeed, Africana women have played a significant role in the liberation struggle that is ongoing. Needless to say, however, something needs to be done about the runaway Black feminists, who want to see their men down and disempowered. Black feminists, who want to make alliances with all sundry but Africana men, speak of intersectionality as if it is a new phenomenon. Who speaks of Malcolm X as if he were a sexist, missing his statements that a society can only rise as much as the woman in it, and that you can only accurately measure the success of a given society by how its women are treated? In a 1993 article by Hudson-Weems, appearing in a Special Issue on Malcolm for *The Western Journal of Black Studies*, for which she served as guest editor, she

both acknowledges and endorses this sentiment. However, the Black feminists in general are selective when it comes to empowering the Africana world, thereby excluding the positive acts of Black men in this respect. Indeed, most among this group would not perceive there being an Africana world that would not be "intersectional" enough in today's academic surroundings. It is rather disconcerting the way much of Black feminism reveals little in way of bringing positive forecasts in relation to men and women relations.

Not so for *Africana Womanism*. In contrast to Black feminism, there is a call for unity among men and women. There is a need for gaining holistic health, wealth, and education that speaks to the needs of community and self-worth as men and women working in tandem to transform places of despair to beacons of salubrious and mutual giving. When Ida B. Wells-Barnett (1862–1931) lived, she existed as a woman who loved her community and wanted an end to the horrors of lynching that predominantly impacted the men of African heritage. The point here is that Ida was a powerful Africana woman in the sense that Dr. Hudson-Weems portrays. She was courageous, self-defining, and self-determined in her crusade for social justice. As a young African American journalist, she met with Frederick Douglass (1818–1895) in his home, and she admired his legacy. She would go on to fight lynching by lecturing abroad in places like Liverpool, England, my birthplace. She is the personification of the Africana woman who does not allow sexism to devour her love of men, yet she will take not one ounce of disrespect. We need more Idas and we certainly need the new edition of *Africana Womanism*, and what we do not need is the myopic Black feminism that abounds currently in academia, too numerous to recount here. Crucially, when reading the new edition of *Africana Womanism,* one can feel the spirit of Ida B. Wells-Barnett emanating from the pages to give strength to both men and women in their continued quest for social justice and peace in their many communities across the world.

Mark Christian, Ph.D.—Chair and Professor, Department of Africana Studies, Lehman College, City University of New York; author of *Black Identity in the 20th Century: Expressions of the US and UK African Diaspora*

FIGURE A.1

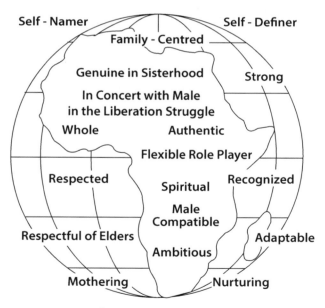

Self - Namer · Self - Definer
Family - Centred
Genuine in Sisterhood · Strong
In Concert with Male
in the Liberation Struggle
Whole · Authentic
Flexible Role Player
Respected · Recognized
Spiritual
Male
Compatible
Respectful of Elders · Adaptable
Ambitious
Mothering · Nurturing

from Africana Womanism

Clenora Hudson-Weems, Ph.D.

FIGURE A.2

BIBLIOGRAPHY

Acholonu, Rose. "Love and the Feminist Utopia in the African Novel." The International Conference on Women in Africa and the African Diaspora: Bridges Across Activism and the Academy at the University of Nigeria-Nsukka, July 1992.

Aidoo, Arna Ata. "Unwelcomed Pals and Decorative Slaves—Or Glimpses of Women as Writers and Characters in Contemporary African Literatures" in *Literature and Society: Selected Essays on African Literature*. Ernest Emenyonu, ed. Oguta, Nigeria: Zim Pan African Publishers, 1989, 1–19.

Ajai, Taiwo. "The Voluptuous Ideal" in *One Is Not a Woman, One Becomes: The African Woman in a Transitional Society*. Daphne Williams Ntiri, ed. Troy: Bedford, 1982, 77–87.

Aldridge, Delores. *Focusing: Black Male-Female Relationships*. Chicago: Third World, 1991.

Aldridge, Delores P. Foreword in *Africana Womanist Literary Theory*. Trenton: Africa World Press, 2004, xi–xiii.

Amadi, Elechi. *Ethic in Nigerian Culture*. Ibadan: Heinemann, 1982.

Aptheker, Bettina. "Strong Is What We Make Each Other: Unlearning Racism Within Women's Studies." *Women's Studies Quarterly*, 9:4 (Winter), 1981, 13–16.

Asante, Molefi K. *The Afrocentric Idea*. Philadelphia: Temple University Press, 1987.

Asante, Molefi Kete. Afterword in *Africana Womanist Literary Theory* by Clenora Hudson-Weems. Trenton: Africa World Press, 2004, 137–139.

Bâ, Mariama. *So Long a Letter*. Great Britain: Heinemann, 1989.

Barksdale, Richard K. "Critical Theory and the Problems of Canonicity in African American Literature" in *Praisesong for Survival: Lectures and Essays, 1957–1989*. Urbana: University of Illinois Press, 1995, 32–40.

Barksdale, Richard K. and Keneth Kinnamon, eds. *Black Writers of America: A Comprehensive Anthology*. New York: Macmillan, 1971.

Blassingame, John. Jacket Blurb, *Emmett Till: The Sacrificial Lamb of the Civil Rights Movement* by Clenora Hudson. Troy: Bedford, 1994.

Blassingame, John W. *The Slave Community: Plantation Life in the Antebellum South*. New York: Oxford University Press, 1979.

Blundell, Janet Boyarin. Book Review of *Disappearing Acts*. *Library Journal*, 114, July 1989, 109.

Bruce, Aubrey. A 2018 conversation with senior sports columnist (*New Pittsburgh Courier*) and co-organizer with his wife, Jennifer (now deceased), for the 1st National Africana Womanism Symposium, Pittsburgh, PA, Spring, 2009. Unpublished.

Cabral, Amilcar. *Return to the Source: Selected Speeches of Amilcar Cabral.* New York and London: Monthly Review Press, 1973.

Carby, Hazel V. *Reconstructing Womanhood: The Emergence of the Afro-American Woman Novelist.* New York: Oxford University Press, 1989.

Carroll, Peter N. and David W. Nobel. *The Free and the Unfree: A New History of the United States.* New York: Penguin Books, 1977.

Carruthers, Jacob. *Intellectual Warfare.* Chicago: Third World Press, 1999.

Christian, Barbara. *Black Feminist Criticism: Perspectives on Black Women Writers.* New York: Pergamon, 1985.

Christian, Mark. Afterword in *Contemporary Africana Theory, Thought and Action: A Guide to Africana Studies.* Trenton: Africa World Press, 2007, 463–465.

Clinton, Catherine. "Women Break New Ground" in *The Underside of American History,* Vol. 2. Thomas R. Fraizer, ed. New York: Harcourt Brace Jovanovich, 1987, 62–83.

Cowan, Connell and Melvyn Kinder. *Smart Women: Foolish Choices.* New York: Clarkson N. Potter, 1985.

Cowser, Angela and Sandra I. Barnes. "From Shack Dweller to Home Owner: The Power of the MBOP, Africana Womanism, and Self-Help Housing among the Shack Dwellers Federation of Namibia." *Journal of Namibian Studies,* 19, 2016, 15–41.

Crooks, Robert and Karla Baur. *Our Sexuality.* Redwood City: Benjamin-Cumming, 1990.

Davidson, Nicholas. *The Failure of Feminism.* Amherst: Prometheus Books, 1988.

Davis, Angela. *Women, Race and Class.* New York: Vintage, 1983.

Diop, Cheikh. *The Cultural Unity of Black Africa.* Chicago: Third World, 1978.

Du Bois, W.E.B. "Criteria of Negro Art" in *Call and Response: The Riverside Anthology of the African American Literary Tradition.* Patricia Liggins Hill et al., eds. Boston and New York: Houghton Mifflin, 1997, 850–855.

Du Bois, W.E.B. "Resolutions at Harper's Ferry, 1906" in *Black Writers of America: A Comprehensive Anthology.* Richard Barksdale and Keneth Kinnamon, eds. New York: Macmillan, 1972, 377–378.

Du Bois, W.E.B. *The Souls of Black Folk.* Greenwich, CT: Fawcette, 1961.

Evans, Sara. *Personal Politics: The Roots of Women's Liberation in the Civil Rights Movement and the New Left.* New York: Knopf, 1979.

Franklin, Clyde W., II. "Black Male-Black Female Conflict: Individually Caused and Culturally Nurtured" in *The Black Family: Essays and Studies.* Robert Staples, ed. Belmont: Wadsworth, 1986, 106–113.

Franklin, John Hope and Alfred A. Moss, Jr. *From Slavery to Freedom: A History of Negro Americans,* 6th ed. New York: McGraw-Hill, 1988.

Friedan, Betty. *The Feminine Mystique.* New York: Dell, 1963.

Gates, Henry Louis. *The Signifying Monkey: A Theory of AfroAmerican Literary Criticism.* New York: Oxford University Press, 1988.

Gerald, Carolyn F. "The Black Writer and His Role" in *The Black Aesthetics.* Gayle Addison, ed. New York: Doubleday, 1971, 349–356.

Giddings, Paula. *When and Where I Enter: The Impact of Black Women on Race and Sex in America.* New York: Bantam, 1984.

Gordon, Vivian. *Black Women, Feminism, and Black Liberation: Which Way?* Chicago: Third World Press, 1987.

Hall, Leland K. "Support Systems and Coping Patterns" in *Black Men.* Lawrence E. Gary, ed. Beverly Hills: Sage, 1981, 159–168.

Hare, Julia. "Feminism in Black and White." Quoted in *Black Issues in Higher Education*, by Mary-Christine Phillips. March 11, 1993, 12–17.

Harris, Robert. Book Endorsement in *Africana Womanism: Reclaiming Ourselves*. Troy: Bedford, 1993.

Harrison, Algea. "Attitudes Toward Procreation among Black Adults" in *Black Families*. Harriette Pipes McAdoo, ed. Beverly Hills and London: Sage, 1981, 199–208.

Harrison, Paul Carter. *The Drama of Nommo*. New York: Grove Press, 1972.

Hewlett, Sylvia Ann. *A Lesser Life*. New York: William Morrow, 1986.

Hill, Patricia Liggins, general editor. *Call and Response: The Riverside Anthology of the African American Literary Tradition*. Boston: Houghton Mifflin, 1997.

Hines, Darlene Clark, ed. *Black Women in United States History*. New York: Carlson, 1990.

hooks, bell. *Feminist Theory: From Margin to Center*. Boston: Southend, 1984.

Hudson, Clenora. *Emmett Till: The Sacrificial Lamb of the Civil Rights Movement*. Troy: Bedford Publishers, 1994.

Hudson-Weems, Clenora. "Africana Womanism: An Historical, Global Perspective for Women of African Descent" in *Call and Response: The Riverside of the African American Literary Tradition*. Boston: Houghton Mifflin, 1997, 1812–1815.

Hudson-Weems, Clenora. "Africana Womanism and the Critical Need for Africana Theory and Thought." *The Western Journal of Black Studies*, 21:2 (Summer) 1997, 79–84.

Hudson-Weems, Clenora. *Africana Womanism: Reclaiming Ourselves*. Troy: Bedford, 1993.

Hudson-Weems, Clenora. *Africana Womanist Literary Theory*. Trenton: Africa World Press, 2004.

Hudson-Weems, Clenora. *Contemporary Africana Theory, Thought and Action: A Guide to Africana Studies*. Trenton: Africa World Press, 2007.

Hudson-Weems, Clenora. "Cultural and Agenda Conflicts in Academia: Critical Issues for Africana Women's Studies." *The Western Journal of Black Studies* 13:4, 1989, 185–189.

Hudson-Weems, Clenora. *Emmett: Legacy, Redemption and Forgiveness*. Bloomington: AuthorHouse, 2014.

Hudson-Weems, Clenora. Foreword in *Rediscoursing African Womanhood in the Search for Sustainable Resistance: Africana Womanism in Multi-Disciplinary Approaches*. Harare: College Press, 2012, xii–xv.

Hudson-Weems, Cleonora. "The Tripartite Plight of African-American Women as Reflected in the Novels of Hurston and Walker." *Journal of Black Studies* 20:2, 1989, 192–207.

Hudson-Withers, Clenora. "Toni Morrison's World of Topsy-Turveydom: A Methodological Explication of New Black Literary Criticism." *The Western Journal of Black Studies* 10:3, 1986, 132–136.

Hurston, Zora Neale. *Their Eyes Were Watching God*. Urbana: University of Illinois Press, 1978.

Karenga, Maulana. "The National Council for Black Studies at Forty: Critical Remembrance, Reflection, and Reaffirmation." *The International Journal of Black Studies*, 17:1–2, 2016, 17–44.

King, Martin Luther King, Jr. *Stride Toward Freedom*. New York: Ballantine Books, 1958.

King, Martin Luther King, Jr. *The Canadian Massey Lecture Series*, 1967.

Klatch, Rebecca E. *Women of the New Right*. Philadelphia: Temple University Press, 1987.

Kristos, Kyle. *Voodoo*. Philadelphia: Lippincott, 1976.

Ladner, Joyce. *Tomorrow's Tomorrow: The Black Woman*. Garden City: Anchor, 1972.

LaRue, Linda. "The Black Movement and Women's Liberation" in *Female Psychology: The Emerging Self*. Sue Cox, ed. Chicago: SRA, 1976, 216–225.

Lewis, Ida. "Conversation: Ida Lewis and Eleanor Holmes Norton." *Essence*, July 1970.

Lincoln, C. Eric. Jacket Blurb, *Emmett Till: The Sacrificial Lamb of the Civil Rights Movement* by Clenora Hudson. Troy: Bedford, 1994.

Lincoln, C. Eric. Book Endorsement for *Africana Womanism: Reclaiming Ourselves*. Troy: Bedford Publishers, 1993.

Lorde, Audre. *Sister Outsider*. Freedom: Crossing Press, 1984.

Marshall, Paule. *Praisesong for the Widow*. New York: A. Dutton Belisk, 1984.

Marshall, Paule. "Reena" in *Black Eyed Susans*. Mary Helen Washington, ed. New York: Anchor, 1975.

Mazama, Ama. "The Afrocentric Paradigm: Contours and Definition." *Journal of Black Studies* 31:4, 2001, 387–405.

Mbalia, Doreatha Drummond. *Toni Morrison's Developing Class Consciousness*. Selinsgrove: Susquehanna University Press, 1991.

McMillan, Terry. *Disappearing Acts*. New York: Viking, 1989.

McMillan, Terry. "Hers," *New York Times*. October 15, 1987.

Mompati, Ruth. "Women and Life Under Apartheid" in *One is Not a Woman, One Becomes: The African Woman in a Transitional Society*. Daphne Williams Ntiri, ed. Troy: Bedford, 1982, 108–113.

Morrison, Toni. *Beloved*. New York: Alfred A. Knopf, 1987.

Morrison, Toni. *The Bluest Eye*. New York: Holt, Rinehart, & Winston, 1970.

Morrison, Toni. "What the Black Woman Thinks About Women's Lib." *New York Times Magazine*, August 1971.

Muwati, Itia, Zifikile Mguni, Tavengwa Gwekwerere and Ruby Magosvongwe. *Rediscoursing African Womanhood in the Search for Sustainable Renaissance: Africana Womanism in Multi-Disciplinary Approaches*. Harare, Zimbabwe: College Press, 2012.

Newson-Horst, Adele S. Book Jacket Blurb for *Africana Womanist Literary Theory*. Trenton: Africa World Press, 2004.

Newson-Horst, Adele S. "*Mama Day*: An Africana Womanist Reading" in *Contemporary Africana Theory, Thought and Action: A Guide to Africana Studies*. Trenton: Africa World Press, 2007, 359–372.

Nigosian, S.A. *World Faiths*. New York: St. Martin's, 1990.

NOW Statement of Purpose. Washington, D.C. October 19, 1966.

Ntiri, Daphne. Introduction in *Africana Womanism: Reclaiming Ourselves*. Troy: Bedford Publishers, 1993, 1–13.

Ntiri, Daphne Williams. "Africana Womanism: The Coming of Age" in *Contemporary Africana Theory, Thought and Action: A Guide to Africana Studies*, Trenton: Africa World Press, 2007, 309–318.

Ntiri, Daphne Williams, ed. *One is Not a Woman, One Becomes: The African Woman in a Transitional Society*. Troy: Bedford, 1982.

Oyewumi, Oyeronke, "Multiculturalism or Multibodism: On the Impossible Intersections of Race and Gender in American White Feminist and Black Nationalist Discourses." *The Western Journal of Black Studies*, 23:3 (Fall), 1999, 182–189.

Ravell-Pinto, Thelma. "Buchi Emecheta at Spelman College." *Sage*, 2:1, 1985, 50–51.

Roberts, Pepe. "Feminism in Africa: Feminism and Africa." *Review of African Political Economy*, 27/28, 1984, 175–184.

Samuels, Wilfred D. and Clenora Hudson-Weems. *Toni Morrison*. Boston: Twayne, 1990.

Sandiforth, Keith A. "Paule Marshall's *Praisesong for the Widow*: The Reluctant Heiress." *Black American Literature Forum*, 20 (Winter), 1986, 372–390.

Scrapa, Giulia. "'Couldn't They Have Done Differently?' Caught in the Web of Race, Gender and Class: Paule Marshall's *Praisesong for the Widow*." *World Literature Written in English*, 29, 1989, 94–104.

Senghor, Leopold Sedar. *Negritude et Civilisation de l'Universel*. Paris: Seuil, 1977.

Sofola, 'Zulu. "Feminism and the Psyche of African Womanhood," presented at the International Conference on Women of Africa and the African Diaspora: Bridges Across Activism and the Academy. University of Nigeria-Nsukka, July 1992.

Sofola, 'Zulu. Foreword in *Africana Womanism: Reclaiming Ourselves*. Troy: Bedford Publishers, xvii–xviii.

Staples, Robert. *Black Masculinity: The Black Male's Role in American Society*. San Francisco: Black Scholar, 1982.

Steady, Filomina Chioma, ed. *The Black Woman Cross-Culturally*. Rochester: Schenkman Books, 1981.

Steady, Filomina Chioma. "African Feminism: A Worldwide Perspective" in *Women in Africa and the African Diaspora*. Rosalyn TerborgPenn, Sharon Harley and Andrea Benton Rushing, eds. Washington, D.C.: Howard University Press, 1987, 3–24.

Steinem, Gloria. "Humanism and the Second Wave of Feminism." *The Humanist*. May/June 1987.

Steinem, Gloria. "Looking to the Future." *Ms*. July/August 1987.

Stewart, James B. "Psychic Duality of Afro-Americans in the Novels of W.E.B. Du Bois." *Phylon*, 44:2, 1983, 93–107.

Stewart, James B. "Perspectives on Reformist, Radical, and Recovery Models of Black Identity Dynamics from the Novels of W.E.B. Du Bois" in *Flight in Search of Vision*. Trenton: Africa World Press, 2004, 107–127.

Stowe, Harriett Beecher. *Uncle Tom's Cabin*. Boston: John P. Jewett and Company, 1851.

Thiam, Awa. *Black Sisters, Speak Out*. London: Pluto Press, 1986 (translated).

Truth, Sojourner. "And Ain't I a Woman" in *Narrative of Sojourner Truth*. New York: Arno and *New York Times*, 1968.

Van Gennep, Arnold. *The Rites of Passage*. Chicago: University of Chicago Press, 1960.

Walker, Alice. *In Search of Our Mothers' Gardens*. San Diego: Harcourt, 1983.

Wall, Cheryl A. "Zora Neale Hurston: Changing Her Own Words" in *American Novelists Revisited: Essays in Feminist Criticism*. Fritz Sleischmann, ed. Boston: G.K., 1982, 371–393.

Wallace, Michele. *Black Macho and the Myth of the Super Woman*. New York: Warner, 1980.

Washington, Mary Helen, ed. *Black-Eyed Susans*. New York: Anchor, 1975.

Watkins, Valethia. "Africana Gender Studies: Toward Thinking Gender without Feminism" in *Africana Theory, Policy and Leadership*, 2016, 63–82.

Watkins, Valethia. "Contested Memories: A Critical Analysis of the Black Feminist Revisionist History Project." *Africology: The Journal of Pan African Studies*, 9:4, July 2016, 271–289.

Welch, Sharon D. *A Feminist Ethic of Risk*. Minneapolis: Fortress, 1990.

Wheeler, Barbara. "Africana Womanism, An African Legacy: It Ain't Easy Being a Queen" in *Contemporary Africana Theory Thought and Action: A Guide to Africa Studies*. Clenora Hudson-Weems, ed. Trenton: Africa World Press, 2004, 319–331.

Wikipedia, on "Intersectionality."

Woolf, Virginia. *A Room of One's Own*. New York: Harcourt, 1957.

Yette, Samuel F. *The Choice: The Issue of Black Survival in America*. Maryland: Cottage, 1971.

Zorbel, Joseph. *Black Shack Alley*. Washington, DC: Three Continents Press, 1980.

ANNOTATED AFRICANA WOMANISM BIBLIOGRAPHY

A blueprint

Aldridge, Delores P. "Towards Integrating Africana Women into Africana Studies" in *Out of the Revolution: The Development of Africana Studies.* Delores P. Aldridge and Carlene Young, eds. Lanham, Boulder, New York and Oxford: Lexington Books, 2001, 191–203. In this particular article in the book, Aldridge states that it is the responsibility of the scholars to educate themselves, and in this case, being educated on the subject Africana Womanism as a workable paradigm for the study of Africana life, culture, and history. Thus, Aldridge asserts that "it is from this perspective of Africana womanism that this discourse is developed." Further, she contends that "Hudson's work has no parallel as a new way of understanding Africana women."

Alexander-Floyd, Nikol G. and Evelyn M. Simien. "Revisiting 'What's in a Name?': Exploring the Contours of Africana Womanist Thought." *Frontiers: A Journal of Women Studies,* 27, 2006, 67–132. Credits Hudson-Weems' Africana Womanism for establishing Black women's place within the walls of academe, specifically its juxtaposition to other female-based concepts. It examines the originality of the theory and the importance of self-naming and self-defining, two of eighteen tenets of the Africana womanist and the foundation for the theory. These key features distinguish Africana Womanism from other womanist/feminist constructs and distant itself from anti-male, traditional gender exclusive discourse.

Blackmon, Janiece. "I Am Because We Are: Africana Womanism as a Vehicle for Empowerment and Influence." Master's Thesis, Virginia Tech, June 2008. Considers Hudson-Weems' Africana Womanism in understanding and appreciating the role of women relative to the structure and activities of key Black grassroots organizations of the 1960s up to the early 2000s, such as the Black Panther Party, Rastafari and the Nation of Gods. Highlighting the dynamics of gender, this work, like Africana Womanism, concludes that racism needs to

be prioritized over sexism, the polar opposite of feminism, which traditionally advocated gender exclusivity. The M.A. thesis points to the strength of Black women, who helped their male companions shape positive organizations for the betterment of our communities.

Cowser, Angela and Sandra I. Barnes. "From Shack Dweller to Home Owner: The Power of the MBOP, Africana Womanism, and Self-Help Housing among the Shack Dwellers Federation of Namibia." *Journal of Namibian Studies*, 19, 2016, 15–41. Explores how Hudson-Weems' Africana Womanism, a family-centered paradigm, played a major role in aiding the Shack Dwellers Federation of Namibia (SDFN), with the assistance of the Self-Help Housing and the Federation membership, in bringing their goals to fruition. The defining attributes of African Womanism, which the women practiced daily, was said to have been behind their ultimate success, radically changing their status via developing leaders, thus, converting shack dwellers into homeowners. The article highlights the tenets of Africana Womanism, actively embraced by these women who emerged as role models.

Davidson, Maria and Scott Davidson. "Perspectives on Womanism, Black Feminism and Africana Womanism" in *African American Studies*. Edinburgh: Edinburgh University Press, 2010, 239–259. Explores the dynamics of the distinctions and commonalities existing between Clenora Hudson-Weems' Africana Womanism, a family-centered paradigm, prioritizing race, class and gender, and other female-based constructs, such as feminism, Black feminism and Womanism, initiated by novelist and essayist Alice Walker. The authors highlight the applicability of the theory and its distinct elements, characterizing the Africana womanist, with particular emphasis on the importance of self-naming and self-defining, as the major cornerstones for the Africana Womanism paradigm for ultimate human survival.

Dove, Nah. "African Womanism: An Afrocentric Theory." *Journal of Black Studies*, 28:5, May 1998, 515–539. The author discusses African Womanism within the context of Westernized constructs, which is an Africana Womanism continuum. She concludes that Hudson-Weems' theory, its methodology and perspective, is a more applicable paradigm for the study and assessment of the realities of Africana women, as Africana people in general exude an Africana Womanist and male perspective. Realizing the limitations of feminism, Dove's assessment concurs with the theorist that Black women have always been Africana Womanists, even before the terminology was put into place, an observation earlier made early by Hudson-Weems, as it is key to an Africana worldview.

Gilliam, Doris. "I Have to Know Who I Am: An Africana Womanist Analysis of Afro-Brazilian Identity in the Literature of Mirian Alves, Esmeralda Ribeiro and Conceição Evaristo." Doctoral Dissertation, Florida State University, 2013. This doctoral dissertation explores Black female identity in the literature of three contemporary African Brazilian writers—Miriam Alves, Esmeralda Ribeiro, and Conceição Evarist—utilizing Clenora Hudson-Weems' Africana Womanism as an authentic theoretical tool of analysis for these literary texts. In so doing, the

dissertator focuses on two of the eighteen characteristics of Africana Womanism, self-naming and self-defining, as she develops an assessment of Black female characterization in each literary text.

Gonzalez, Flora M. "Cultural Mestizaje in the Essays and Poetry of Nancy Morejon." *Callaloo*, 28:4, 2005, 990–1011. Discusses the life and works of an Afro-Cuban writer, Nancy Morejón, who, in a subtle compelling way, discusses race and revolution in her crafty style in celebrating her Afro-Cuban heritage. Gonzalez praises the poet for her skills in treating themes and topics not acceptable in her country during that time, which was in the midst of revolutions and which represents, as many countries do, the acceptance of racial dominance. Further, the focus on the works evokes in many ways, the essence of Hudson-Weems' Africana Womanism, which like the poetry of the subject, represents an active participant within a family-centered paradigm that prioritizes race first.

Harvey, I.S. "The Role of Spirituality and Africana Womanism in the Self-Management of Chronic Conditions among Older African Americans." *Journal of Nursing Education and Practice*, 3:12, 2013, 81. Offers useful information relative to the connection between spirituality and healthcare. It provides invaluable insights into the journey of chronically ill African-American seniors from a holistic Africana Womanist perspective, as one of the main characteristics of Africana Womanism is spirituality, which has played a major role in the health of these patients, many of whom trust and revere God as penultimate in their everyday lives.

Hubbard, LaRese. "Anna Julia Cooper and Africana Womanism: Some Early Conceptual Contributions." *Black Women, Gender, and Families*, 4:2, Fall 2010, 31–53. Expounds on basic fundamental descriptors of Africana womanism as one discusses Anna Julia Cooper, often narrowly referred to as an eminent, pre-feminist, and her philosophical, political and personal persuasion from an Africana Womanist perspective. Utilizing the definition and features characterizing Clenora Hudson-Weems' Africana Womanism, along with Molefi Kete Asante's Afrocentricity, Cooper, a family-centered, race defender, resolute in a collective struggle with her male counterpart against racism, proves to be an Africana Womanist, long before the existence of the theory, as stated by the conceptualizer.

Hudson-Weems, Clenora. "Africana Womanism: The Flip Side of the Coin." *The Western Journal of Black Studies*, 25:3, Fall 2001, 137–145. In the lead article in this Special Issue on Africana Womanism, the writer makes a serious commentary on the overall status of strained Black male-female relations, be they intimate or platonic, given racial the weight of pressures on the Black family continuing into the twentieth century. As Africana Womanism was designed to specifically address critical issues impacting Black life relative to Black women as female companions, mothers and supportive sisters, it has become an antidote, offering authentic interpretations of our collective role as activist in securing ultimate Black survival. The selection also comments on Nobel Prize-winning author, Toni Morrison, and her spin on the strain of female relationships in particular

in her commencement address, entitled "Cinderella's Stepsisters," delivered at Barnard College in the 1980s, wherein she also speaks of how one could be discriminated against in other ways based solely on differences.

Hudson-Weems, Clenora. *Africana Womanist Literary Theory*. Trenton: Africa World Press, 2004. Hudson-Weems second Africana Womanism book is a sequel to the first one, which offers more in-depth information about the growing paradigm. Not only is there more commentary on the eighteen characteristics of Africana Womanism, as presented in the chapter entitled "Genuine Sisterhood or Lack Thereof," but there is also a guide for assessing male-female relationships presented in another chapter, "Africana Male-Female Relationships and Sexism in the Africana Community," culminating in a list of fifteen positive and negative elements of male-female relationships.

Hudson-Weems, Clenora. "The Tripartite Plight of Africana American Women as Reflected in the Novels of Hurston and Walker." *Journal of Black Studies*, 20:2, December 1989, 192–207. Citing racial domination as the foundation of the triple plight of Africana women, this article delivers an Africana Womanist analysis of Zora Neale Hurston's *Their Eyes Were Watching God* and Alice Walker's *The Color Purple*, although the latter demonstrates a strain attempt to demonstrate the existence of feminism/womanism as a valid tool of analysis of the plight of Black women. Nonetheless, there is strong evidence of the validity of Africana Womanism as a stronger tool in interpreting Black life.

Jennings, Regina. "Africana Womanism in the Black Panther Party: A Personal Story." *The Western Journal of Black Studies*, 25:3, Fall 2001, 146–152. The actual journey of a young Black woman, an active member of the Black Panther Party, who observes and experiences the collective struggle of both men and women for the protection of the family and its children in particular, against racial dominance in America, which negatively impacts black life. The author argues that sexism, too, also a serious nemesis to be combatted, was a real threat to her existence as a woman, although racism had to be confronted first, thus, justifying the Africana Womanism prioritization of race, class and gender for human survival.

Johnson, Linda Ann. "Claiming/Reclaiming Africana Womanist Literary Texts." Doctoral Dissertation, University of Missouri, 2006. An interpretation of several African Diaspora novels from Africa, the Caribbean and the United States, using Africana Womanism, an authentic race-based, family-centered methodology as an authentic tool of analysis. This study focuses on the impact of racism and economic disparity experienced by Blacks in general, male and female, hence demonstrating an indisputable common bond, while confirming the prioritization of race, class and gender. The major tenets of Hudson-Weems' Africana Womanism explored here clearly evidence the collectivity and complementarity of all—men and women, socially, politically, economically and spiritually.

Langley, April. "Lucy Terry Prince: The Cultural and Literary Legacy of Africana Womanism." *The Western Journal of Black Studies*, 25:3, Fall 2001, 153–162.

A close and careful examination of the life and works of an eighteenth-century poet and activist, Lucy Terry Prince, utilizing the theoretical construct of Africana Womanism. It identifies key features characterizing the Africana Womanist, including partnering with her male companion in the on-going struggle for total equity. An exemplar of resistance against racial oppression, this Africana Womanist reading ultimately validates the theory as a legitimate tool for contextualizing even the earliest writings of the Africana American literary tradition.

Makaudze, Godwin. "Africana Womanism and Shona Children's Games." *The Journal of Pan African Studies*, 6:10, June 2014, 128–143. Expounds on the relativity of Africana Womanism to male-female relationships in Zimbabwe, focusing on several Africana Womanism features, such as family-centrality, spirituality, mothering and nurturing. In checking its applicability via observing the girls in the children's games, Makaudze concludes that they exude many Africana Womanism descriptors, like male compatibility, in concert with males in the struggle, and respectful of elders, thus, validating the premise that Hudson-Weems' Africana theory is, indeed, designed for all Africana women.

Mangena, Tendai. "Theorizing Women Existence: Reflections on the Relevance of the Africana." Doctoral Dissertation, University of Cincinnati, 2014. Highlights that the major challenges in assessing African women's literature is the lack of authentic tools of analysis and the pervasiveness of feminism. Africana Womanism, an Afrocentric approach, has significantly changed that reality in that the theory offers yet another theoretical concept, one that no longer limits one to an analysis solely from a feminist perspective. This is important, for a literary work should be evaluated within its own historical and cultural matrix utilizing its own authentic tools of analysis for substantive, accurate interpretations, as is the case of Hudson-Weems' Africana Womanism.

Mazama, Amm. "The Afrocentric Paradigm: Contours and Definition." *Journal of Black Studies*, 31:4, 2001, 387–405. In this perceptive article on her area of expertise, Afrocentricity, Mazama makes a strong endorsement of Africana Womanism as a truly authentic Afrocentric paradigm for the study and assessment of Africana life and history. In fact, she acknowledges that "the term Africana Womanist itself is the first step toward defining ourselves in setting goals that are consistent with our culture and history. In other words, it is the 1st step toward existing on our own terms" (400–401).

Mena, Jasmine A., and P. Khalil Saucier. "'Don't Let Me Be Misunderstood': Nina Simone's Africana Womanism." *Journal of Black Studies*, 45:3, 2014, 247–265. A study of Nina Simone's music to identify struggles in both political activism and male-female relationships, thus, correlating the two in her protest songs that align directly with the theory of Africana Womanism. It discusses Simone's understanding of racism, reflecting socio-political issues as a means of raising Black consciousness. Moreover, defined as strong and authentic, important descriptors of Hudson-Weems' Africana Womanism, the artist insists upon being heard, not "misunderstood," as she "speaks truth to power" in her own creative way as a means of initiating cultural resistance for our ultimate freedom.

Muwati, I., Z. Gambahaya and T. Gwekwerere. "Africana Womanism and African Proverbs: Theoretical Grounding of Mothering/Motherhood in Shona and Ndebele Cultural Discourse." *The Western Journal of Black Studies*, 35:1, 2011, 1–8. The authors strongly validate Clenora Hudson-Weems' Africana Womanism as an authentic intellectual paradigm, grounded in African culture, which is evident with reference to African values, handed down throughout the centuries via the oral tradition, including proverbs and the family. The eighteen characteristics of Africana Womanism are applied in this profound study.

Mweseli, Monica. "Africana Womanism or Feminism." *Agenda*, 21:71, 2007, 130, DOI: 10.1080/10130950.2007.9674821. This article, assessible online, gives us a close glimpse at the major differences between Africana Womanism and feminism in general. The writer highlights two of the main eighteen characteristics of Africana Womanism in particular—in concert with the male in the struggle and male compatible—to demonstrate just how the Africana male and female have traditionally been, and continue the practice of being "in it together."

Mweseli, Monica. "Africana Womanism and Shona Children's Games." *The Journal of Pan African Studies*, 6:10, June 2014, 128–143. Examines the validity of Hudson-Weems' assessment of Africana male-female relationships as a necessary positive characteristic of Africana Womanism, which is grounded in an historical and cultural context. With reference specifically to the Shona of Zimbabwe, the theory represents a more holistic and realistic explication of elements characterizing true Africana Womanism and can be applied as a template to be used in children's games for highlighting its applicability to African life.

Newson-Horst, Adele S. Gloria Naylor's "Mama Day": An Africana Womanist Reading" in *Contemporary Africana Theory, Thought and Action: A Guide to Africana Studies*. Trenton: Africa World Press, 2007, 359–372. Convincingly explores the physical and spiritual lives of Gloria Naylor's main characters, using Africana Womanism as the tool of analysis. The author highlights three of the eighteen features of the Africana womanist: Family Centeredness, Male Companionship and Spiritual Awareness. To demonstrate the presence of these Africana Womanism tenets in the novel, she develops key characters, all of whom in some way represent the power of family-centrality. Cocoa, the great-niece of the title character, is a symbol of the desire for a positive male-female relationship; and Mama Day herself stands as the embodiment of spirituality in which the novel abounds.

Ntiri, Daphne W. "Africana Womanism: The Coming of Age" in *Contemporary Africana Theory, Thought and Action: A Guide to Africana Studies*. Trenton: Africa World Press, 2007, 309–318. Documents the growing acceptance, impact and popularity of Africana Womanism, evidenced by the global adoption of the theory, and demands for the first publication on the theory, *Africana Womanism: Reclaiming Ourselves* in 1993, experiencing numerous editions and a sequel, *Africana Womanist Literary Theory* in 2004. It establishes the foundation of the paradigm, its paramount significance in that because of major dissimilarities between European women and women of African descent, it is virtually impossible for any single construct, i.e., feminism, to be able to answer the needs of *all* women, indeed, a powerful premise.

Pellerin, Marquita. "Defining Africana Womanhood: Developing an Africana Womanism Methodology." *The Western Journal of Black Studies*, 36:1, Spring 2012, 76–85. Strongly supports Hudson-Weems' Africana Womanism and its agenda as spelled out in the eighteen distinct characteristics, i.e., self-naming and self-defining. She offers a list of positive goal for the Africana woman, which reflect the established tenets of Africana Womanism. She also responds to the media's violation of the image of black women via obvious stereotypes. Conversely, Black women rise to the occasion and counter those misconceptions about them with their own positive assessment of themselves, thus, becoming self-namers and self-definers.

Reed, Pamela Yaa Asantewaa. "Africana Womanism and African Feminism: A Philosophical, Literary, and Cosmological Dialectic on Family." *The Western Journal of Black Studies*, 25:3, Fall 2001, 168–176. Examines emergent theories by leading thinkers today on the critical issue of the global Africana community. The article presents perspectives of not only the Africana Womanist and the African feminist, different in name only, thereby uniting in a positive addition to the study of the Africana family, but perspectives of other African scholars and writers as well, all having their own philosophical and ideological perspectives.

Steiner, Anne. "Frances Watkins Harper: Eminent Pre-Africana Womanist" in *Contemporary Africana Theory, Thought and Action: A Guide to Africana Studies*. Trenton: Africa World Press, 2007, 333–341. Details the life and times of Frances Watkins Harper, a noted female writer-activist during slavery, who is the embodiment of a true Africana womanist, thus, an eminent pre-Africana womanist. The writer describes the family-centered, race-based activities of the subject, hence, characterizing her as an Africana womanist. The selection validates the need for prioritizing race first, as her political persuasion dictates this position as a natural for all Africana people, a persuasion that pre-dates feminism, thereby debunking any notion that gender issues must fall under an exclusive gendered paradigm.

Stephens, Ronald J., Maureen Deaveny and Venetria K. Patton. "Come Color My Rainbow: Themes of Africana Womanism in the Poetic Vision of Audrey Kathryn Bullet." *Journal of Black Studies*, 32:4, 2002, 464–479. Analyzes the work and its key figure within the context of Africana Womanism, coined by Clenora Hudson-Weems, concluding that Audrey Kathryn Bullet is, in fact, a model Africana womanist activist in her Black community. Possessing many of the characteristics of the Africana womanist, particularly in the poem in which she exudes a presence that represents spirituality, strength and authenticity, she also stands as a constant force in concert with her male companion in the struggle for human rights.

Thompson, Betty Taylor. "Common Bonds from Africa to the U.S.: Africana Womanist Literary Analysis" in *Contemporary Africana Theory, Thought and Action: A Guide to Africana Studies*. Trenton: Africa World Press, 2007, 343–357. Explores the commonalities in themes, critical issues and characters in the writings of African novelists, Mariama Bâ, Flora Nwapa and Tsitsi Dangarembga, and African-American novelists, Toni Morrison and Gloria Naylor. This analysis

offers an Africana Womanist interpretation, utilizing a workable methodology for authenticating unifying concerns of Africana women. In applying various tenets of Africana Womanism, this piece speaks volumes to the inadequacies found in other female-centered theoretical methodologies.

Tillis, Antonio D. "Nancy Morejón's 'Mujer Negra': An Africana Womanist Reading." *Hispanic Journal*, 22:2, 2001, 483–494. Presenting a background and overview of the life of Nancy Morejón, a noted Cuban writer, the article examines how the poet incorporates race, family, Afro-Cuban religions and politics, particularly relative to the oppressed and their struggle against racism in her poetry. Also presented is a commentary on the importance of Havana, Cuba, the birthplace of this poet, to her poetry, which sets the stage for her work and how she treats blackness within an Africana Womanism context, as outlined by Clenora Hudson-Weems, wherein race is a priority for people of African descent.

Wheeler, Barbara. "Africana Womanism, An African Legacy: It Ain't Easy Being a Queen" in *Contemporary Africana Theory, Thought and Action: A Guide to Africana Studies*. Trenton: Africa World Press, 2007, 319–331. Presents a litany of legendary African queens, dating back to antiquity, all of whom are great role models for Black women today. Moreover, this chapter reveals that the historical figures herein, who strongly embody the characteristics of the true African womanist, could also serve as the very foundation for the race-based theoretical concept of Hudson-Weems' Africana Womanism itself, carefully designed for all women of African descent.

Williams, C. Rose-Green. "Rewriting the History of the Afro-Cuban Woman: Nancy Morejón's 'Black Woman'." *Caribbean Quarterly*, 34:1/2, 1988, 10–18. The article gives an Africana Womanist reading of Nancy Morejón's poetry wherein Africana Womanism traits are appropriate in analyzing the current and historical realities of Black life in Cuba. The article, wherein slavery is the primary subject, naturally entertains the premise that race is no question the primary issue and, thus, Hudson-Weems' theory emerges as a highly workable tool of analysis for the works of this well-known, celebrated author, as well as other global figures.

APPENDIX

Africana-Melanated Womanism syllabus

Engl. 4420/Black Studies—Contemp. Africana-Melanated Womanist Writers
Class: Tuesdays/Thursdays, 11:00–12:15
Instructor: **Dr. Clenora Hudson-Weems, Professor of English**
Websites: http://web.missouri.edu/~hudsonweemsc/
www.africanawomanism.com

Course description, rationale, goals and objectives

English 4420, Africana-Melanated Womanism, is an undergraduate and graduate course specifically designed to broaden one's scope from a family-centered perspective in the area of issues, recurring themes and/or trends in modern Africana-Melanated women fiction, highlighting its applicability to our everyday lives worldwide. An in-depth study of the lives and selected works by five leading Africana-Melanated women writers—Pre-Africana-Melanated Womanist, **Zora Neale Hurston** (*Their Eyes Were Watching God*); African American/Caribbean Novelist, Paule Marshall (*Praisesong for the Widow*); Nobel Prize-winning author, **Toni Morrison** *(Beloved)*; Popular Cultural Novelist, **Terry McMillan** *(Disappearing Acts)*; and Former Rap Star Artist, Sister Souljah *(No Disrespect)*—will be enhanced by careful readings of two books from the Africana Womanism Trilogy—*Africana Womanism: Reclaiming Ourselves* and *Africana Womanist Literary Theory*—as well as readings of scholarly articles by and about the various authors. Methodologically, we will be highlighting the prioritization of Race, Class & Gender, a key feature in this paradigm, committed to the empowerment and equality of all, rather than a gender exclusive agenda (female-centered, female-empowerment) so characteristic of other female-based constructs. Students will be introduced to an authentic theoretical

concept and methodology, Africana-Melanated Womanism, and will be applying Africana-Melanated Womanist theory to the five Africana-Melanated womanist novels, clearly reflecting our daily lives throughout the world.

Meshed together, the primary and secondary reading materials, and other media materials, will aid students in refining their own individual concepts about not only the writings of the individual authors, but about critical current issues, particularly as they relate to Africana-Melanated women and their families and communities. The ultimate objective of the course, then, is to enhance one's knowledge and appreciation of Africana-Melanated women and their interconnection with their families (men and children) in particular and Africana life and culture (historically and currently) in general.

The purpose of this course is to introduce students to yet another theoretical construct, in addition to the widely known female-based theory—Feminism. Africana-Melanated Womanism is an authentic paradigm designed specifically for all women of African descent, and by extension, for all men and women in general. It demonstrates that we are all IN IT TOGETHER!

Textbooks and course materials

Primary sources (required)

HudsonWeems, Clenora, *Africana Womanism: Reclaiming Ourselves* (Bedford Publishers, 1993 — translated into Greek)

HudsonWeems, Clenora, *Africana Womanist Literary Theory* (Africa World Press, 2004—translated into Portuguese)

Hurston, Zora Neale, *Their Eyes Were Watching God* (University of Illinois Press)

Marshall, Paule, *Praisesong for the Widow* (Dutton)

McMillan, Terry, *Disappearing Acts* (Knopf)

Morrison, Toni, *Beloved* (Alfred A. Knopf)
Souljah, Sister, *No Disrespect* (Vintage Books)

Secondary sources (selections from these pieces are required)

Bonetti, Kay, *The American Audio Prose Library*—Interview with Toni Morrison (1980s); Interview with Clenora HudsonWeems (1995)

Hill, Patricia Liggins, general editor, *Call & Response: The Riverside Anthology of the African American Literary Tradition* (Houghton Mifflin, 1998)

Samuels, Wilfred and Clenora HudsonWeems, *Toni Morrison* (PrenticeHall, 1990)

Web Page Materials—Articles on Africana Womanism From *Africana Womanism: Reclaiming Ourselves*

Media coverage (newspaper, TV, etc.) on subject

Handout(s)—"Africana-Melanated Womanism"

YouTube—"Africana Womanism: A Global Paradigm for Human Survival"—
Bowdoin College, 2015

YouTube—"Voices Unheard: A Conversation within Feminism & [Africana]
Womanism"—U of Wisconsin-Oshkosh, 2015

Videos *Africana Womanism*—Convocation at Southern Utah U, 2007

> *Africana Womanism vs Black Feminism*—Barbara Christian and Clenora
> Hudson-Weems (Lincoln University, June 1993)
>
> *The Issue Is*—St. Thomas, U.S. Virgin Islands, June 1994

Grade determination

Attendance is mandatory; three or more unexcused absences will result in
lowering class grade a minimum of one grade level.★

—Class Participation 10%
—Oral Report 15%
—Pop Quizzes 15%
—MidTerm 25%
—Final Research Paper/Annotated Bibliography (7–10 pages): 35%

*If you anticipate barriers related to the format or requirements of this course, if you have
emergency medical information to share with me, or if you need to make arrangements in
case the building must be evacuated, please let me know as soon as possible.*

Schedule

Weeks 1–14:

1. Course Overview Course Requirements—Class Participation; Oral Re-
 ports; Quizzes and Exams; the Research Paper/Annotated Bibliography—
 Documentation, etc.
 Google Africana Womanism; check Wikipedia and peruse Web Page Ma-
 terials on Africana Womanism.
2. *Africana Womanism: Reclaiming Ourselves*—ON WEBSITE—Foreword
 (pp. xvii–xviii) and Chapter I (pp. 17–32)
 Africana Womanist Literary Theory—Chapter II (pp. 22–32)
 Bonetti, Kay—*American Audio Prose Library*—Interview—Hudson-Weems
3. *Africana Womanist Literary Theory*—Preliminaries; Chapter I (pp. 1–21)
 Chapters III (pp. 33–50); Chapter IV (pp. 51–63)
 YouTube—*Africana Womanism*, Bowdoin College, SEPT 2015

4. Africana Womanist Literary Theory—Chapter V (pp. 65–77)
 Chapter VI (pp. 79–97); Chapter X—Conclusion-Afterword (pp. 151–139)
 Video—*The Issue Is*—Video on Africana Womanism
5. *Call & Response*—Women's Voices of SelfDefinitions, pp. 1376–1381
 Oral Reports:
 Alice Walker—Introduction to "In Search of Our Mothers' Gardens" (On "Womanism")
 Handout
 Clenora HudsonWeems—"Africana Womanism: An Historical, Global Perspective for Women of African Descent," *C & R*, p. 1812
 Barbara Smith—"Toward a Black Feminist Criticism," *C & R*
 bell hooks—"Black Women: Shaping Feminist Theory," *C & R*, p. 1844
 Video—Southern Utah U. Convocation Address on Africana Womanism
6. Oral Reports:
 Video—Television Interview with Dr. Barbara Christian and Dr. Clenora Hudson-Weems on Black Feminism versus Africana Womanism (1995)
 Discussion on Africana Womanist Interpretation of literary text(s) by the following literary critics: LaRese Hubbard; April Langley
7. Quiz on Hurston's *Their Eyes Were Watching God*
 "*Hurston's Their Eyes Were Watching God: Seeking Wholeness*" in
 Africana Womanism: Reclaiming Ourselves, pp. 81–91 (On Website)Oral Reports
8. Hurston Cont.
 Mid-Term Exam
9. Paule Marshall—Bio Headnotes (*Call and Response*)
 Oral Reports
 Marshall's Praisesong for the Widow: Authentic Existence in Africana Womanism, pp. 105–117
10. Marshall Cont.
 Discussion on Africana Womanist Interpretation of literary text(s) by the following literary critics: Linda Ann Johnson; Adele Newson-Horst
11. Toni Morrison—Bio Headnotes (*Call and Response*, pp. 1694–1699)
 Quiz on *Beloved*
 From Samuels and HudsonWeems in *Toni Morrison*, pp. 1–30; pp. 94–138
 "Morrison's *Beloved*: All Parts Equal," Chapter VIII in *Africana Womanist Literary Theory*, pp. 115–126
 Morrison Oral Reports
12. *Africana Womanist Literary Theory*, Movie Review, Chapter IX, 127–130.
 Quiz on McMillan's *Disappearing Acts*
 McMillan Oral Reports
 "*McMillan's Disappearing Acts: In it Together,*" *Africana Womanism: Reclaiming Ourselves, pp. 133–142* (On Website)
13. McMillan Oral Reports Cont.
 Quiz on Sister Souljah's *No Disrespect*
 Oral Reports

"Sister Souljah's *No Disrespect*: The Africana Womanist Dilemma" (*AWLT*, 99–113)

14. Sister Souljah's Oral Reports Cont.
 Research Paper or Annotated Bibliography Due; Course Evaluations

Africana Womanism: "I Got Your Back, Boo"

Don't you know by now, girl, we're all In It Together?
Family-Centrality—that's it; we're going nowhere without the other
That means the men, the women, and children, too,
Truly collectively working—"I got your back, Boo."

Racism means the violation of our constitutional rights,
Which creates on-going legal and even physical fights;
This 1st priority for humankind is doing what it must do,
Echoing our 1st lady, Michelle—"I got your back, Boo."

Classism is the hoarding of financial privileges,
Privileges we must all have now in pursuit of happiness.
Without a piece of the financial pie, we're doomed to have a coup,
Remember—protect the other—"I got your back, Boo."

Sexism, the final abominable sin of female subjugation,
A battle we must wage to restore our family relations.
All forms of sin inevitably fall under 1 of the 3 offenses.
Africana Womanism corrects our common senses.

> Clenora Hudson-Weems, Ph.D. Written and
> Dedicated to All Africana Women, 2009

IN IT TOGETHER

INDEX

Made in the USA
Columbia, SC
20 January 2023

10711043R00098